# Contents

*v*

*Color plates follow page 154.*

# FROM
# THE
# CENTER

## feminist essays
## on women's art

# LUCY R. LIPPARD

A Dutton Paperback

E. P. DUTTON   NEW YORK

For all the women artists coming out
from the center everywhere

10 9 8 7 6 5 4 3

Published simultaneously in Canada by Clarke, Irwin and
Company Limited, Toronto and Vancouver.

ISBN   0-525-47427-7

# Introduction:
# Changing Since *Changing*

It's strange to stop and go back when I feel I've only started. While the essays in this book represent five years' work—the greater part of my energies since *Changing* was published in 1971[1]—they are in fact only the early stages of an ongoing process, a small percentage of what I hope to write about women's art. Looking back, I get impatient with the slow and laborious development of my feminism and its application to esthetics and politics. What was I doing all that time? (Well, I was being mother, lover, homemaker, part-time political activist, writing fiction, and earning a living.) The first two years of the movement wailed by in a haze of polemic, picketing, paperwork, and exhilaration. Now, instead of hashing over the past, I wish I could leap into the future and bring back the essays that come next—those on the twenty-odd artists who have particularly interested me, and those on ideas, and those on artists whose work I haven't even seen yet. It's all very frustrating. Similarly, the five-year attempt, represented by these essays, to generalize about a feminist art would be much easier to communicate if I could reproduce the three hundred and fifty slides I show when I'm talking—or, for that matter, if I could reproduce the whole New York Women's Art Registry, or all the W.E.B. (West-East Bag) registries, or slides of what every woman

---

[1] *Changing: Essays in Art Criticism* (New York: Dutton Paperbacks, 1971). Most of this book was written from 1966 to 1968; proofs were completed early in 1970.

*1*

everywhere is doing. Because it is exposure to such an immense variety of art by women that has formed the ideas in this book. Without the visual experience, the more specific one gets, the more absurd the generalizations sound.

The women's movement changed my life in many ways, not the least being my approach to criticism. It may not show too clearly from the outside; I'm still working on that. But from inside, from where I live, there is a new freedom to say how I feel, and to respond to all art on a far more personal level. I'm more willing to be confessional, vulnerable, autobiographical, even embarrassing, if that seems called for. I just reread *Changing* looking for contradictions, however, and found fewer than I expected. In 1966 and 1967 I was proselytizing for a public art, a broader art audience, looking for sexual content, declaring that it was "time that the word *intuitive* regained its dignity and rejoined the word *conceptual* as a necessary esthetic ingredient." I got in a word against Salvador Dali's rip-off of Meret Oppenheim, and the first three artists discussed in one essay were women. On the other hand, the monographs were all on men.[2] I knew women artists whose work I respected immensely, but somehow I hadn't gotten around to writing about them yet. (I was still working on a piece on Eva Hesse when she died, and the fact that I have since written a book on her, a book that was a great influence on my own development, doesn't make me feel much better about that.) All through *Changing*, I say "the artist, *he*," "the reader and viewer, *he*," and worse still—a real case of confused identity—"the critic, *he*."

Throughout *Changing*, I can also see that I was drawing back from certain tabus, among them "sentiment," "emotionalism," "permissive lyricism," and "literary generalization" —of all of which I am now frequently guilty. I disapproved of Oscar Wilde's description of criticism as "the highest form of autobiography," and preferred it to be not "self-expression, but autodidacticism." The major point of disagreement with my then self was my denial of the need for

---

[2] In fact I did write two short pieces on individual women (aside, of course, from many reviews of women's shows in *Art International* in 1965 and 1966), both in 1968. The one on Irene Siegel is reprinted here (pp. 151–154); the other was on June Leaf, as a catalogue preface to her show at the Allan Frumkin Gallery. This is not reprinted as I am working on a long-projected and more extensive piece on her.

integrating art with "other experience," for personal interpretation. "Is there any reason," I demanded, "why the rarefied atmosphere of esthetic pleasure should be obscured by everyday emotional and associative obsessions, by definite pasts, presents, and futures, by 'human' experience? Overt human content and the need for overt human content in the visual arts in this century is˙rapidly diminishing. . . . Thus the issue of introducing 'other experience' into art is, in the context of rejective [Minimal] styles, and for better or worse, irrelevant."[3] Reading this over, I shudder at its narrowness, taking consolation only in the fact that I ignored this rule in other essays, since I never could resist puns, associative and psychological readings, and snuck them in when I could.

I recognize now the seeds of feminism in my revolt against Clement Greenberg's patronization of artists, against the imposition of the taste of one class on everybody, against the notion that if you don't like so-and-so's work for the "right" reasons, you can't like it at all, as well as against the "masterpiece" syndrome, the "three great artists" syndrome, and so forth. I was opposed to all these male authority figures not because they were male, however, but because they were authorities. I considered myself one of the boys—the Bowery Boys[4] rather than the Green Mountain Boys. While this choice of an opposing position came from esthetic and social identification, it was not finally so different from its opposite. The same pie was being consumed by all. Eventually I came to realize this only through the combined influences of Ad Reinhardt's witty ambivalence toward the art world, of a group of artists in Rosario, Argentina, who felt they could not merely make art in a world so miserable and corrupt, and of the Art Workers' Coalition "alternatives," "action," and "decentralization" committees. One of the first feminist artits' groups—W.A.R.—came out of the Coalition too, but I resisted them for over a year. I was decidedly not accustomed to identifying with female underdogs—with oppressed people

---

[3] "Excerpts," from "After a Fashion—The Group Show," *The Hudson Review* (Winter 1966–1967), in *Changing*, pp. 205–206.

[4] The Bowery Boys (my term, we all lived on or around it in the early 1960s) were Robert Ryman, Sol LeWitt, Robert Mangold, Frank Lincoln Viner, Tom Doyle, Ray Donarski—and Eva Hesse, Sylvia Mangold, and me. They differed not only in esthetic but also in political attitudes from the Greenberg artists and their mentors, some of whom, for instance, were in favor of the war in Vietnam.

and unknown artists, yes, but *women*—that was too close for comfort. "I made it as a person, not as a woman," I kept saying. Androgyny was only attractive because it was too hard to be a woman.

It is no accident that I finally accepted feminism during a period spent alone with my five-year-old son in a fishing village in a foreign country, good and far away from the art world. I had retreated to write fiction—something I had been doing in fits and starts all my life and have always intended to make my "real" career. First, I realized that the book I planned to write didn't come from me, but from the artists I lived with and wrote about. They were, of course, mostly men. And second, I realized that I was ashamed of being a woman. Trite as this may sound in retrospect, it came as an earthshaking revelation. (I was ashamed of being ashamed.) It changed entirely what I wanted to do. I began to write for myself rather than for some imaginary male audience and, by extension, I began to write for women. When I got back to New York, Brenda Miller and Poppy Johnson suggested I join them, with Faith Ringgold, and protest the Whitney Museum's lousy coverage of women artists in their Annual Exhibitions. As the process of consciousness continued, I realized with relief that I no longer had to walk a tightrope and pretend to be what I wasn't. Working with women I could be—for better *and* worse— what I was. Looking back, I find it ironic that it took fiction to make me recognize fact.

Five years after the birth of my feminist consciousness, I still have to question every assumption, every reaction I have, in order to examine them for signs of preconditioning. Some changes came across fast. In the winter of 1970, I went to a great many women's studios and my preconceptions were jolted daily. I thought serious artists had to have big, professional-looking spaces. I found women in corners of men's studios, in bedrooms and children's rooms, even in kitchens, working away. I thought important American art was large. I found women working small both out of inclination and necessity. I thought important art had to show a formal "advance" over the art preceding it. I found that I could be moved more by content than by context. I was accustomed to male artists coming on with a veneer of self-confidence, jargon, articulation of formal problems, in other words, "knowing what they were doing." I found some women were

confused, unsure of themselves, much more vulnerable, but at the same time far more willing to open themselves and their work to personal and associative readings on the part of the viewer, willing to participate in the sharing of their art, their experience, their lives. It is no coincidence that the advent of a behaviorist, autobiographical art coincided with the rise of the women's movement.

One thing I find about my more recent criticism is that along with a denial of historical determinism comes a resistance to relating art by women to that of the men still dominating the art world. If I write about Mary Miss, for instance, I don't compare her achievements in time to those of Bill Bollinger or Alan Saret, not only because I don't think they are trying to do the same things, but also because her innovative early work never entered the general consciousness; making a belated case for unseen innovations, hidden developments, tends to sound rather pathetic. My reluctance to compare can be attributed to several other things: one, my preference for a dialogue with the work itself, in the *present;* two, my desire to help forge a separate feminist esthetic consciousness; three, the "inauthenticity" of some of my favorite women's art when compared to the male mainstream, and conversely the "inauthenticity" of the male mainstream when compared to some of my favorite artists' work (these streams diverge, or run parallel, or perhaps they are oil and water); and thus a protective impulse, a resistance to bringing this art in all its newborn sensitivity into a history that has rejected its sources. Much women's art, forged in isolation, is deprived not only of a historical context, but also of that dialogue with other recent art that makes it possible to categorize or discuss in regard to public interrelationships, esthetic or professional. It is not that the women weren't aware all that time of the artworld art, so much as those men were not aware of *their* art. The notoriously late starts of many women artists, late esthetic developments, and belated success or even attention—these can be attributed to that isolation as well as to more mundane domestic factors and public discrimination. For instance, when *Artforum* began a couple of years ago to do a series of short articles on "younger artists" (they called them "featurettes"), many of these turned out to be women well into their thirties. Similarly, when I did my first women's show, I selected only artists who had never had a show in New York. Several of them were in their thirties and forties. I could never have

arrived at such a strong show of men on that basis; by that point of maturity in this day and age, they would nearly all have been shown. Due to this long-term bottleneck, there simply is more good work by women than by men appearing today. I myself am accused of discrimination against men, but it really boils down to good old "quality," which is nothing *but* my personal preference. And this situation makes me feel good, although the reasons behind it don't; I can't help wondering how many women artists have fallen by the wayside.

Feminism, or at least the self-consciousness of femaleness, has opened the way for a new context within which to think about art by women. So far, such thinking (and feminist criticism itself) is only tentative. Within the old, "progressive," or "evolutionary" contexts, much women's art is "not innovative," or "retrograde" (or so I have been told repeatedly by men since I started writing about women; apparently I no longer qualify for the "avant-garde"). Some women artists are consciously reacting against avant-gardism and retrenching in esthetic areas neglected or ignored in the past; others are unaffected by such rebellious motivations but continue to work in personal modes that outwardly resemble varied art styles of the recent past. One of the major questions facing feminist criticism has to be whether stylistic innovation is indeed the only innovation, or whether other aspects of originality have yet to be investigated: "Maybe the existing forms of art for the ideas men have had are inadequate for the ideas women have."[5] Susana Torre suggests that perhaps women, unable to identify with historical styles, are really more interested in *art itself*, in self expression and its collective history and communication, differing from the traditional notion of the avant-garde by opposing not styles and forms, but ideologies.[6]

To run counter to the so-called mainstreams is one way of developing a feminist context, although therein lies the danger of being controlled by what one opposes. Also, the perception of artworld viewers, trained to see within the other context, may not be able to distinguish the genuine attempts to forge a new mode or a new image for new, and thereby unrecognizable, content. Old habits die hard. Some feminist

[5] Judy Chicago, *Strait* (Buffalo, February 1973).
[6] In conversation with the author about this introduction.

artists have chosen a fundamentally sexual or erotic imagery that is inescapably seen "through the object's eye" (to use the title of a painting by Joan Semmel). Others have opted for a realist or conceptual celebration of female experience in which birth, motherhood, rape, maintenance, household imagery, windows, menstruation, autobiography, family background, and portraits of friends figure prominently. Others feel the only feminist art is that with a "right-on" political posterlike content. Others are involved in materials and colors formerly denigrated as "feminine," or in a more symbolic or abstract parallel to their experiences; for example, images of veiling, confinement, enclosure, pressures, barriers, constrictions, as well as of growth, unwinding, unfolding, and sensuous surfaces are common. Others are dealing with organic "life" images and others are starting with the self as subject, moving from the inside outward. All of this work, at its best, exchanges stylistic derivation for a convincing insight into a potential female culture. Every artist trying to extricate her personal expressions and a universal feminism from the styles and prejudices of a male culture is undertaking a risky and courageous enterprise.

But feminist art does not consist simply of imagery or of "picturings," although these must inevitably be a vehicle for its effect. Judith Stein has pointed out that "perhaps the only things a truly feminist artist would concern herself with are the feminist movement and building a feminist art system inside a feminist society."[7] Until that society is clarified, feminist art must struggle to define itself within the art system as it stands—a capitalist system already appropriated by, and probably more appropriate to, male art. The formal anti-content tradition that has been prevalent in the last fifteen years of esthetics and criticism of abstract art militates against comprehension of a feminist art with different values. For as Shulamith Firestone has pointed out: "In those cases where individual women have participated in male culture, they have had to do so in male terms. And it shows. . . . It is not just a question of being as competent, it is also a question of being *authentic*."[8]

The earliest feminist artists (I'm thinking particularly of

---

[7] Judith Stein, "For a Truly Feminist Art," *The Big News* (California Institute of the Arts) 1, No. 9 (May 22, 1972), p. 5.

[8] Shulamith Firestone, *The Dialectic of Sex* (New York: Bantam Books, 1971), p. 157.

Judy Chicago in 1970 and 1971) found that no matter how much they talked about their intentions, public perception was unable to grasp the meaning of the work as they had intended it. Because Chicago's form language had painfully evolved out of years in the male culture, it was still superficially recognizable within that culture and could be read back into it even by relatively sympathetic viewers. Only when her imagery grew increasingly sexual and overt, and only when this process coincided with a higher level of consciousness in the general art world as well as in her primary audience—the Los Angeles women's community—did it begin to make sense as feminist art.

Psychological interpretations of art have not been popular since the late 1950s, and an artist insisting on content, when faced by an audience trained not to peer past the surface or to look behind the object, will complain that "no one understands what I'm doing," just as the artist who persists in a neutral, intellectual or formal reading will be distressed by an "ignorant" audience that approaches art from its own life experience and associations. An exclusively female audience might alter this perceptual distortion or prejudice to some extent, but sooner or later the goal of feminist art, bolstered by the confidence and understanding received in a female community, is to enter the real world and affect everyone—all those people whom contemporary art has failed to reach or to move. The question of authenticity is one of the greatest barriers to the comprehensibility of a feminist art, and it is one that feminist criticism must confront so that the larger public may also deal with it.

Clearly everyone looks forward to the time when the distinctions between male and female are minimized in favor of a more human equality. This will not happen until we understand the elements and conditions that underlie the experience of each sex. A lot of women artists have joined together, successfully, to bring more women into the system as it now stands. But if the art itself, whatever its "quality," is indistinguishable from the art made by men that is already in the galleries, nothing will change. Arguments against distinction between men's and women's expressions inevitably contain elements of fear or competition, or maintain an isolationist insistence on the distinction of every artist's work from that of every other artist's. (Nobody's art is an immaculate conception, but in esthetics parthenogenesis is possible; women can now begin to work from the embryonic history

of other women's art.) The most valid objection to the no-
tion of a "woman's art" is the basic fear that an individual's
art will not be seen with a free eye, or seen with equal con-
centration, or seen as one intended it, or seen at all, if pre-
conceptions and categorizations overwhelm it. But it would
be naïve not to realize the extent to which this is already
true in today's art world. I wince when I hear all the lovely
variety of women's art lumped together as a single entity.
Nor do I think all art by women or all feminist art is good
art. At the moment that's not even the point, because I'm
questioning what good art is anyway. While I hope that the
mere presence of more women in the art establishment is
changing its values slightly, simply because women are dif-
ferent from men, I worry that we will be absorbed and mis-
led before we can fully develop a solid value structure of
our own.

The gap between object and intelligent perception of the
object is, of course, one of the prevailing problems of mak-
ing art at any time in an alienated society. It is a time and
space gap filled only when the work is finally shown, dis-
cussed, written about, deciphered by an audience—in short,
when the moment of communication is at hand. But the
feminist gap is a more fundamental one. It cannot be closed
by mere absorption into the current system. In the bad old
days, women artists often worked in isolation, worked from
and for themselves and were paradoxically freer from the
pressures and influences felt within the art world. For once
there, the temptation is to work for the art audience. That
temptation may prove a more effective barrier to the evo-
lution of a feminist art than discrimination is. I should know.
I am still entrenched in this same art world I so often pro-
test. In fact, feminism is my sole remaining excuse for being
there. There are so few of us writing primarily on women's
art, and so few feminists in the establishment, that I feel
needed. I *am* needed. At the same time, maybe it's a cop-out.
The goal of radical feminism is to change the world. I would
like to revolutionize, but I am stuck with reform because of
the context I work in. Right now art feminism is trapped
within the system.

While I feel strongly that women should have a chance at
everything that men have, even the bad things, I am all
too aware of the traps set by the art world for the ambitious
artist. And women are, of course, as ambitious as men, al-
though one of the feminist goals is to get rid of hierarchies.

The older women, who are just having their first exhibitions after years of lonely struggle, are discovering they *can* be ambitious. The younger women, just finding their ways free of total male domination, are more wary of ambition but they are also surer of themselves and well able to compete. As a critic, it's none of my business to tell artists not to grab whatever chances for fame and fortune that present themselves, especially when I'm making a living off the same system. The entrance of more art by women into the establishment is certainly good for the establishment. But it is, perhaps, less of a good thing for a feminist art. One of the questions we have yet to answer is whether women do want the same things that men have wanted; whether "greatness" in its present form is in fact desirable.[9]

Perhaps the greatest challenge to the feminist movement in the visual arts, then, is the establishment of new criteria by which to evaluate not only the esthetic effect, but the communicative effectiveness of art attempting to avoid becoming a new establishment in itself, or, god forbid, a new stylistic "movement," to be rapidly superseded by some other one. Women's conditioning and capacity to please can lead to pleasing a broad audience as well as to pleasing the art hierarchy—a broad audience which would be, of course, half female. Finding that audience, making contact, is a political as much as an artistic act, but it is as creative as anything an artist can do. It takes immense amounts of energy, courage, originality. The artworld route is easier. Nevertheless, there are women emerging, all over the world now, who have realized through experience how unsatisfying success can be in an alien framework. They are the ones who will make a feminist art reflecting a different set of values. Precisely which values these will be can be worked out only in relationship to a new community, not to the present art world, which can be called a community only at times of severe stress or crisis, when the competition at its core is temporarily submerged. Perhaps the art will not change until the community changes it, or until it changes in response to the community. We have not wholly realized how deep a transformation is necessary.

To begin with, we have to think about why it is so difficult to go past a certain point in discussing the ways in which

[9] See Carol Duncan, "When Greatness Is a Box of Wheaties," *Artforum*, 14, No. 2 (October 1975), pp. 60–64.

a woman's art can answer the needs of a greater female (and, potentially, a liberated male) audience. The fact that most women artists are not very interested in these needs dampens, but hopefully will not extinguish, the spark. Why are we all still so afraid of being *other* than men? Women are still in hiding. We still find it difficult, even the young ones, to express ourselves freely in large groups of men. Since the art world is still dominated by men, this attitude pervades the art that is being made. In the process, feelings and forms are neutralized. For this reason, I am all in favor of a separatist art world for the time being—separate women's schools, galleries, museums—until we reach the point when women are as at home in the world as men are. The danger of separatism, however, is that it can become not a training ground, but a protective womb. The only effective strategies are those effective inside and outside a separatist society. Exchange, for instance, is a feminist strategy; out of dialogue between peers comes a focus to be shared by others. There is no reason why strong women artists cannot emerge from a feminist community to operate in both spheres, why they cannot, in fact, form a *trialectic* between the female world, the art world, and the real world. That's where I'd like to be. How to get there is the question.

I know now that I have not only to analyze my own (acculturated) taste but also to translate it into a value system which can universalize the task. (Male experience is already universal.) I have not only to reexamine the psychological and social motivations of myself and of the artists I write about, but also to find out what the prevalent metaphors refer to beyond themselves. I have to develop a temperamental consciousness into a cultural consciousness. So while I wish I could claim that this book established a new feminist criticism, all I can say is that it extends the basic knowledge of art by women, that it provides the raw material for such a development. The ongoing process that forms my own criticism will produce neither conclusions nor solutions, but will, I hope, engender more questions, more dialogue, more discussion, more investigation on the part of women artists and critics as well as myself. The art written about here contains the seeds of such change, more or less invisible now— but growing, growing.

# PART I: GENERAL ESSAYS

# Freelancing the Dragon[*]

Interview with the Editors of *Art-Rite*

In print Lucy Lippard seems enthusiastic and committed to the art she deals with. And so she is in person, but with an added measure of ambivalence. Of our major critics, Lippard probably has the strongest reservations about the art organization of which she is a part. One reason may be that she has another outlet; she has been writing fiction off and on since she was twelve; she has published a few short pieces, has one unpublished long work with an agent, and is laboring on a second.

She was born in New York in 1937, an only child and the daughter of a medical educator; she was and still is something of an antiacademic rebel. When she went to Smith, she majored in art instead of English because she thought that she had read everything herself and didn't want people telling her about the things she cared most about. ("My parents called me an antisnob snob.") She went to Paris in her junior year and "completely cut loose, completely floating," going to galleries, meeting artists, looking over the shoulders of friends who were working at Stanley William Hayter's printmaking studio.

After graduating (and winning the prize for the "most original literary composition"), she went to a Mexican village with the American Friends Service Committee. There she

---

[*] Reprinted from *Art-Rite*, No. 5 (Spring 1974).

taught Aztec children English and geography, planted beans, dug latrines, and improved her Spanish. When she came to New York in 1958, she wanted a job in a gallery, "which seemed more romantic than a museum, but luckily I wasn't pretty enough and I couldn't type." She went to Robert Goldwater (who was later to be her thesis advisor, and, later yet, a friend and husband of an admired artist—Louise Bourgeois). She said she was going to be a writer, but wanted to do a little art criticism for a "warm-up." He broke it to her gently that it just wouldn't be that easy. Undaunted, she went straight to Hilton Kramer, then editor of *Arts*, and did some trial reviews. She described them as awful and naïve; "so-and-so has quite a nice sense of color" sort of thing. He was kind about them and told her to come back after she had lived through an art season, but she felt so "hideously rejected" that she lay low for six more years.

She got a job as a page, indexer, researcher at The Museum of Modern Art Library, where the librarian, Bernard Karpel, was a great influence and steered her toward Dada and Surrealism. She dragged piles of heavy periodicals to people who are now her colleagues, met museum guards Dan Flavin and Robert Ryman, and night watchman Sol LeWitt, who would also become a major influence on her thought. She hung out on the fringes of Tenth Street and started meeting artists.

At the same time, she began to attend the N.Y.U. Institute of Fine Arts, "because with an M.A. I could get $3.00 an hour instead of $2.00 for art research." She went to Florence to take a graduate course with H. W. Janson (Max Kozloff was also a student there), and returned to New York via Paris, determined to "work in a dime store and write fiction." But it turned out to be easier getting work as a free-lance art-history researcher ("I called myself an art-historical whore, because I'd research anything anybody asked me to"), and she went back to the Institute at nights.

*I was working full time by then to support me and Bob Ryman, who'd been working full time himself for years and needed some real time to paint. I was a pariah at the Institute where an M.A. was supposed to take four sacred years, and where you were not supposed to be involved in contemporary art and not supposed to work for a living. . . . I was the proletarian of the Institute . . . nobody wore jeans;*

*the mark of that then was wearing long black stockings and your hair down over your face. . . . I felt very ostracized and belligerent about being ostracized, but at the same time kind of above it all.*

She was then becoming "passionately involved" with the issues and intensities of recent art. In 1962 she and Ryman moved to the Bowery from Avenue D, and eventually became part of a neighborhood clique of practically unknown artists, including Bob and Sylvia Mangold, Frank Viner, Dan Graham, Ray Donarski, Eva Hesse, Tom Doyle, and Sol LeWitt "who was the intellectual heart of the situation. Aside from Bob, he was the first man to take me seriously as a professional and he has done the same for a lot of women artists too."

The first criticism she published was in the *College Art Journal* (1962), an academic piece comparing Dubuffet and Ernst (provoked by work for MOMA shows of both artists, and her M.A. thesis on Ernst). Then for a year she worked on a Rosenquist article and in 1964 Max Kozloff asked her to write the New York reviews for the youthful *Artforum*. ("It was such a crummy little magazine in those days I couldn't even get some of the galleries to give me photographs for it.") Phil Leider later said he didn't like those reviews but he used two sets of them. When Kozloff left *Art International*, Lippard was asked to fill the reviewing spot. ("In *Art International* you wrote your heart out in each long review because it was the major place for people to see your work and the artist's work.") When Barbara Rose also left almost immediately after that, she suddenly became the "senior critic for New York City," responsible for covering some thirty-five shows a month. She was eight months pregnant. Her first "New York Letter" appeared in November 1964, followed a month later by her son Ethan. "Luckily the editor was in Switzerland. I didn't tell him till I'd had the baby and handed in my reviews on time."

For at least a couple of her earlier years Lippard wrote what was then called the "new criticism," an art-historically grounded and very formally analytical style, "which, looking back, seems such a waste of time. . . . I used to spend half my little space describing the work in minute detail, and no one who hadn't seen it in the flesh could tell what it looked like from verbal description anyway."

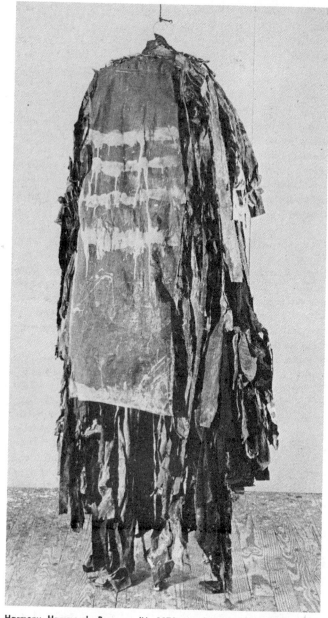

Harmony Hammond: Presence IV. 1972. Acrylic and cloth. **82″ × 29″ ×
14″**. Photo: Dale Anderson.

Since then, she has experimented with an art-imitative style, compiled data or presented work with little or no comment ("presentations"[1]), and currently is using an open expository style. *Pop Art* and *Six Years: The Dematerialization of the Art Object* . . . represent two poles of her critical methodology. The former is a historically accurate and thorough exposition of Pop style, sociology, iconography, and artist discourse. The latter is a compendium of information on a vaguely defined area of artmaking, presenting plans and/or documents of the artwork, if the art could not be presented intact. There is no critical interference aside from a short foreword, a short postscript, and occasional textual insertions for clarity. *Six Years* pointedly contains none of the usual critical explication, but she does consider this book criticism for all its departure from linear explanation.

Of this form Lippard says:

*I think that if I explained the art, it would reach the same middle-class audience that it is reaching now. . . . I don't have an urge to write popular accounts that would be read by people to whom less popular accounts are equally accessible, if they could only get their heads together to read intelligently and think for themselves.*

*I started out with the idea that criticism was going to be a provocation, another kind of provocation than the art. . . . But people don't look, don't think when they look. . . . So we find ourselves either writing pap to be fed to the "art public" or P.R. for the market, or incestuous annotation for the inner art scene—which isn't much of a contribution to anybody.*

Trying to broaden her "contribution," Lippard found out just how circumscribed a critic's position is supposed to be. She has organized several more exhibitions in spite of the reaction her controversial first one, "Eccentric Abstraction," got back in 1966 (Eva Hesse, Alice Adams, Bruce Nauman, Louise Bourgeois, Gary Kuehn, Keith Sonnier, Don Potts, Frank Viner). "Critics didn't often do shows then and most of the reviews griped about that instead of writing about the art." Her shows have varied in form and intent, from the

---

[1] Such as "Two Proposals: Lucy Lippard Presents the Ideas of Adrian Piper and Eleanor Antin" (*Art and Artists*, March 1972), in which I wrote a very brief preface and the rest of the article was by the artists.

first women's-movement-oriented show to "exhibition as criti-
cism," or "situations" into which artists could work, as an at-
tempt at an unwritten critical vehicle.[2]

Lippard has certain basic reservations about criticism:

*I've never had much faith in art criticism as a primary form
because you are leaning on somebody else's work. It's not that
it can't be a positive parasitic process, not that you can't bring
new insights to the work, or get out the artist's intentions
better than the artist himself or herself might be able to do,
but I can't think of any criticism that has ever stood up in
the long run as a real parallel to the art. Some of the critics
we respect the most didn't write good criticism—they were
good poets or something. It's self-indulgence when you come
right down to it, you like something and you enjoy plunging
into it with words. I don't finally know what the hell criti-
cism does for anybody except the artist and the writer.*

With few exceptions she now writes only about art she
likes, and the very visual and fragmentary fiction she has
been writing has in turn been "decidedly influenced by the

---

[2] Among the approximately dozen exhibitions I have organized
since 1966 is one series of which I am particularly fond. Titled
numerically by the population of the city in which each one
originated, they include *557,087* (Seattle), *955,000* (Vancouver,
more or less the same works as the first), *2,972,453* (Buenos
Aires, an entirely new group of artists), and *c. 7500* (Valencia,
California). The catalogues in each case were randomly read
index cards, one designed by each artist and some containing
my "text"; these cards could be mixed together and reassembled
in endless different ways; some could be discarded, others kept,
etc. The most recent of these shows (*c. 7500*) included only
women artists: Renate Altenrath, Laurie Anderson, Eleanor Antin,
Jacki Apple, Alice Aycock, Jennifer Bartlett, Hanne Darboven,
Agnes Denes, Doree Dunlap, Nancy Holt, Poppy Johnson, Nancy
Kitchel, Christine Kozlov, Suzanne Kuffler, Pat Lasch, Berna-
dette Mayer, Christiane Möbus, Rita Myers, Renee Nahum, N. E.
Thing Co., Ulrike (Rosenbach) Nolden, Adrian Piper, Judith
Stein, Athena Tacha, Mierle Ukeles, Martha Wilson. It was origi-
nated at the California Institute of the Arts, Valencia, Cali-
fornia, and independently circulated to the Wadsworth Atheneum,
Hartford, Connecticut; Moore College of Art, Philadelphia; Walker
Art Center, Minneapolis; Institute of Contemporary Art, Boston;
Smith College Museum of Art, Northampton, Massachusetts; The
Garage, London, England; A.I.R. Gallery, New York; And/Or,
Seattle; and the Vassar College Museum of Art, Poughkeepsie,
New York.

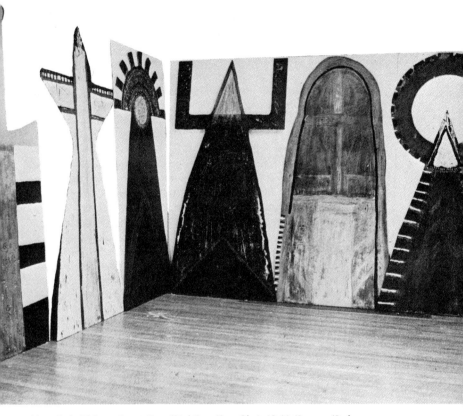

Mary Beth Edelson: *Great Maya/Bird Tara/Sun Gloria/Celtic/Passage/Red Sophia,* from *Great Goddesses* series. 1974. Paint on plywood. 48″ × 96″. "The ascending archetypal symbols of the feminine unfold today in the psyche of modern Everywoman. They encompass the multiple forms of the Great Goddess. Reaching across the centuries we take the hands of our Ancient Sisters. The Great Goddess, alive and well, is rising to announce to the patriarchs that their 5,000 years are up—Hallelujah! Here we come."

art I like." She feels changes in criticism can be partially based on alteration of critical form.

*I wish criticism could be loosened up to the point where it would really follow the art almost blindly, not in a sense of no criteria, but blindly into the esthetic, drawing back only to elucidate or complain, but for the most part riding with the art. Like criticism on Olitski should be all mushy, and on Judd all straight and trim. I'd like to be able to write a good stream-of-consciousness criticism. I don't think that all those academic transitional passages should be necessary.*

Examples of Lippard's developing experimentation can be found in her collection of essays, *Changing*, among them "Art Within the Arctic Circle" and "Absentee Information and or Criticism." A recent variant is her "essay" on the Readymades in The Museum of Modern Art's Duchamp catalogue, which is a narrative made up of "found" fragments and a mass of puns.

At best this art-imitative strategy is only partially successful, as Lippard will readily admit. "At one point in the mid-1960s several of us were trying to make art *and* criticism more difficult so it and fine art couldn't be absorbed by the alarmingly larger and richer audience so easily. That mystique doesn't seem to exist now. I think most critics now would at least *like* to be broadly readable."

Lippard is well aware of the problems that seem inherent to criticism, and yet she continues to write. Such ambivalent awareness characterizes Lucy's position in the art world in general. But criticism is a way of life for her, and she frankly enjoys "that gap between the visual and the verbal." Beyond what changes criticism can wreak upon itself, Lippard feels that "it is crucial that art acquire a broader audience or it will stifle in its own narrow confines." She would like to be able to get art out to "the masses" but pragmatically believes that traditional criticism can't function in the real world. "The way is going to have to be paved by the art, which is the primary act, the direct communication. I am waiting to be led out there by art I like. It hasn't happened often so far."

Lippard's complaints about the art world read almost like a description of it: "Artworks sincerely made by committed artists are turned into commodities, used as decoration and

conversation pieces for an elite audience, forced into competition with other art, and thereby made impotent to really provoke insight—all too often with the artist's consent. The uncommunicative aspect of much art now is really sad." But at the same time, "I find there is always art around that interests me . . . if I go to ninety galleries I see at least nine shows that make me think or feel—not bad but tiring."

She had hoped that Conceptual Art would reach a large audience and transcend the closed art market for expensive objects, or at least decentralize the New York base. It did not, of course, make much headway. "Conceptual Art . . . got co-opted too and I certainly don't blame any of the artists because artists should be able to make a living off what they do like everybody else. I blame the society that puts property values over anything else."

Lippard would like to see the end of the central New-York-based "mainstream," so that people would feel freer to choose what they make and what they take.

*I think that pluralism is the only choice at the moment— lots of different ideas thrown out, and the audience at least being made to think for itself enough so that it has to choose something . . . now is a healthy time to make art because there isn't one thing you have to do. Also an advantage of a decentralized art world would be that people could do something "derivative" and enjoy it. Art should depart from the established monolith—each area of interest should have its own community of artists, critics, and public.*

These are ideas that continue to grow, in part from her dialectic with artist Charles Simonds, with whom she lives.

Lippard's objections to both criticism and the system might seem too strong to allow her to stay in it, but she remains, ruefully. "*I can never figure out if I should keep on plugging for the work and the values I care about and provide at least a whisper of dissent from the artworld mainstream, or quit entirely in protest. But then who would care? There's nothing I can say that I won't go back on in the next thirty seconds, and back on again as I waver between my own involvement in art and in social values and the inevitable contradictions between the two. . . .*"

Lippard was radicalized by a trip to Argentina in 1968 (the year of her Guggenheim Fellowship to write on Ad Rein-

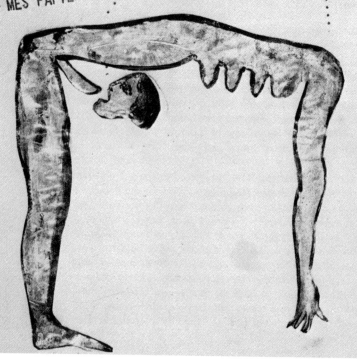

NT DE SEPTEMBRE 1937 A AUJOURD'HUI IL M EST
QUE J'AI ÉTÉ ARRETÉ, MIS EN PRISON A DUBLIN,
É EN FRANCE, INTERNÉ AU HAVRE. TRANSFÉRÉ DU
A ROUEN, DE ROUEN À SAINTE-ANNE A PARIS, DE
E-ANNE À VILLE ÉVRARD, DE VILLE ÉVRARD A CHE-
BENOÎT ET DE CHEZAL-BENOÎT A RODEZ. TOUTES
AFFAIRES M'ONT ÉTÉ PRISES PAR LA POLICE ET
S MES PAPIERS ON ÉTÉ PERDUS.          ARTAUD

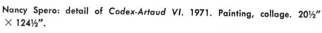

Nancy Spero: detail of *Codex-Artaud VI.* 1971. Painting, collage. 20½″
× 124½″.

hardt). Since then she has been active politically, at least
in terms of the options open to her. She worked for the anti-
war movement, the Art Workers' Coalition, supports the goals
of the National Art Workers Community, organizes benefits
like the Chilean Emergency show now being held (1974).

Since 1970 she has been particularly involved with women
artists' groups, helping to found the Ad Hoc Women Artists'
Committee, the Women's Art Registry, and W.E.B. (West-
East Bag). She often feels isolated in her efforts to improve
artists' rights. "The reason artists are so constantly used,
why they have no legal rights whatsoever, is that they are
still letting themselves and their works be made into com-
modities, although I have to admit that in this society they
haven't got much choice. Still, some energy exerted in an-
other direction might come up with a choice." Lippard has a
general political awareness that leads her toward anti-insti-
tutional polemic. However she seems to apply this on a
broad level only, and personally she identifies with artists as
individuals who each have the same right to "success," even
if overall she objects to that standard of achievement, that
goal or reward. It seems that in Lucy's eyes no individual
should be blamed for not changing the world—or art's rotten
context. But who should change it then?

*I am caught in a state of being totally aware that I am
supporting a system I abhor by writing criticism and yet
being hooked enough on art to find it hard to stop, especially
if I can get more women's work seen and taken seriously in
the process. Certainly free-lancing is the only way I can
exist. I don't like working for anyone else, or teaching (though
I do a lot of lecturing, just ad lib), and I hardly belong in an
institution.*

Her willingness to enter the system as artist-forwarder is
indicated by a spate of articles in a variety of publications,
including *Artforum*, from which she had abstained for four
years. Her boycott began in 1967, in protest against *Art-
forum*'s Greenbergian line and the fact that they didn't want
articles on many artists who interested her, though some of
these would soon become *Artforum*'s own cover boys. "The
boycott, it should be said, was mutual." Now she is con-
tributing to *Artforum* in part because it began to publish
short articles on "younger artists." "It turns out that most
women of any age fall into the category of younger artists

because they haven't shown or been recognized or taken seriously."

Lippard admits that for years she was not attuned to the plight of women artists. She was a believing victim of the cliché "if you got anyplace as a woman you must be better than most women because everybody knew women were inferior. You couldn't identify with other women; the art world bore it out. There were virtually *no* women artists visible."

In 1970 Lippard realized what the women's movement was about. "A lot of the work I did with women artists at the beginning was to assuage the guilt about the way I had treated them myself. . . . Now I simply see more work I like that's by women than by men." She despairs, believing that the most desired thing she can do for women artists is introduce them into the system she dislikes, "get them a piece of that rotten pie, at least until some alternative shows up in New York, as it has in Los Angeles. It may be impossible here, the art world is so powerful. I'm damned if *I've* been able to come up with one."

For all her doubts, Lippard adds needed quizzical insight to the evolution of Fine Art Culture. She takes an obvious joy in being an outsider, a sniper, but really believes that she is "not doing anything different from what everybody else is doing." Because "so little has changed, aside from the immense increase in the number of women on the scene," Lippard feels that she hasn't pushed hard enough. But who pushes harder?

*The women's movement has changed many things in my life. I'm tackling some of the ramifications of that change in a book I'm writing now on Eva Hesse. For years I tried to write about art-as-art under the influence of Reinhardt (whose moral emphasis also had a huge effect on me), leaving out personal knowledge and experience. But in this book I'm trying to tread the same precarious edge that Eva did in her own work—which was pure abstract art but was utterly informed and expanded by her life. I knew her well and it would be absurd to "forget" what I knew of her as a person and write a hard-assed Minimal critical book. The women's movement has allowed me to be much more exposed about my own feelings, less afraid of what people think, more out front with emotional reaction to art, which has been hidden*

*away in the last decade or so of criticism. I am having to deal with the same things writing an article on Judy Chicago, who is integrating a very personal, often embarrassing content into her abstract form language. It is the sort of writing I could only allow myself in fiction until now . . . it won't change the world either, but it's a breakthrough for me.*[3]

---

[3] A more recent conversation about this is found in Ann Stephen, "At the Edge of a Feminist Criticism: An Interview with Lucy Lippard," *Meanjin Quarterly* (Melbourne, Australia, October 1975).

# Sexual Politics: Art Style*

For the last three New York seasons, and particularly during the past winter, women artists have begun to protest discrimination against their sex in the art world. Active protest began in 1969 with W.A.R. (Women Artists in Revolution)—the women's group affiliated with the Art Workers' Coalition—whose pioneering efforts received virtually no support from better-known artists of either sex. From October 1970 to February 1971, another group, also emerging from the A.W.C. called itself the Ad Hoc Women Artists' Committee and addressed itself solely to the issue of the Whitney Museum's Annual Exhibition of American Art. That group now exists on a broader basis and focuses on (1) weekly discussion groups, (2) political action in the streets, and (3) legal action in concert with W.A.R. A third group is restricted to figurative artists and a fourth general organization of women in the arts was formed in the spring. There are also numerous smaller consciousness-raising groups of women artists.

On the West Coast, Judy Chicago and Miriam Schapiro are setting up the first feminist art program, at the California Institute of the Arts in Valencia, based on Judy's work at Fresno, and Marcia Tucker will direct a women's course at

---

* This is the original, longer, version of "Sexual Politics: Art Style," which appeared in *Art in America*, 59, No. 5 (September 1971).

the School of Visual Arts here this coming winter.[1] In June
the newly formed Los Angeles Council of Women Artists
threatened a civil rights suit against the Los Angeles County
Museum of Art with statistics that reflect the national situa-
tion: only twenty-nine out of seven hundred and thirteen
artists whose works appeared in group shows at the museum
in the past ten years were women. Of fifty-three one-artist
shows, only one was devoted to a woman (the same record
as New York's Museum of Modern Art; both women were
photographers—Dorothea Lange and Berenice Abbott). On
June 1, 1971, less than one percent of all work displayed at
the Los Angeles museum was by women. A spokesman from
the museum, according to the *Los Angeles Times*, "declined
to comment," though he held up as hopeful the fact that
the two *assistants* to the male curator of modern art were
women. (Assistants to curators, like editorial assistants in
publishing, are rarely allowed any independent responsibility
and are usually underpaid, overtitled slaves.) In the last few
months, W.E.B. (West-East Bag) has been created as a
liaison network to inform women artists' groups internationally
of each other's actions, legal maneuvers, methodology, dis-
cussion topics, and techniques; so far it has representatives
in twelve states and five countries.

The history of these actions is complex, infuriating, exhila-
rating—especially that at the Whitney, which was sustained
over an active four-month period of picketing, public inter-
viewing, and harassment (such as an anonymously forged
press release announcing the Annual would be fifty percent
female; five hundred fake tickets to the opening, for women;
guerrilla actions within the museum, etc.). The result was that
the Whitney's consciousness suddenly raised the number
of women in the Annual from the past year's four and a
half percent (painting) to twenty-two percent, although it
was a sculpture year and, according to the "Did a Little
Girl Like You Make That Great Big Sculpture?" syndrome,
there aren't supposed to be many women sculptors.

Yet in spite of all this activity, and a number of symposia
addressed to the subject, the art world was and still is late
in coming to grips with sexism. It is a male-dominated world

---

[1] An optimistic statement given the vicissitudes of this course.
After two more years of administrative hanky-panky, the women's
course was finally set up, thanks to continuing protests from stu-
dents and teachers.

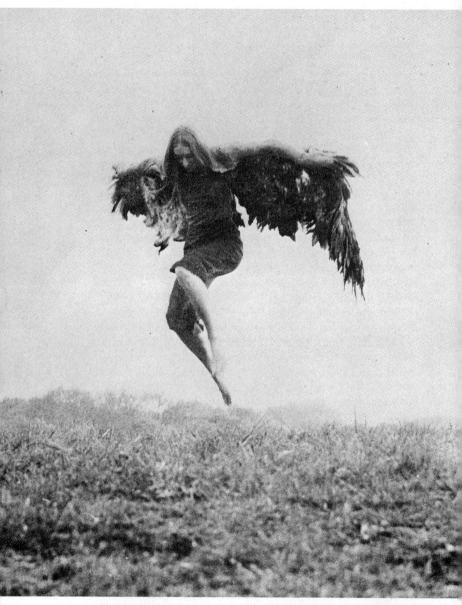

Christiane Möbus: *A New Life (or) The Unnecessary Betrothal of Frau Holle
with the Shaman.* 1972. One of a series of photographs. Photo: Renate
Altenrath.

despite the few women dealers, critics, and curators whose names always crop up as tokens and, more curiously, despite the notion that most collectors are advised by their wives. The reasons for this domination in a field considered conventionally a kind of "sissy" occupation, not serious in itself, are inherent in the society we live in. Real change won't come until woman-man relationships are fundamentally altered. In the meantime, however, discrimination against women in the art world consists of: (1) disregarding women or stripping them of self-confidence from art school on; (2) refusing to consider a married woman or mother a serious artist no matter how hard she works or what she produces; (3) labeling women unfeminine and abnormally assertive if they persist in maintaining the value of their art or protest their treatment; (4) treating women artists as sex objects and using this as an excuse not to visit their studios or not to show their work ("Sure, her work looked terrific, but she's such a good-looking chick if I went to her studio I wouldn't know if I liked the work or her," one male dealer told me earnestly. "So I never went."); (5) using fear of social or professional rejection to turn successful women against unsuccessful women, and vice versa; (6) ripping off women if they participate in the unfortunately influential social life of the art world (if she comes to the bar with a man, she's a sexual appendage and is ignored as such; if she comes with a woman, she's gay; if she comes alone, she's on the make); (7) identifying women artists with their men ("that's so-and-so's wife; I think she paints too"); (8) exploiting a woman's inherent sensitivity and upbringing as a nonviolent creature by resorting to personal insults, shouting down, arrogance, and artworld clout to avoid confrontation or to subdue and discourage women who may be more intelligent and articulate or better artists than their male company; and (9) galleries turning an artist away without seeing her slides ("Sorry, we already have a woman," or "Women are too difficult"—direct quotes from dealers, although since the women's movement, people are more careful to whom they say these things).

The roots of this discrimination can probably be traced to the fact that making art is considered a primary function, like running a business, or a government, and women are conventionally relegated to the secondary, housekeeping activities, such as writing about, exhibiting, caring for the art made by men. Artmaking in America has had a particularly virile

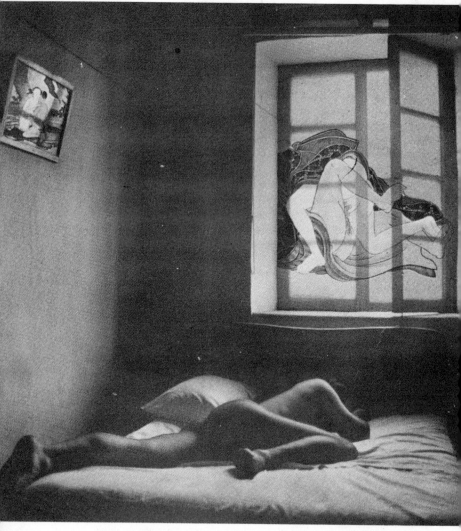

Joanne Leonard: *October Dreams,* from *Dreams and Nightmares* series. 1971/72. Black-and-white positive transparency, partially opaqued, with collage behind. 12" × 16". Photo: Joanne Leonard.

tradition over the last twenty-five years, the ideal of large-scale, "tough," uncompromising work being implicitly a masculine prerogative. Men are somehow "professional" artists even if they must teach a twenty-hour week, work forty hours as a carpenter, museum guard, designer, or any of the other temporary tasks with which most artists are forced to support themselves in an unsympathetic society. Women, on the other hand, especially if they are married and have children, are supposed to be wholly consumed by menial labors. If a single woman artist supports herself teaching, waitressing, working as a "gallery girl," she is often called a dilettante. If she is a mother, she may work full time in her studio and she will not be taken seriously by other artists until she has become so thoroughly paranoid about her position that she can be called "an aggressive bitch" or an opportunist. It doesn't seem to occur to people that women who can manage all this and still be serious artists may be *more* serious than their male counterparts.

The rare woman who has made it into the public eye tends to reject younger or lesser women artists for fear of competition, for fear of being forced into a "woman's ghetto," and thereby having her work taken less seriously. She is likely to say "*I* made it on my own, as a person, why can't they?"; at the same time she will occasionally acknowledge how rough it was to make it as a woman, how hard it was to remain "ultrafeminine" (which may be a major issue, since by this time she has so often been accused of being the opposite by men and by other women jealous of her talent and drive). Saddest of all is when a woman's identity becomes so absorbed by the male world that she believes herself one of an extraordinary elite who are strong enough and good enough to make it, not realizing that she denigrates and isolates herself and her work by being ashamed of her own sex. If her art is good, it cannot be changed by pride in being a woman.

The worst sources, not only of discrimination, but of the tragic feelings of inferiority so common among women artists, are the art schools and college art departments (especially at women's colleges), most of which have few or no female faculty despite a plethora of unknown male names. Women comprise a majority of art students, at least for the early years; after that they begin to drop out as a result of having no women teachers after whom to model themselves, seeing few women shown in museums and galleries, lack of

June Leaf: *Head.* 1975. Mixed media on paper. 14″ × 20″. Courtesy Terry Dintenfass, Inc., New York. Photo: Geoffrey Clements.

encouragement from male professors who tell them that they'll just get married anyway, or that the only women artists who make it are dykes, or that they'll get along fine if they screw their instructors, or that pale colors, weak design, cunt images, fine line are "feminine" (i.e. bad), but less so when perpetrated by men. Small wonder that there are far fewer women in the graduate schools, that survivors of this system are afraid to take their slides to galleries, or invite criticism, that they find it difficult to work in isolation if their husbands move them to the suburbs, that they marry an artist instead of continuing to be one, or become the despised "lady painter" in between children, without studio space or materials money. . . .

When a woman does have a show, the same attitudes prevail in regard to journalistic coverage. And last spring, an all-woman show, the first of its kind in the New York area since the current feminist movement, was ignored by the art press and rather pathetically mocked in a *Times* news story by a woman who was basically sympathetic and enthusiastic, but presumably had to keep her contacts intact. Cindy Nemser's collection of statements by critics on women's art is not being published as planned, perhaps because some of the critics made such asses of themselves on the subject.[2] The one art magazine that has had any feature coverage of the "woman problem" (two articles out of the whole contents, which enabled it to be called "the woman's issue") now feels it need never mention the word again.[3]

Survey shows are the most obvious examples of discrimination, which is why the Whitney Annual was chosen for a sustained public protest. If such shows are indeed focused on no particular taste, but on what is "being done" in such and such an area this year, why are so few women's studios visited? The Ad Hoc Women Artists' Committee demanded equal opportunity—as many women's works viewed as men's, and submitted a long list in case the museum didn't know any women artists. It was still up to the "judges" to decide whether this would result in equal representation, but the museums continue to refuse to make public any of their obviously incriminating figures on the process of selecting such shows.

Connections in the art world are, for better or worse, made through friends and galleries. Aside from, or because of the problem of competition with men, women rarely seem to be recommended by their male friends and are lucky to be given a corner, or a third, of their husband's or friend's studio where they can even show work. Few are represented by the big galleries to which the curators refer when doing a show. Only recently have some women critics begun to turn their attention primarily to women's work. Many women in the art world (and men, too) are afraid to alienate the men

---

[2] See p. 63.

[3] *Art News* (January 1971); this so-called issue was also blown up into a book that, incidentally, took its name, unacknowledged (like this article, named by the editors), from Kate Millett. No other American art magazine has done a special issue on women since.

Joan Semmel: *Intimacy-Autonomy*. 1974. Oil on canvas. 50″ × 98″. Courtesy Lerner-Heller Gallery, New York.

who run it for fear of being ostracized. If they have no position they are afraid to antagonize those who might help them; if they have a position they don't want to endanger it by being associated with anyone not equally "important." (This goes, unfortunately, for all artists considering any political involvement of any kind.) The situation is changing, but not fast enough. The rule still overwhelms the exceptions.

What applies to group shows applies equally to foundation grants, which again claim to concentrate on no single style, gallery affiliation, or institutional support. The statistics here are even worse. The usual defense is that not many women applied, or that they weren't "good enough." It is important to remember that so-called quality applied to a list of, say, twenty-five younger artists given grants or shown in a museum will not be agreed upon by any five "experts." If "quality" is admittedly elusive, why is it that foundations ignore women with *qualifications* (one-artist shows, prestigious group exhibitions, specialized press coverage, even

age and length of career) far exceeding those of male colleagues who do receive grants? A Women's Art Registry, now including slides by several hundred women, makes it clear that a large number of female artists are working on a par with men. Last spring it was possible for me to put together, in good conscience, an exhibition of twenty-six women who had never had one-artist shows. I could not have organized an exhibition of that strength (*all* this being regulated by my own taste, of course) of unshown male artists; by the time they are that mature, most men have had a show somewhere. All grant lists, all art school faculties, and all group shows include a certain percentage of names that are totally inexplicable to anybody. Why aren't these, *at least,* replaced with women whose work is as good as the best men accepted? The John Simon Guggenheim Foundation and the National Endowment for the Arts, among others, have lousy records.[4] In fact, there isn't any artworld institution so far that hasn't.

---

[4] The Guggenheim Foundation has changed little since this was written, maintaining for years, despite complaints from the outside, an apparent "rule" of one female painter or sculptor a year; recently it has gone up to two or three. The National Endowment, on the other hand, has improved a good deal.

# Prefaces to Catalogues
# of Women's Exhibitions (three parts)

## I. 1971: "Twenty Six Contemporary Women Artists"*

I took on this show because I knew there were many women artists whose work was as good or better than that currently being shown, but who, because of the prevailingly discriminatory policies of most galleries and museums, can rarely get anyone to visit their studios or take them as seriously as their male counterparts. The show itself, of course, is about art. The restriction to women's art has its obviously polemic source, but as a framework within which to exhibit good art it is no more restrictive than, say, exhibitions of German, Cubist, Black and white, soft, young, or new art. I chose what I chose because of my personal tastes, accumulated over six years of writing about and twelve years of looking at contemporary art. These tastes are for the most part based on a broad acceptance of the double mainstream of modern art, the so-called avant-garde, which for better or worse has been largely white and male-dominated.

---

* Reprinted from *Twenty Six Contemporary Women Artists,* Aldrich Museum, Ridgefield, Connecticut, April 1971. The artists in the show were: Cecile Abish, Alice Aycock, Cynthia Carlson, Sue Ann Childress, Glorianna Davenport, Susan Hall, Mary Heilmann, Audrey Hemenway, Laurace James, Mablen Jones, Carol Kinne, Christine Kozlov, Sylvia Mangold, Brenda Miller, Mary Miss, Dona Nelson, Louise Parks, Shirley Pettibone, How-ardena Pindell, Adrian Piper, Reeva Potoff, Paula Tavins, Merrill Wagner, Grace Bakst Wapner, Jacqueline Winsor, Barbara Zucker.

Reeva Potoff: *Outcropping.* 1969–1971. Polyurethane on cardboard. 3′ 4″ × 12′ × 15′ 1″. Photo: Reeva Potoff.

Within the next few years, I expect a body of art history and criticism will emerge that is more suited to women's sensibilities. In the meantime, I have no clear picture of what, if anything, constitutes "women's art," although I am convinced that there is a latent difference in sensibility; and *vive la différence.* After selecting this show from hundreds of possibilities, I was aware of a strong personal identification with work by women, but as yet I hesitate to draw any conclusions from it; I sensed a similar undercurrent in 1966 and 1968 when organizing two shows called "Eccentric Abstraction" and "Soft Sculpture," which included more women

Cecile Abish: *4 Into 3.* April 1973. Earth. Ramapo College, New Jersey. 4′ × 37′ 6″. Excavations 8″, heaps 12″.

than was my habit or anyone else's at that time. I have heard suggestions that the common factor is a vague "earthiness," "organic images," "curved lines," and, most convincingly, a centralized focus (Judy Chicago's idea). But until a great many women artists surface who have been taught by women, turned on by women's art as much as all artists have been turned on by the widely exposed art of men, until women artists have become aware and unashamed of the particularities of their own sensibilities—until then, I don't think anything definitive can be said on the subject.

It is, however, fully possible, and necessary, to reject the

inane clichés of "feminine" art based on superficial character-
istics such as delicacy, prettiness, paleness, sweetness, and
lack of structure. Miriam Brumer has pointed out that from
Renoir to Lyrical Abstraction, these qualities are consistently
found in art made by men. As the search for more profound
biological, psychological, and political sources advances, far
more interesting common factors will be exposed. Organiza-
tions like the pioneering W.A.R. (Women Artists in Revolu-
tion), the more recent Ad Hoc Women Artists' Committee,
and the West Coast groups; art historians like Linda Nochlin
Pommer and critics like Cindy Nemser are among those who
have begun to raise and propose answers to these questions
in the art world. My own answer, for the time being, is this
show, the work of all the other women who could have been
included in it, the work of those few who have already
"made it," and of those who have the guts to keep up the
struggle and make it easier for their sisters.

I also took on this show as a form of personal retribution
to women artists I'd slighted, unintentionally, in the past. I
have recently become aware of my own previous reluctance
to take women's work as seriously as men's, the result of a
common conditioning from which we all suffer. (When I was
an art historian, the problem rarely arose; most women
artists have already been "evaluated" out of the picture by
male-oriented historians.[1]) The woman artist has tended to
be seen either as another artist's wife, or mistress, or as a
dilettante. Now I know that, contrary to popular opinion,
women are not any more "part-time artists" than anyone else.
Very few artists of any sex in America do not work at some-
thing other than their art to earn a living, though it's true
that women often have three jobs instead of two: their art,
work for pay, and the traditional unpaid "work that's never
done." The infamous Queens housewife who tries to crack
the gallery circuit is working against odds no Queens house-
painter (Frank Stella was one) has had to contend with. I
admire tremendously the courage of those who stick to it.

---

[1] Women critics have taken their lumps, too; for example,
Clement Greenberg: "What did in all the lady art critics with
the triple names was the collapse of Abstract Expressionism. . . .
The delusion persists you can talk about art as you can about
matters of fact or scientific situations. You can't and that's why
there's so much crap talked and written about art and why
someone like Miss Lippard can be taken seriously . . ." (quoted
from an interview in *The Montreal Star*, November 29, 1969).

Women's art often has an obsessive element to it; it *has* to, given the obstacles laid in its path. It is far easier to be successful as a woman critic, curator, or historian than as a woman artist, since these are secondary, or housekeeping activities, considered more natural for women than the primary activity of making art.

For these and endless other reasons, choosing this show has been an exhilarating and a depressing experience; exhilarating because I saw so much personal and esthetic strength, so much more good work than even I had suspected; depressing because of the spectacle of so many women torn between so-called femininity and their work (a choice that will, hopefully, soon be outdated), and because I couldn't see enough, because I had to make judgments and choices and narrow down several hundred artists to twenty-six. In order to facilitate the task of going to some one hundred studios in the New York area in six weeks, I made one wholly arbitrary limitation. I hope it was at least no more unfair than any other. No one in this exhibition has had a one-woman show in New York prior to March 1, when I made my final decisions. For the injustices incorporated in this limitation, I apologize, specifically to the three women whom I asked to participate and had to withdraw because they had shown: Agnes Denes, Pat Johanson, and Anne Wilson; and generally to all those whose work I liked very much and didn't include for illogical reasons of space, compatibility, in short, my manner of putting together a show as a whole. . . .

## II. 1973: "Why Separate Women's Art?"°

A large-scale exhibition of women's art in New York ["Women Choose Women"] is necessary at this time for a variety of reasons: because so few women have up until now been taken seriously enough to be considered for, still less included in, museum group shows; because there are so few women in the major commercial galleries; because young

---

° A revised amalgam of prefaces to the catalogues for: "Ten Artists (Who Also Happen to be Women)," The Kenan Art Center, Lockport, New York, and the Michael C. Rockefeller Arts Center, Fredonia, New York, January 1973; "Women Choose Women," organized and selected by Women in the Arts, The New York Cultural Center, New York City, October 1973; and to the "Women's Issue" of *Art and Artists*, 8, No. 7 (October 1973).

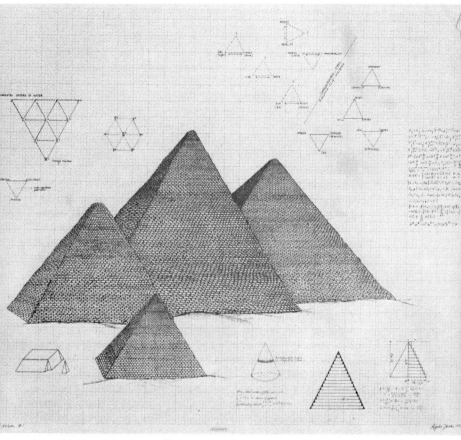

Agnes Denes: *Pyramid Series #1: 4000 B.C.* 1973. Ink on graph paper. 22" × 28". Photo: Eric Pollitzer. "The *Pyramid Series* includes 4,000 B.C., which examines dichotomous vs. trichotomous societies, (static vs. evolutionary); *4,000 years*, where my statements are transliterated into Middle Egyptian hieroglyphic writing, thus creating a span balance of four thousand years of change in language and communication, and *Pascal's Triangle*. In these sixteen-foot drawings the span balance is created with logical structures. A triangular number system is formed. The form is then distorted and the structure dissected into its components, leaving only the connective systems as the memory of its inherent logic. The steps are then reversed and the numbers are replaced with rectangular stones of Pyramids, retaining the curvature and logic design of *Pascal's Triangle*. In subsequent drawings the triangle reverses itself to become structural form once again, showing variations in span balances such as bridges, shells, and receding spirals. Each form begins with a seed (idea) and grows in a way that eventually reveals the principles of its growth."

women artists are lucky if they can find ten successful older women artists to whom to look as role models; because although seventy-five percent of the undergraduate art students are female, only two percent of their teachers are female. And above all—because the New York museums have been particularly discriminatory, usually under the guise of being discriminating.

A couple of years ago even a sympathetic observer could dredge up the names of no more than twenty women artists who were well known at all. Even other women artists had trouble remembering colleagues. This, I suspect, was as much a psychological block on their part as a statistical fact, having to do with not wanting to be identified as a woman artist. A simultaneous pride in uniqueness and an underlying fear of inferiority seemed then to affect the ranks of women artists themselves. Yet once the protests and meetings and shows began in New York, women's own memories loosened up to the point where endless friends from art school who had been working away in silence suddenly began to surface, and groups began to get together for consciousness raising, for esthetic discussion, for political actions, to remedy the years of suppression.

Grisly tales of maltreatment and inhumanity emerged from these sessions, including those from art-school students whose professors classically discouraged them by historical and sexual denigration. This treatment was even handed out by well-meaning men so conditioned that it never occurred to them that they were making it impossible for many women to continue working. The survivors became understandably reluctant to identify with other women's art, thus encouraging the isolation which, until recently, made so many women artists accomplices to their own professional murders. Others simply retired from the artworld competition and worked in total isolation. The single most moving aspect of the early days of the women's art movement was the reemergence of and communication among these "invisible" people; included were women already in the art world by marriage or friendship who had rarely profited from the studio visits, bar talk, and discussions of their work that the men had limited primarily to their "peers" (other men). Slowly women artists came out of the woodwork, and slowly a real community was formed.

One meeting I attended early in 1971 seems in retrospect to be particularly significant. Some thirty-five women artists

sat in a large circle and described their work, with no visual aids. Time after time, objects of an acceptably ambitious art-world nature and scale would be described; then there would be a curious pause and the artist would add hesitantly something to the effect of "and . . . in my private time (or in the summer, or at night), I make these little collages (or journals, or work with dolls, or paint on pebbles)." One woman made large, hard-edge, color canvases, but in her spare time she was photographing friends in the nude against mylar hangings, creating a strange, intimate but fugitive world that seemed in direct conflict with her "public" style. When it was my turn, I "confessed" to writing fiction. This "closet art," too vulnerable and private (and by implication "minor") for public display, often seemed to touch the core of women's experience, women's art, but most of us were afraid at that time to send these tender sprouts into the dog-eat-dog world of "high" art. Only the subsequent establishment of women's galleries, women's shows, women's courses, paved the way for eventual exposure.

*

Whenever there is a women's show, or a Black artists' show, or any similarly "segregated" event, objections are raised on the basis that art is art and has no sex, no color. That's all very well, but artists do, and there has been considerable discrimination against artists of a certain sex and a certain color. A woman's show is no more arbitrary a manner of bringing together a group of artworks than a show of Czechoslovakian Art Since 1945 or Artists Under Thirty-five. When you open a magazine or enter an exhibition space, you have to look at what is there individually, no matter how vague or arbitrary the label under which it is hanging. If you can't enjoy good art because it is hanging with art by one political group or another, but you can enjoy art if it is grouped under the imposition of a movement or a theme or some curatorial whim, then you probably should think about why you are looking at art in the first place.

Women's shows function, hopefully, as educational devices for the institutions exhibiting them.[2] A similar function

---

[2] Hardly the result, however, in the first women's show I did, at the request of Larry Aldrich, who later told *The New York Times* (May 30, 1971) that "he didn't see anything in it he wanted to buy." This was untrue, for he had attempted to purchase one difficult-to-transport piece at such a cut rate that the

Alice Adams: *Large Vault.* 1974. Wood. 15′ × 15′ ×3′ 8″. Photo: Bill Gordy.

is served by independent shows, by the establishment of women's co-op galleries like A.I.R., Soho 20, and the Women's Interarts Center in New York, Hera in Rhode Island, Artemesia and ARC in Chicago, those in the Los Angeles Woman's Building; and by organizations like the Women's Art Registry, a slide collection founded in response to the constant comment that "there are no women working in kinetics, or light, or Conceptual or . . . even sculpture";[3] or W.E.B. (West-East Bag), an international network of women artists' groups.[4] These and others like them are beginning to indicate the tip of the iceberg, or the volcano, that is women's art; they are providing ways for women outside the major art centers to keep in touch with each other and with their new female audience.

*

I became involved in the women's movement for endless reasons, but the most public one is the fact that, as a working critic for five years, I had been guilty of the same lack of seriousness toward women's work as the museums and galleries. Although I had once been an artist's wife, serving tea and smoothing the way for visitors, and had had my own infuriating experiences in that anonymous role, I continued to go to men's studios and either disregard or matronize the women artists who worked in corners of their husband's spaces, or in the bedroom, even in the kitchen. I was, I think now, unconsciously responding to her sense of inferiority and insecurity as well as to my own (my "reputation" supposedly depended on male support and respect. . . .).

---

artist preferred to destroy it rather than let him have it. He also refused to have slides made of the show, as he customarily did of all other shows in his museum, and claimed a "first-time incidence of money-back requests from the public." Although this was the first women's art show since the resurgence of the women's movement, it was never reviewed in the art press.

[3] The Women's Art Registry, founded by the Ad Hoc Women Artists' Committee in the winter of 1970/71, now occupies a space of its own at the nonprofit gallery Artists' Space in New York City. It provided the model for other W.E.B. registries in other cities, and more recently, for mixed-gender artists' registries all over the country.

[4] W.E.B. now has groups in twenty-two states and eleven foreign countries. It was originally founded to keep the early groups in Los Angeles and New York in touch with each other—thus the title.

Now, three years later, a lot has changed, but there is still an immense amount of changing yet to be done. One no longer hears as a matter of course comments from dealers like "I can't have a woman in the gallery, they're too difficult," or "Collectors won't buy women's work." Nor does the art press dare use the term "feminine" in a value-judgmental context, something that once caused many women literally to be afraid of using delicate line, sewn materials, household imagery, or pastel colors—especially pink. One well-known stain painter was accused in a review of "painting her monthlies." This won't happen anymore, or if it does, such a statement might come from an artist who, exploring her own experience, is doing just that!

<center>*</center>

Totally aside from the political necessities fulfilled by women's shows, they also provide a fascinating field of speculation for the question asked so often over the last two or three years: Is there a women's art? And if so, what is it like? One of the difficulties in drawing any conclusions so early in the game is the fact that art is inevitably influenced by other art publicly made visible, which now means primarily art by men. However, the overwhelming fact remains that a woman's experience in this society—social and biological—is simply not like that of a man. If art comes from inside, as it must, then the art of men and women must be different too. And if this factor does not show up in women's work, only repression can be to blame.

For every time I can be specific about this differentiation, there are endless times in which it remains just out of reach. Perhaps it is impossible to pin it down until women's place in society is indeed equalized and women's work can be studied outside of the confines of oppressive conditioning. Nevertheless, generalizations are made in every field, especially art, and often profitably. It seems most important that our eyes and spirits be attuned to the glimpses we are afforded of women's sensibility and imagery. There are some things I've noticed that I can't seem to deny. For example, in 1966 I was organizing a show around the work of Eva Hesse and Frank Viner—a kind of offbeat, not quite Minimal, not quite funky style I called "Eccentric Abstraction" that later developed into so-called anti-form. I found a lot of women doing this kind of sensuous geometric work—far more than I'd encountered on similar searches for other styles,

and in addition, I, a woman, was doing the show because this kind of work appealed to me personally. I wondered briefly about that at the time, and did still more so four years later when I became involved in the women's movement. When I went to a great many women's studios in the winter of 1970/71, I noticed that these and other elements often recurred. It might have been attributable to my own taste, or to something more universal. When I first heard Judy Chicago's and Miriam Schapiro's theories about the high incidence of central-core imagery, of boxes, ovals, spheres, and "empty" centers in women's art, I vehemently resisted them. I was still resisting them when we visited the women's show I organized for the Aldrich Museum, and they ran from work to work shouting "there it is!" There it was. I was astounded, because I'd had no intentions of focusing on that idea, no knowledge that I had been doing so.

Here, in any case, for your own consideration, are some of these elements that recur: a uniform density, or overall texture, often sensuously tactile and repetitive or detailed to the point of obsession; the preponderance of circular forms, central focus, inner space (sometimes contradicting the first aspect); a ubiquitous linear "bag" or parabolic form that turns in on itself; layers, or strata, or veils; an indefinable looseness or flexibility of handling; windows; autobiographical content; animals; flowers; a certain kind of fragmentation; a new fondness for the pinks and pastels and ephemeral cloud colors that used to be tabu unless a woman wanted to be accused of making "feminine" art. Theories and refutations and new theories and new refutations will continue to surround this issue, but it is a rewarding debate that can only help women artists and critics to develop a sense of our individual esthetic directions, and perhaps in the process to define more clearly the web formed by the multiple threads of these individual developments.

°

Once the fact that there are women working, and working well, in all media and in all styles gets through to those in the art establishment, and once those in charge of that establishment begin to implement their newfound knowledge by selecting women the same way men have been selected all along, the process of segregation may be obsolete. Or there is the chance that women artists will not want to be used the same way men have been all along.

Paula Tavins: *Untitled.* 1969. Latex modules filled with plaster. Each unit 6" × 6" × 4½".

### III. 1975: Excerpts from the Catalogues of Three Women's Exhibitions

*Mothers of Perception*°

I am struck by the fact that a show like this, in which delicate touch, pale colors, and gyno-sensuous imagery are frankly associated with femaleness (by the artists themselves rather than by a patronizing reviewer deigning to cover "minor" art), could not have taken place five years ago, when so many women artists still feared the adjective *feminine*. And for good reason. Such subject matter, such admission of sexual consciousness has traditionally been taken as a synonym for inferiority. It is no longer true that the greatest compliment a woman artist can receive is the classic: You paint like a man. In Gail Crimmins's quietly precise rendition of old photographs, the figures are wistful and distant, seen through a veil of nostalgia. Judith Szarama's bulbous oral fish swimming in an unfamiliar medium, Winona Taylor's pastel flowers, hands, ballet slippers, ribbons, woven into a nostalgic memento, Marjorie Pickard's tactile crotched leaves, and Debora Hunter's misty photographs of young women peering into their futures are all unashamedly feminine. The vulnerability of women's lives is poignantly exposed, but the very fact of this exposure, and the pride of

° Reprinted from *Mothers of Perception,* Rebecca Cooper Gallery, Newport, Rhode Island, Spring 1975.

the statements accompanying the work, lend to these fragile images a new strength which recalls the survival over the ages of this same morphology. An extremely sensual, and by extension sexual, impact is found in this work by no co-incidence. . . . A female audience will be able to identify with the soft skin of natural surfaces, with little girls' ambitions to be ballerinas, with the layered and obsessively detailed techniques, with the hidden/expansive anatomical forms veiled in poetic subject matter. Other women will reject these elements as panderings to a stereotype better forgotten. There is some truth in both approaches, though the power of the feminist movement lies in the fact that every-thing is open and possible now, that no one art can be imposed. At the same time, equality does not necessarily lie in androgyny alone. If we as women do not return to the sources of our art and our experience before we attempt to transcend them in a newly humanized form, the results will be far less fertile.

## Women Artists Series: Year Five°

Five years of women artists at the Douglass Library, forty-four one-woman shows by the end of this season, plus group shows of New Jersey women and of the Rip-Off File:[5] Landmarks for an alternative exhibition space within a (usually sexist) institution. Until recently no fiscal support except from women's groups. Until this year a bastion amid an all-male faculty at this women's college. In previous catalogues the artists' statements often referred to their alienation from the art world, to the warmth and solidarity of feminist groups, to the new community of women artists. They talked about their struggles, about hustling, about mirrors, and self-portraits, breaking boundaries, the nature of art, the sky, the edge, and the surface. They offered "circuits, events, signals, waves," "a feeling of movement," an "ironic, perverse, creative order, transcribed from the domestic arena," "bands of light . . . bands of 'song' or 'talk,'" " a symbolic interpretation of life forms," a "picked-up image, its space acti-

---

° Reprinted from *Women Artists Series: Year Five,* Mabel Smith Douglass Library, New Brunswick, New Jersey, 1975.

[5] The Rip-Off File, a publication of statements of exploitation by artworld women, published by an independent group of women artists with the help of the Ad Hoc Women Artists' Committee; it was also made into an exhibition.

Laurace James: *Toggle Grounds.* 1972. Wood, rope, hardware. 12' 6"
high. All elements are variable, so the sculpture has many different
"shapes."

vated by incidents and events," the "possession of a surface."
They were "being tactile, geometric, organic, subtle, sensu-
ous, serene, mystical," "thinking about how we can feminize
our society, how we can make images which reflect a new
set of values," and thinking about "the fleeting gestures, mo-
ments . . . caught in motion, the rhythm of the whole,

seemingly discordant and incomplete," and how it "relates to fractured time." They tried "to turn woman from an object into an active subject."

＊

Women's shows are still very important. In the past five years, thanks in great measure to such "separatism," there has been an increase in the numbers of women artists shown in commercial galleries and in large museum shows. But even now the figures are nowhere near equal representation, and the teaching situation remains virtually unimproved in many schools where the student body remains mostly female and the faculty remains mostly male.[6] At this point, when the women artists movement is just entering maturity, nothing could be more dangerous than a loss of energy, loss of identification, which means, inevitably, a loss of ground. But aside from the strictly professional aspects, and farther reaching, is the psychological factor. It would be still sadder to lose the strength transmitted from artist to artist, generation to generation, when women support other women in alternate situations such as women's co-op galleries, workshops, art centers, local shows, open shows, "salons des refusés" like this one, and hopefully, in the future, more connections between feminist artists and broader, extra-artworld audiences. An increasing amount of vital work by feminist artists is being shown in more or less isolated places. This fact bodes well for an expanded consciousness, a rejection of the social and esthetic pressures that constrict artworld conventions, customs, fads. The Douglass series is unique, and also exemplary in that it has included well-known and unknown artists, a broad range of style, age, and intent. Its organizers[7] have had the courage to be honest with themselves and with their audience, which has responded in kind by strong reactions—for and against—each individual show.

---

[6] I have been suggesting, unsuccessfully, for several years, that women students not only assure their own futures by demanding more women teachers, more direct role models, but also implement this demand with a boycott on payment of tuition, which should cripple schools with largely female student bodies.

[7] The series began at the suggestion of and with the encouragement and inspiration of Joan Snyder; it has been organized each year by Lynn Miller and Naomi Kuchinsky. The library was chosen as an alternate exhibition space when the regular school art galleries refused to show women.

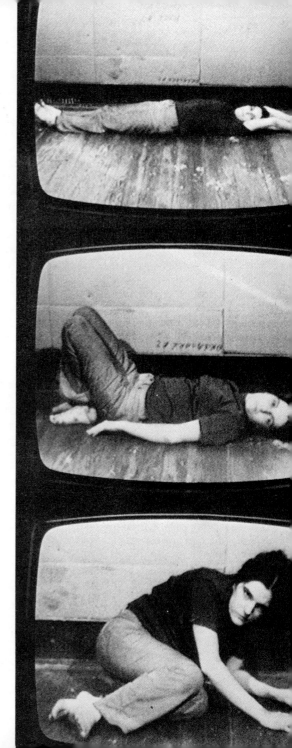

Rita Myers: details of *Slow Squeeze 1*. 1973. Video performance (black-and-white tape, 10 minutes). "The camera is trained on myself, lying on my back with my arms extended over my head. My body extends across the width of the monitor, feet and fingertips just within its lateral boundaries. The monitor is used as a feedback device. The camera begins a very slow zoom in, which is at first undetectable. As this zoom begins to shrink the field of the monitor, I am forced to relinquish the space occupied by my body in its initial position. My goal is to remain within the boundaries of the monitor as its field progressively diminishes. In the end, the space allowed me is extremely compressed, and my body is curled in on itself, as tight as possible."

*Works on Paper: Women Artists**

This exhibition marks another triumph for persistence, hard work, and a good cause. But its worst result would be a false sense of victory. Much has been accomplished since 1969, when Women Artists in Revolution pioneered the women's visual-arts movement in New York. But much has yet to be done. Established institutions seem to have set a twenty percent quota for female representation in group shows. While commercial galleries have done more for women (for obvious reasons), other organizations have resisted all but the most minute changes.

The major question is whether or not women are falling into the same traps, the same commercialism, the same success-oriented egotism sustained by the male art world. Other questions follow: Is "making it" into a "good" gallery or museum show the only goal? Who is the feminist artist's audience? Shouldn't women's groups and galleries be attempting to revive the relationship between art and people? How can women's art and imagery most strongly translate the goals of feminism into effective and communicable visual metaphors? The struggle has not ended just because a few more women show and sell more work in a sterile art world. We haven't any real laurels to rest on yet.

---

* Reprinted from catalogue *Works on Paper: Women Artists,* The Brooklyn Museum and Women in the Arts Foundation, Brooklyn, New York, October 1975. Like the "Women Choose Women" show at the New York Cultural Center in 1973, also sponsored by Women in the Arts and chosen by and/or from their own membership, this show and catalogue were paid for by the exhibiting artists with grants they raised themselves and with entry fees. It is regrettable that although far less important shows are supported by the institutions, women must continue to make their own ways. This somewhat mitigates the gratitude we must feel to the two museums who at least opened their doors where others feared even to open their eyes.

# Household Images in Art*

Probably more than most artists, women make art to escape, overwhelm, or transform daily realities. So it makes sense that those women artists who do focus on domestic imagery often seem to be taking off from, rather than getting off on, the implications of floors and brooms and dirty laundry. They work from such imagery because it's there, because it's what they know best, because they can't escape it.

Of course, men have dealt with domestic imagery, too. In the early 1960s, the male artists moved into woman's domain and pillaged with impunity. The result was Pop Art, the most popular American art movement ever. (Popular with men and women alike, or just those women who had maids to deal with the absurdity of that sort of imagery?)

If the first major Pop artists had been women, the movement might never have gotten out of the kitchen. Then it would have struck those same critics who welcomed and eulogized Pop Art as just women making more genre art. But since it was primarily men who were painting and sculpting the ironing boards, dishwashers, appliances, food and soap ads, or soup cans, the choice of imagery was considered a breakthrough. The same is true of a more recent "movement" known as Lyrical Abstraction, based on wishy-washy color and nuance, which would have been called "merely" feminine if it hadn't been taken up by a lot of men as well. The art world works this way, which may explain why there are fewer women artists working with "household imagery" than one would expect.

* Reprinted from *Ms.*, 1, No. 9 (March 1973).

After all, the few women artists making it in the 1950s and 1960s were rarely housewives, and anybody who was took care to hide it when showing her work in the serious art world. (Because women were considered "part-time artists," if they worked for a living outside of art, or were married, or had a child, they didn't have to be taken seriously.) Another version of the same tabu was made unmistakably clear in art schools. "Female techniques" like sewing, weaving, knitting, ceramics, even the use of pastel colors (pink!) and delicate lines—all natural elements of artmaking—were avoided by women. They knew they could not afford to be called "feminine artists," the implications of inferiority having been all too precisely learned from experience.

Some of this has been changed, or at least modified, by the women's movement. Many women artists have organized, are shedding their shackles, proudly untying the apron strings—and, in some cases, keeping the apron on, flaunting it, turning it into art. For example, there is *Womanhouse,* made in 1971 by students at the California Institute of the Arts with their teachers, feminists Judy Chicago and Miriam Schapiro. This immense and immensely successful project was an attempt to concretize the fantasies and oppressions of women's experience. It included a dollhouse room, a menstruation bathroom, a bridal staircase, a nude womannequin emerging from a (linen) closet, a pink kitchen with fried-egg–breast decor, and an elaborate bedroom in which a seated woman perpetually made herself up and brushed her hair.

Most of the work I've seen that deals with household imagery does so either by means of a cool, detached realism, or funky fantasy. Examples are Los Angeles artist Wanda West-coast's lumpy curtain sculptures, or Brooklynite Sandra de Sando's plaster birthday cakes decorated with cookies and animal crackers. Also in New York, Rosalind Hodgkins's holocaustically erotic, angry, funny paintings rigorously organize a pictorial vocabulary that rivals a mail-order catalogue. In Chicago, Ellen Lanyon takes off from old magic manuals and bewitches her way out of *Housekeeper's Terror* (one of her titles) with paintings of mysteriously balanced dishes and silverware, often invaded by bird and animal life. Irene Siegel, another Chicagoan, used to make beautifully detailed drawings of unmade beds.

The two most frequent images are fundamentally television-

ary. The first is food. Why? Perhaps for compensation;
stuffing yourself until there's no room inside for anything else.
New York painter Janet Fish depicts produce, bottled or
super-wrapped, lined up neatly on the shelf. Judy Ott, in
Lawrence, Kansas, paints steaks and pies sailing out across
the galaxies, as if to say, "Out of my house." The second
prevalent image is a "down" one—floors, tools for cleaning
floors. Marjorie Strider's freestanding brooms and ,dustpans
(wielded by an invisible Somebody Else) have a Disney-like
quality of "singing while we work." Susan Crile does paintings
of decorative rugs that become both pictures of floors and
abstract canvases. Sylvia Mangold's paintings of bare wooden
floors (though sometimes defiled by a pile of dirty laundry)
have the clarity and innocence of hope. Isn't cleaning up all
about hope? And doesn't the futile repetition of endless house-
work mean losing hope?

When Mangold paints a laundryless floor, it exudes the
peace and quiet of being left alone in the morning light. The
same feeling is evoked by the crisply real interiors of
Yvonne Jacquette or Cecile Gray Bazelon. But the intimacy
of familiar things can give way to suffocation by things that
are too familiar. Grace Samburg's linoleum floor with a bottle
of Rose-Ex cleaner and a stove strikes me as less about sun-
light on the surfaces of homelife than about pollution and the
relentless New York soot filtering in through the windows.
And Muriel Castanis' dishrag, clothes, laundry, tablecloths,
and whole furnished domestic environments (made from
cloth stiffened with epoxy) are ghostly reminders of the iso-
lation in which so many women, even those who are artists,
frequently find themselves trapped.

Finally, a stylistic exception in the treatment of domestic
imagery: Mierle Laderman Ukeles' Conceptual artwork
and/or exhibition called "Maintenance Art," or "Care," a
written project for a museum show in which she would,
among other things, perform all her housework and domestic
duties in public. She sees women's role ("unification . . .
the perpetuation and maintenance of the species, survival sys-
tems, equilibrium") as representing the life instinct in art.
This opposes the death instinct, or the reigning principle of
the avant-garde ("to follow one's own part to the death—do
your own thing, dynamic change"). She thereby airs the real
problem; what she calls, "the sour ball of every revolution:
after the revolution, who's going to pick up the garbage on
Monday morning?"

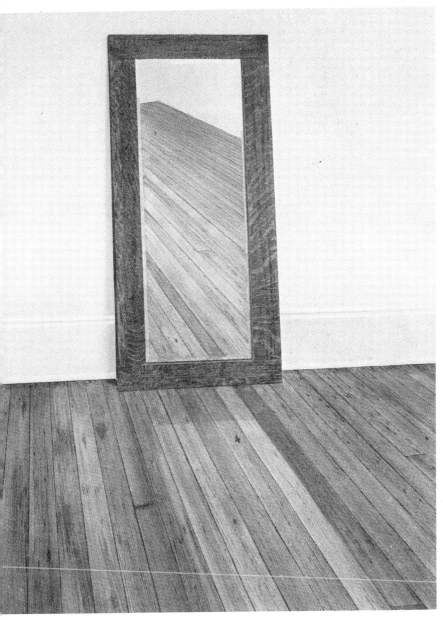

Sylvia Mangold: *Floor, Floor Mirror, Wall.* 1973. Acrylic on canvas. 51″ × 67½″. Courtesy Fischbach Gallery, New York. Photo: Rudy Burckhardt.

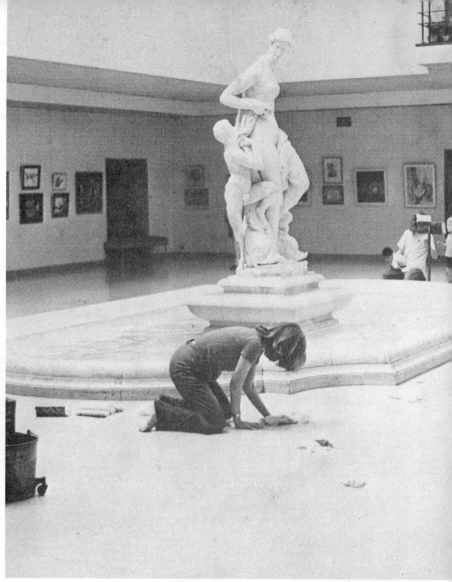

Mierle Laderman Ukeles: *Washing, Tracks, Maintenance: Maintenance Art Activity III.* July 22, 1973. Wadsworth Atheneum, Hartford, Connecticut. Performance: "Activity: 1. Wash several areas of museum where spectator traffic occurs. . . . 2. Wait for people to track it up. Washing (damp/dry mop) will not be too wet to constitute a danger of slipping, and artist will warn people anyway to be careful. 3. Re-wash, keep washing until museum closes. Rags used will be accumulated and piled on the site. Maintain for whole day. 4. Areas will be stamped with Maintenance Art stamp."

# Fragments

I. From *The New York Element*°

Saturday, 3:00 P.M. The Whitney is picketed by the Ad Hoc Women Artists' Committee, a group loosely associated with the A.W.C.; the hoc ad which it dresses itself is fifty percent women's art in the Whitney's surveys of American art (sculpture this year). Despite a great increase in female representation—from about four and a half percent at last year's painting show to twenty-two percent this year[1]—the group has picketed every Saturday, armed with police whistles. The basic issues are the current lack of equal attention to women's work, the Ford Foundation and New York State Arts Council funds laid on museums now practicing discrimination. The main activity is consciousness raising in public—discussions, sometimes confrontations, with Madison Avenue passersby and museum visitors. The drawbridge entrance seems expressly designed for effective picketing. Some funny things happen: An art student asks when we are going to get the schools for having so few women

---

° Excerpt from "Charitable Visits by the A.W.C. to Whitney, MOMA, Met," reprinted from *The New York Element*, 2, No. 4 (March–April 1971).

[1] This increase was largely due to the pressure from women's groups, as the museum's director admitted in *The New York Times*; curators contacted women artists out of the blue at the last minute to boost the percentages. For further information, see *A Documentary Herstory of Women Artists in Revolution* (New York: Women's Interart Center, 1973).

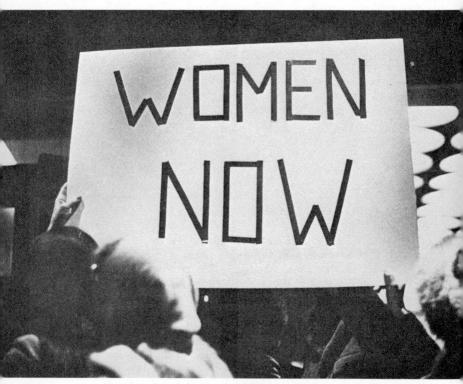

Women Now. Winter 1970/71. Whitney Annual Protest by Ad Hoc Women Artists' Committee. Photo: Amy Stromsten.

faculty (*Soon*). An older woman, beminked, shouts over her shoulder that we're *ridiculous*. We look down and see she is leading a rat-sized dog in ruffled pantaloons and tiny boots. Two short-haired young working men jeer that we want alimony and won't go into the army; we say we'd lay down the guns faster than they, given the chance, and several of us have supported our husbands, don't believe in alimony; they stop, talk a long time, and go away friendly. A well-dressed man around fifty-five refuses to walk around us and crashes through our big sign instead; the woman on the end holds her ground; he hauls off and gives her another shove

that spills the next person's coffee; she turns and throws the remains in his face; coffee is still seeping down into his cashmere scarf when the police arrive, but nothing is done to us. The white-haired lady who has been at the Whitney desk for years tells us "I was a suffragette." A gray-flanneled suburban woman interviewed in the Georgia O'Keeffe shows says she is a sculptor but has experienced no discrimination as a woman artist; an odd look comes over her face when she adds "but of course . . . I use a man's name," and she walks off looking dazed. A Yale co-ed writes us and says, "What confidence you inspired in me concerning the future of women artists! Your protest at the Whitney Museum represents a noble breakthrough."

## II. Letter, December 21, 1970°

I "evaluate" women's work on the same basis as men's, though evaluation is a term I prefer to avoid. I write about and show work that I like, no matter who did it. The problem rarely if ever came up in art-historical work since most women artists tended to have been "evaluated" out of the picture by previous (male?) historians. However, over the five years I've been writing criticism and organizing exhibitions of contemporary art, I became slowly aware of and eventually appalled by my own (and others') reluctance to take women's work as seriously as men's. While there have been outstanding exceptions, I tended to approach, as so many still do, women artists as the wives or girls of male artists instead of as serious painters or sculptors in their own rights—a result of previous conditioning from which we all suffer. If my record wasn't quite as bad as some others during this period, it was because I was lucky enough to be exposed to the work of several extremely serious and innovatory women artists who to some extent reversed such a bias. In the last six months, for extra-esthetic reasons, I have become particularly interested in seeing and making visible women's art in the hope that the situation of neglect that has existed for so long in the past can be remedied in the future. At the same time, I continue to approach all art across my own formal, psychological, etc., prejudices. Some of these prejudices re-

---

° In response to Cindy Nemser's request for "a statement as to how you, as an art critic or historian, evaluate women's art"; replies were published in *Women in Art,* 1, No. 1 (Winter 1971).

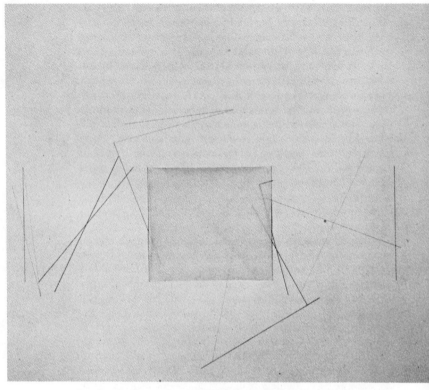

Dorothea Rockburne: *Drawing Which Makes Itself Series, Indication Drawing for "Neighborhood."* 1973. Carbon paper, paper, lines. Approx. 34" × 60". Courtesy John Weber Gallery, New York. Collection The Minneapolis Art Institute. Photo: Nathan Rabin.

sult from the fact that I am a woman and just learning to be proud of it.

### III. The Great Grid Irony°

A) Perhaps by coincidence, perhaps not, many of the artists who have drawn from the grid's precise strains a particularly

---

° A. Excerpt from "Top to Bottom, Left to Right," in *Grids,* In-

unique interpretation are women. Agnes Martin's channels of nuance stretched on a rack of linear tensions which "destroy the rectangle" are the legendary examples of an unrepetitive use of a repetitive medium. Dona Nelson's variations on the theme push color weights against the grid's heavy boundaries. For Eva Hesse the grid provided a long sought-after discipline within which her own obsessions could finally be expressed. Knowing that a relatively rigid framework could control her inclinations to chaos, she said in 1970: *I was always aware that I should take order versus chaos, stringy versus mass, huge versus small, and I would try to find the most absurd opposites or extreme opposites. . . . Repetition exaggerates. If something is meaningful, maybe it's more meaningful said ten times. It's not just an esthetic choice. If something is absurd, it's much more exaggerated, much more absurd if it's repeated . . .*

Merrill Wagner's prints were made by masking off a grid, then drawing rapidly over the whole surface; when the tape is stripped, the result is a negative-positive, handmade-mechanical contrast. Mary Heilmann distorts the grid to conform to the almost crude, almost naïve character of her tactile surfaces and an imagery often derived from open nature. Pat Lasch's threaded lines fan out from points originating in autobiographical data. Joan Snyder's rhythmic signs and wounds are all the more moving for their balancing on the verge of freedom from and dependence upon the underlying grid: *If you're going to dissect something, you can't just do it from the front, you have to go into the surface.*

B) Lucy Lippard points out that "perhaps by coincidence, perhaps not, many of the artists who have drawn a particularly unique interpretation from the grid's precise strains are women." To the extent that women artists use grids Martin is a probable influence on their practice. That is to

---

stitute of Contemporary Art, University of Pennsylvania, Philadelphia, 1972.

B. Reprinted from Lawrence Alloway, "Agnes Martin," *Artforum*, 11, No. 8 (April 1973), p. 36.

C. Letter from Lucy R. Lippard to *Artforum*, May 17, 1973; not published. Although this letter was not published, those of several women artists similarly protesting were published in *Artforum* (September 1973), and Alloway also included them when the article was reprinted in his collection of essays, *Topics in American Art* (New York: W. W. Norton, 1975).

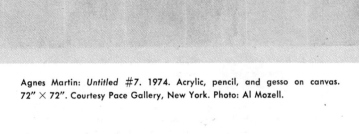

Agnes Martin: *Untitled #7.* 1974. Acrylic, pencil, and gesso on canvas. 72″ × 72″. Courtesy Pace Gallery, New York. Photo: Al Mozell.

say, rather than taking grids as an inherent tendency of women's art, I consider their use to be learned and, in fact, the aura surrounding Martin and the influence of Lippard herself may be precisely the predisposing factors. It is notable that a number of the women artists who use grids, or synonymous forms, are associated with the Women's Ad Hoc Committee, of which Lippard was a cofounder. There may be a factor special to women and that is their recent willingness to use domestic techniques such as sewing and pleating in the construction of searching works of art. Martin implies this kind of repetitive technique by forms that resemble stitching and by occasional reminiscences of the motifs on American Indian textiles. . . ."

C) Lawrence Alloway's statement that a few members of the Ad Hoc Women Artists' Committee use the grid because I was a co-founder of that politically activist (not esthetic) organization is absurd. And, perhaps not coincidentally, divisive. I resent it on my own part as well as on that of the artists. The grid has been a predictable element in the New York art vocabulary since the early 1960s, via Reinhardt, Ryman, Poons, Kelly, LeWitt, and endless others, as well as Martin, whose cult three years ago was not what it is now. Ad Hoc was founded in late 1970. I resent the implication that women artists are so retrograde that this technique didn't occur to them until then. When I visited over one hundred women's studios in 1970 to choose a show, I found many using grids—by that time in very personal ways relating little to previous uses. Most of the women who ended up in the show had never been to an Ad Hoc meeting. I suspect more Ad Hoc members paint in styles related to so-called Lyrical Abstraction and Radical Realism modes than use grids. *That* can hardly be blamed on me!

**IV: Letter to a Young Woman Artist, March 6, 1974***

I'm sorry this has to be so short, because I have a lot I'd like to talk about with you, but try to read between the lines. I hope you're angry but get it over with fast and *use* it while you've got it. I hope you don't stop being angry now

---

* Reprinted from *Anonymous Was a Woman,* Feminist Art Program, California Institute of the Arts, Valencia, California, 1974.

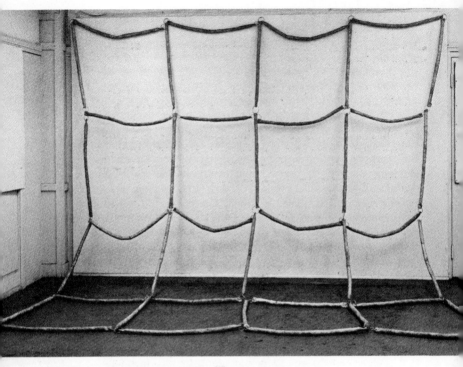

Howardena Pindell: *Untitled 1970–71.* Synthetic polymer, polyurethane, canvas, enamel, grommets, rings. 11′ 7″ × 12′ 8″ × 3″. Photo: William Suttle.

and then until things are better for all women, not just artists; I hope you're working from yourself and know how to fuck the artworld pressures when you get out there; and I hope you're working for everybody else too; I hope you'll be the one to figure out a way to keep art from being used the wrong way and for the wrong things in this society; I hope you make your art accessible to more people, to all women and to everybody; I hope you think about that *now* and aren't waiting till you make it, because that's likely to be too late. I hope you remember that being a feminist carries with it a real responsibility to be a *human.* I hope and I hope and I hope. . . .

## V. From Notes for Two Unpublished Essays*

The images most frequently appearing in women's art have biological and sexual sources, to the horror of those who use these configurations neutrally, or those who fear biological determinism. The central focus or aperture (*not* necessarily a "void"), domes, spheres, cylinders, eggs, ovals, containers, phalluses tend to occur most often in early, or immature, or naïve, not yet acculturated work. Unless consciously deepened as part of a mature individual esthetic, they tend to disappear or go underground with the rise of sophistication, exposure to the art world, and success. Needless to say, some men also use these images; there is no technique, form, or approach used exclusively by women. Yet those listed above are ubiquitous in large groups of work by women in and out of the New York or Los Angeles art worlds—far more so than in any body of work by men. Whether this fact is due solely to conditioning, or whether other elements are in question, cannot be decided yet, but must surely be investigated.

Artistic motivation and imagery have rarely been studied by people who understand the esthetic and art-historical sources as well as the psychological ones. And on the other hand, much has been written in recent years about the perception of contemporary art from the retinal and philosophical points of view, and from that of Gestalt psychology, but a most significant element in seeing art has been neglected—how a viewer innocent of "art appreciation" looks at art, and the influence of the individual's experience, fantasies, and associations as they merge, or not, with those of the artist. Because women's erotic experience is not the same as men's, and because a great deal less is known about it than about male sexuality in art, this area of identification may be harder to perceive. Because of the dangers of exposure, sexual imagery in women's art has been externalized so unconsciously that it remains personally threatening for many artists to confront their own content. There are endless degrees of

---

* "Sensuous, Sensual, Sexual and/or Erotic Abstraction," to be published in Joan Semmel, ed., *The New Eros* (New York: Hacker Art Books, 1976); and "Centers and Fragments: Women's Spaces," to be published by Watson-Guptill for the Architectural League and The Brooklyn Museum in conjunction with "Women in American Architecture and Design," an exhibition projected for 1977 at The Brooklyn Museum.

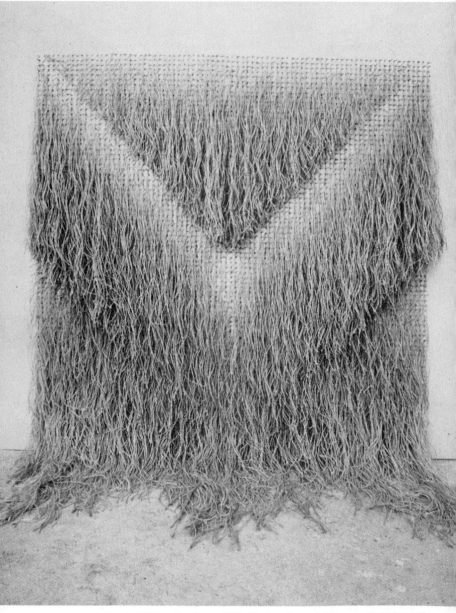

Brenda Miller: *Diandrous*. 1973. Sisal, nails, and blue pencil. 80" × 80" × 1" to 40". Courtesy Sperone, Westwater, Fischer, New York.

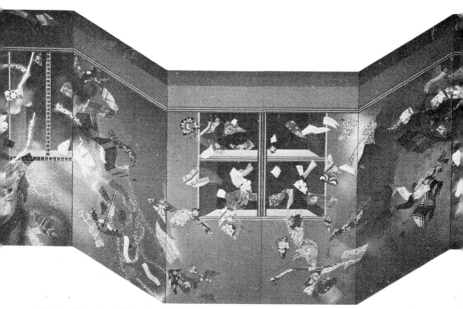

Miriam Schapiro: *Night Song*. 1973. Screen in 6 panels. Acrylic, paper, fabric collage, ribbon. Each panel 68" × 28". Courtesy Andre Emmerich, New York. Photo: Frank J. Thomas.

acceptance, neutralization, and outright denial involved in any study of women's imagery, especially sexual imagery. Conditioning, however, now works both ways. In contrast to those women artists who have suffered too long and lean over backward to avoid association and identification with other women, there are those who lean over forward to culti-vate their feminist identities through self-conscious choice of "female" images and techniques and content. Among the former is Georgia O'Keeffe, who said, "Eroticism! That's something people themselves put in the paintings. They've found things that never entered my mind. That doesn't mean they weren't there, but the things they said astonished me."[2] Among the latter are those Los Angeles feminists who are "not indiscriminately interested in just any art made by

[2] Georgia O'Keeffe, quoted in Dorothy Seiberling, "The Female View of Erotica," *New York Magazine* (February 11, 1974).

Lynda Benglis: *Gray*. 1972.
Purified beeswax, damar resin,
pigments on masonite. 36" ×
5". Courtesy Paula Cooper,
New York. Photo: Steve Sloman.

women, for a lot of women have emotionally and psychically internalized the male world. . . . We are interested in a level of sensation and sensitivity directly related to cunt sensation. I'm not talking about sex or orgasm as much as I am about the experience of cunt as a living, seeking, pulsating organism."[3]

Needless to say, there is a broad middle ground between these two attitudes. Louise Bourgeois was able to overcome those years in which female sexual imagery was acceptable only if subliminal and the artist was seen as a feeble medium whose "natural" acts were left to be "culturally" interpreted by others. "For a long time," she recalls, "the sexual aspect in my art was not openly acknowledged. People talked about the erotic aspects, about my obsessions, but they didn't discuss the phallic aspects. If they had, I would have ceased to do it. . . . Now I admit the imagery. I am not embarrassed about it."[4]

It is no accident that so much of the dialogue about whether there is and what is a female imagery has centered upon sexual concepts. If women are more obsessed by sexuality than men, it is because we have been raised and conditioned to think of ourselves and our futures in sexual terms. Sex is a way of obtaining our desires and it is also the key to the love and affection we are supposed to be so dependent on. Lynda Benglis, for instance, believes that a female sensibility is based on the fact that "women want to please . . . women make pleasing art."[5] And for better or worse, our interpretations are also conditioned by the pervasive influence of Freud, who listed as symbolic representations of the female genitalia "all such objects as share with them the property of enclosing a space or are capable of acting as receptacles such as pits, hollows, and caves." Many women artists, whether or not they choose to acknowledge the role of interior space and central-core imagery, are consciously preoccupied with formal relationships between inside and outside—among them Louise Bourgeois, Mary Miss, Ree Morton, and Jackie Winsor.

---

[3] Faith Wilding, "After Consciousness-Raising, What?," *Everywoman*, 2, No. 7 (May 1971).

[4] Louise Bourgeois, quoted in Seiberling, *op. cit.*

[5] Lynda Benglis, contribution to "Un-skirting the Issue," *Art-Rite*, No. 5 (Spring 1974).

Traditionally, inside represents female, outside, male. We have broadly accepted the male concern with facade and monument, the female concern with function and environment; the male concern with permanence and structural imposition, the female concern with adaptability and psychological needs; the male concern with public image, the female resistance to specialization; the male concern with abstract theory, the female concern with biography and autobiography. These stereotypes are more often proved right than wrong. Interiors are seen in women's literature as prisons and sanctuaries. In the visual arts, women's images of enclosed space convey either confinement (inside looking out, as in the many graphic works depicting windows from the inside, windows as barriers or protectors) or else freedom within confinement (inside looking in, turning to the self in isolation) or combinations of the two.

Sometimes nature is "out there," on the other side of the window, representing life and opposed to compartmentalized death. The editor of a 1945 kitchen-improvement contest for farm women noted, "I don't believe there was an entry that didn't mention plans for enlarging at least one window," and the first criterion for a house was one which "fits the land." As the earth is identified with the female body, the garden may provide a transition to the world seen through the window. Christine Oatman's environmental sculpture, *A Child's Garden of Verses* (plate 4), is a fantasy in praise of fiction, poetry, the imagination as escape. Shoes and socks belonging to an invisible little girl are left outside the gate in a picket fence which encloses a grassy plot. Barefoot, her senses tuned, she belies her confinement by creating other worlds within, marked by piles of books and tiny constructions that seem to have emerged from their pages—a Greek temple of sugar cubes occupied by a Monarch butterfly; a glass train going through a tunnel hollowed out of a loaf of bread; a sky-painted egg.

On another level, that of the universal mythologies of Mother Nature, the Devouring Mother as part of the ouroboric "Great Round" of nature, birth and death, there are Eunice Golden's series of abstracted sexual landscapes, one of which shows woman crucified on the land, paralleling Paul Shepard's notion that the sexual anthropomorphism of the world is the "last defense against the naïve reductionism and pseudo materialism of the [male] technological society

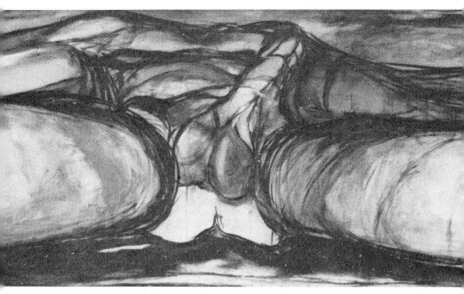

Eunice Golden: *Landscape* #160. 1972. Acrylic on paper. 26″ × 51″.

which confers death and uniformity on the landscape."[6] An untitled painting by Cynthia Carlson of a padded or furrowed landscape, or cave, with the earth's skin peeled away in layers by three inhuman instruments to admit light from a distance (plate 9), is an extraordinary combination of several of these themes—an image at once cruel and hopeful, which might evoke the pain of either violation or rebirth.

At the core of experiencing any sensuous to sexual art is body identification. I have used, out of context, the psychological term "body ego," and Gaston Bachelard's "muscular consciousness" to refer to that sensation of physical identification between a work of art (especially sculpture in its three-dimensionality) and the body of the maker and/or viewer. As Barbara Hepworth has said, people who find her work difficult to understand are "the ones who've decided

[6] Paul Shepard, *Man in the Landscape* (New York: Ballantine Books, 1972), p. 96.

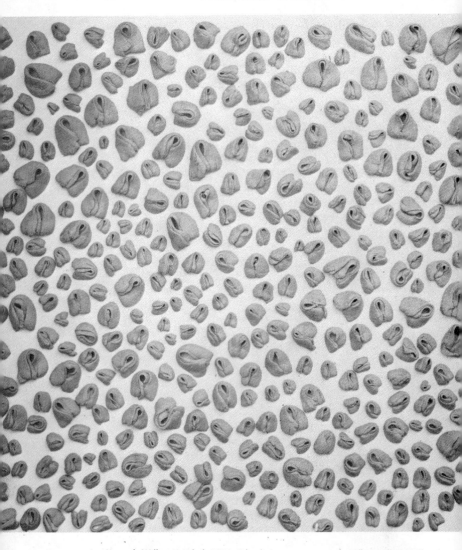

Hannah Wilke: *Untitled.* 1974. Kneaded eraser on wood. 13″ × 13″ × 1½″. Courtesy Ronald Feldman Fine Arts, Inc., New York. Collection Eeva-Inkeri, New York. Photo: Eeva-Inkeri.

that women artists are no damned good anyway and they stiffen up as soon as they see a work. So they won't go round; they can't touch. . . . You can't make sculpture without involving your body. . . . The spectator is the same. . . . In sculpture the main thing to do is to stand on your toes and become aware to the fingertips."[7]

When private expression is exposed to public interpretation, a certain amount of dislocation inevitably results. This is all the truer of art based on women's sensuality, which has traditionally been forbidden and devaluated subject matter. Since artists learn from communicating with their audiences, and the broader based the audience, the more they learn, the damage done to women unable to exhibit, teach, find role models in history, participate and communicate in the art world, becomes particularly devastating. If it is generally assumed that there is opposition between nature and culture, if "woman creates naturally from within her own being, while men are free to, or forced to, create artificially . . . through cultural means,"[8] then it helps to explain why women choosing to depict their own sexual experience would have been considered in dangerous opposition to "high art." Like the education of children, contemporary art "evolves" from the defiling environment of women to the more exalted and abstract world of men. Sexual art made by women, recalling in its yawning and often ominous pits and mountains the origin of man, is distasteful and threatening to the "maturity" of the male-dominated establishment. Even Hepworth has been accused of making "menacing forms." As Barbara Rose has remarked, erotic art focused on vaginal images "is profoundly radical in that it attacks the basis of male supremacy from the point of view of depth psychology," attacks "the most fundamental area of male supremacy—that a penis, because it is visible, is superior. . . . Women's erotic art is in effect propaganda for sexual equality based on discrediting . . . the idea of women as unclean Pandoras with evil boxes."[9]

The stereotypes of "female imagery" have not been im-

---

[7] From Cindy Nemser, "Conversation with Barbara Hepworth," *The Feminist Art Journal*, 2, No. 2 (Spring 1973).

[8] Sherry B. Ortner, "Is Female to Male as Nature Is to Culture?," *Feminist Studies*, 1, No. 2 (Fall 1972).

[9] Barbara Rose, "Vaginal Iconology," *New York Magazine* (February 11, 1974).

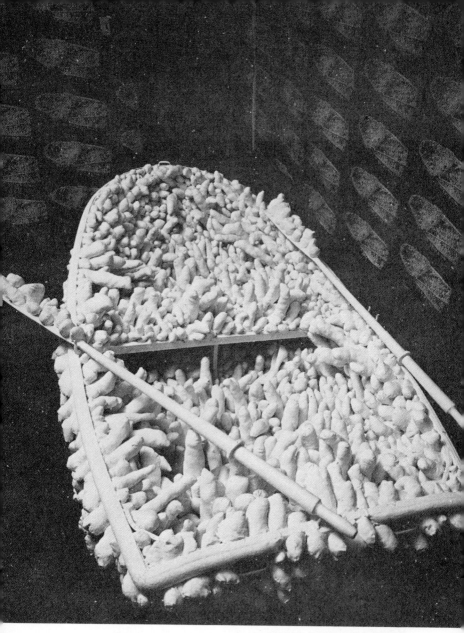

Yayoi Kusama: from "One Thousand Boat Show." 1962. Stuffed canvas and wood. 132" long. Installation at Stedelijk Museum, Amsterdam, 1963.

posed by men. Women are not so weak. They have arisen from the work of those few women who dared to make such subject matter visible and to accept the potential scorn of a society unfamiliar with it. A notable example is Lee Bontecou, whose sculpture from the early 1960s, with its dark central cavities forced into high relief and the occasional *vagina dentata* form, was received with apprehension, although eventually accepted on the basis of its formal power. At the end of that decade, however, Bontecou's art changed drastically—not in style, or even imagery, but in strategy—from the "tough" threatening canvas and metal constructions to tender, transparent plastic fishes and flowers whose insides are totally exposed rather than remaining dark secrets. Seeing these, one realized just how much the earlier work, which had seemed so bold in its "femaleness," had in fact been confined by the rules of the art society in which it was understood. Perhaps the most overwhelming problem facing the development of a truly feminist art is the state of esthetic perception in the culture as a whole.

# What Is Female Imagery?*

The women participating in this discussion are: Susan Hall, figurative painter; Lucy Lippard, art critic; Linda Nochlin, art historian; Joan Snyder, abstract painter; Susana Torre, architect.

*What is female imagery?*

NOCHLIN: My first reaction is anger, because the term is so constricting. I'm human, undefined by preconceptions, an androgynous being that isn't slated to give birth to any particular imagery. But my second reaction is to try and think it through. I do live in a society, and who I am is determined by the structure of experience a woman is supposed to have. My experience is filtered through a complex interaction between me and the expectations that the world has of me.

I've been reading Dorothy Richardson, who, I think, invented the stream-of-consciousness style at the beginning of this century. She consciously set out to create a female style and imagery, the quality of female existence in a certain time and place. She captured a middle-class Englishwoman's experience and sensibility. That's female imagery, not something Jungian—predetermined and absolute.

* Reprinted from *Ms.*, 3, No. 11 (May 1975); New York section only. Chicago and Los Angeles were also included in the article. The tape was made on October 3, 1973; by the time it was published, it was out of date. This is a drastically shortened version of the original which was edited by the magazine.

LIPPARD: How about visual imagery?

NOCHLIN: That's where it gets hard for me. It's not a specific image, iconography, or subject that has to do exclusively with women. It has more to do with process, or modalities of approaching experience, but even then I get stuck. It has to be invented, like any iconography.

HALL: There's a scale of negative and positive physical charges in men and women. Somebody said that man is sixty percent positive physically—projected out toward the world—and forty percent negative, mentally. Woman is just the reverse. So together they form a bond. Then there are many subtle combinations of masculine and feminine. I thought about these related to painting, from Helen Frankenthaler to Georgia O'Keeffe. And I realized that in order to be an artist at all you have to have, physically, a certain kind of energy, a certain kind of momentum. It would be very difficult on this level for the superfeminine inward woman to do art work because she would need that physically charged energy.

SNYDER: I think there is a female sensibility. I know what it *isn't.* But I can't pinpoint what it is, though I've boasted I can walk into the Whitney Annual and pick out the women's work.

Women have been working in the closet for so long that we're now seeing new and original work by women that we don't see by men. The sociologist in me would like to explore the lives of artists to understand why they're making their art. The quality of people's lives has a lot to do with the art they make. One of the dangers women are facing right now is that we've been accepted into the art world and are acting out male artists' life-styles. That's an enormous danger to any kind of sensibility. Whether or not we're going to change anything has a lot to do with how we respond —or what our needs are, I guess.

LIPPARD: Of course, "female imagery" was first used, and should continue to be used, to mean female *sexual* imagery. That wasn't understood and it all got confused. I prefer "female sensibility" because it's vaguer, even more impossible to pin down. There is a lot of sexual imagery in women's art —circles, domes, eggs, spheres, boxes, biomorphic shapes, maybe a certain striation or layering. But that's too specific. It's more interesting to think about fragments, which imply a certain antilogical, antilinear approach also common to many women's work. I like fragments, networks, everything

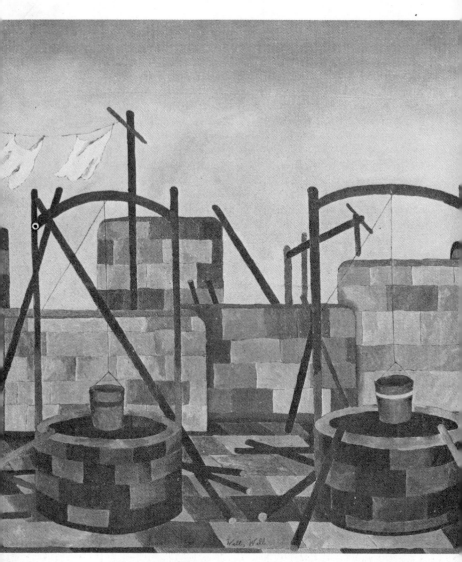

(Above) Susan Hall: *Well, Well.* 1973. Acrylic on canvas. 37½" × 34½".
Courtesy Nancy Hoffman Gallery, New York. Photo: Robert E. Mates and
Paul Katz.

(Right) Pat Steir: *Night Chart III (Dawn).* 1973. Oil, wax crayon, pencil
canvas. 84" × 84". Courtesy Fourcade, Droll, Inc., New York. Collecti
S. I. Newhouse, New York. Photo: Bevan Davies.

about everything. Men's work isn't so much cliché-aggressive, all angles and phallic, as it's closed—the "this is *my* image" number. Women are, for all kinds of reasons, more open, into themselves in a very different way.

TORRE: I read in *Architectural Design* that the only way in which a woman can experience herself as a person is through a creative act of her own. "Creative" doesn't necessarily mean artmaking: political action can be an act of

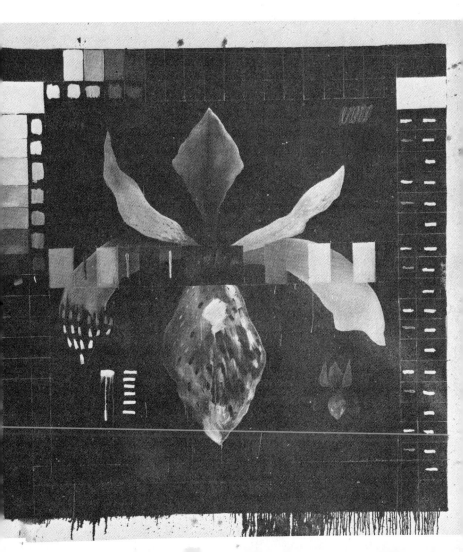

creation, too. That's crucial for women. Feminism shouldn't be an interpretation of this world, but a transformation of it. Right now, the issue of sensibility is secondary to the issue of consciousness. Female consciousness is different from male consciousness, and it's still in the process of being structured. It's impossible to give a tight definition of something that's in the process of becoming, but we can talk tentatively about a particular stage of this process in various areas—female imagery, for instance.

The image is an incredibly powerful medium. It can express in synthesis levels of consciousness that are not rationally apparent but can mesmerize people. I see the making of a female imagery as a tool for generating further consciousness in other women, and people in general. As an architect, it seems to me that women more than men should be able to find, through the daily appropriation of space, a closer correlation between spaces and biological and cultural rituals. We are less removed from spatial experience than men.

NOCHLIN: I was part of the 1950s—cosmopolitan, asexual, ideologically male-dominated. I never looked at an artist's work as masculine or feminine. Now my whole perception of reality has been irrevocably altered; feminism has made me question all the presuppositions and ideologies about art I've been handed over the years. Why is one form considered "good" and another "not good"? I often see women's styles as being partly conditioned by opposition, as having meaning in the context of being opposed to existing styles. The painter Florine Stettheimer, for instance, did conventionally "advanced academic" work at the turn of the century. She knew what the avant-garde was doing—Marcel Duchamp and other innovators were her friends. But eventually she said No to both the academic and the avant-garde modes and went on to invent something of her own, something private, something that was called "feminine." She's being appreciated more fully now; we're ready to look at her work in its totality, not just as negatively "bizarre, feminine form," but as a conscious step, radical in the 1920s and 1930s.

I'm looking at Gertrude Stein differently, too, as one of the innovators of our century in many fields. I hadn't thought of her as a woman expressing a woman's experience before. Yet Florine Stettheimer and Gertrude Stein aren't in any way alike. I find analogies in how they invent in opposition to what's prevailing, but I don't find a common thread and

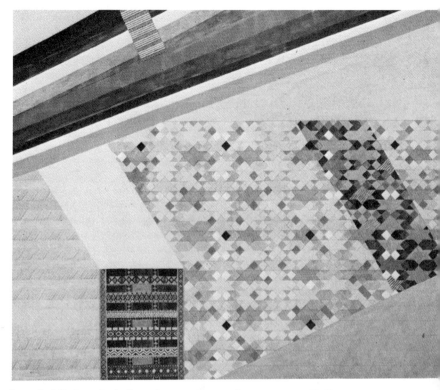

Joyce Kozloff: *Tent—Roof—Floor—Carpet.* 1975. Acrylic on canvas. 78" × 96". Çourtesy Tibor de Nagy Gallery, New York. Photo: Eric Pollitzer.

I don't think that's necessary. I don't find a common thread in American art from the late nineteenth century, either. But I'm interested in exploring the quality and the style and seeing what possibilities there are for inventing or adapting languages or forms in women's work. I don't want to pin it down because women aren't any more alike in an easily definable way than men. Perhaps we should talk of female *styles*, always in the plural.

HALL: Things only become clear to me after I've finished a series of paintings, because I don't want to paint something

that was that clear and specific to begin with. I'm conscious of a diffused kind of process.

LIPPARD: That's the way I work and I find a lot of women work. But I wonder if that's *because* of our alienation from logic and rationality or whether it comes from somewhere else.

HALL: When I'm involved in something difficult, what interests me is seeing ways of moving beyond it. All the power struggles in the art world, all the problems with galleries, are just challenges. We have to meet them and move on to the other side, whatever that is.

LIPPARD: I have such *doubts* about writing on women artists in the art magazines and doing shows that get women into more shows within the current rotten structure. I've been dragging them into something most of them know very little about, because most women artists have been so isolated from the workings of the art world. There's this conflict about getting a piece of the pie, even if it's poisonous, and knowing it's really their choice and not mine.

SNYDER: I think women tend to be more autobiographical in their work than men. If anybody was really looking at my own work, I'd be very embarrassed because they'd know all about me. My work is an open diary. That's what I often miss in men's work—an autobiographical or narrative aspect. Some women artists are making statements that make me say, "Oh, right, I know exactly what she's talking about." I can't do that with most of my male artist contemporaries. Men talk about art a lot and I don't think women talk about art as much as they talk about life.

LIPPARD: You made this beautiful claim—which maybe all of us feel but are scared to make: that you can tell women's art from men's art. How?

SNYDER: It has to do with a kind of softness, layering, a certain color sensibility, a more expressive work than any man is going to do right now, and a repetitiousness—use of grids, obsessive in a way. When I look at women's art, I look for ideas and images that not only move me visually, but tell me something about who the artist is, what she is, what she's trying to say. I'm not interested in art so mysterious that it doesn't tell me a thing.

In 1968 I did flock paintings, using flesh colors and sensuous, vagina-type shapes, stretching membranes, little seeds, floating objects. They were sensuous paintings and they were about me. And then I needed to make them more layered,

Michelle Stuart: #28. 1974. Rocks, earth, graphite, muslin-mounted rag paper. 144″ X 62″. Courtesy Max Hutchinson Gallery, New York. Photo: Bevan Davies.

Barbara Zucker: *Dark Huts*. 1973. Hydrocal, cheesecloth, pigment. 50 units, each 9" high. Installation at Sarah Lawrence College, Bronxville, New York. Photo: Richard Nonas.

maybe to tell a story. Now when I look back, to try to fig-
ure out where my grids came from, I see that I started do-
ing them about a month before I got married. When I
made the decision to put structure into my life, structure
appeared in my painting.

LIPPARD: I do feel that women are more interested in
people, probably because you live vicariously if you're iso-
lated. So women become more interested in soap opera and
fiction. But women also care more about variety than men,
and variety connects to fragmentation and to the autobio-
graphical aspect, too—as a sort of defiance. We play so
many roles in our lives, while most men play only one or

two. The beginning of any woman's career has always been the business of sitting back and listening to men and thinking, "Well, I have an identity, too; it isn't very interesting, maybe. I've never met Mark Rothko and I never did this and I never did that, but I have my little things." Those "little things" are the secrets that women turn in on and depend on.

In a way, the women's movement gave me permission to like the art I always identified with, but didn't allow myself to like because if I had, I might not have been so successful. This wasn't at all conscious. I loved and identified with the art I was seeing, too, but I was leaving some important things out. By the time the women's movement hit, I was feeling almost male. I lived alone with my kid in another country for a while then, writing fiction, and when I came back, I wasn't ashamed of being a woman anymore. The idea of identifying with women's work was very exciting to me—the whole thing of caring. A lot of women's work, and the best of men's work, has an indefinable aspect of *caring* about it.

Another totally separate thing is that the cliché of women's art is getting as bad as the cliché of men's art. Before the movement, women were denying their identity, trying to be neutral, and intentionally making art that couldn't be called "feminine." When somebody said, "You paint like a man," or "You write like a man," you were supposed to be happy, and you *were* happy, because you knew you were at least making neutral art instead of feminine art—god forbid. So now we're bending over backward in the other direction, insisting that there are clichés that define women's art. Women now make "women's art" instead of "men's art" or "neutral art." It may be easier to find out what women's art is, or what female imagery is, quick, this second, because the work of women who've been isolated and closeted, which has come out in the last three years, is personal, still has the blush of innocence on it. That level we may never see again. I want to catch those ephemeral moments before we all move into a different, and, I hope, more powerful and clearer level.

# Six*

*Is there a women's art?*

What do you mean—an art by women?

*A lot of women do art, but is there an art made only by women?*

All women?

*No, just an art, no matter how little of it—not a style and not a technique, but something broader—that's done only by women.*

I don't know. Is there?

*Well, there should be. Women's experience—social and biological—in this and every other society, is different from men's.*

And every *person's* experience is different from every other person's. Art is individual.

*It's still possible to generalize about it. Black experience is different from white. Poor is different from rich. Child's art is different from adult's. And women's is different from men's.*

But art is a mixture. Art is androgynous.

*Sure, artists are probably more androgynous than "normal" people. Like male artists, no matter how macho they are (or because of it), have more of the woman in them than some other men in other professions. God knows women artists have traditionally had to have some "male" in them to get the hell up and create something on the primary level—or rather to have it seen as such. It takes imagination to*

---

* One of a series of columns, reprinted from *Studio International,* 187, No. 963 (February 1974), slightly revised.

(Above) Joan Jonas: Margaret Wilson and Joan Jonas in fan sequence from *Organic Honey's Vertical Roll.* 1972. Performance with video. (Below, right) Eleanor Antin: *The Artist as Prima Ballerina.* 1973. Photograph. (Below, left) Jacki Apple with Martha Wilson: *Transformance (Claudia).* December 15, 1973. Performance by the artists and other participants, Plaza Hotel, New York.

*transcend your sex. But it's dangerous, like building a house on sand. If you don't know your own identity, the real meaning of your own experience, you can't just jump up and "transcend." Eva Hesse once described the female part of her art as its sensitivity and the male part as its strength. Hopefully a year later she would have realized it could all be unified, that strength is female too.*

Why will so few women admit to using their own bodies or biological experience even as *unconscious* subject matter?

*Because it has been common knowledge that "women are inferior" and women artists trying to transcend that in their work sensibly don't want to identify with inferiority. So why not aspire to "maleness"?*

But now that everybody knows women aren't inferior?

*Ha! Everybody hasn't gotten the message yet. Anyway, it still holds in our generations, through conditioning. It's in the back of our minds, as fear or as rage, even when the rhetoric's on our lips.*

Not in the back of *mine*, it isn't.

*You're lucky, then. Another reason women don't like their art to be seen through their bodies is that women have been sex objects all along and to let your art be seen that way is just falling right back into the same old rut.*

Not once attitudes are changed. Not once you can be proud of being a woman.

*Nobody whose consciousness has been raised wants to be seen as just a vagina, an interior space, a cunt. You're hardly doing women a favor by laying that kind of restriction on them.*

It's not a restriction. It's a basic element to our own identities we have to come to terms with. Did you hear yourself say "*just* a vagina"? Anyway, I didn't say that sexual or biological identity was the only factor in women's art. But to make art that is together, unified with the maker, that too has to be acknowledged instead of apologized for. And it's *there*. I looked at the New York Women's Art Registry—something like twenty-five hundred slides of women's work; I saw them with a man and he kept saying, "a man couldn't have made this work." It wasn't necessarily a compliment, but it was a fact we could both see. A huge amount of the work, especially the more naïve or funky (and therefore often more directly inside art, less affected by bandwagon artworld numbers), did have blatant sexual matter, and so did a lot of the work made by women who deny that subject matter

even when it's visible, by saying, "oh, I wasn't thinking about that so it isn't there." Sex is bound to be a factor in women's work precisely because women have been sex objects and are much more aware of their bodies than men. Men are aware of their pricks. Women are aware that every movement they make in public is supposed to have sexual content for the opposite sex. *Some* of that *has* to come out in the work. When it's absolutely absent, when it isn't even suggested, I wonder.

*But that's like the cliché "Women are irrational and men are rational"; "Women are illogical, men are logical." You're taking women down to the level of mere bodies, while men can repress that and are allowed to make art with their minds.*

No. No, not at all. Just that good art by either sex, no matter how "objective" or "nonobjective," has to have both elements or it's dead. But I must say that I think a lot of what we call logic and rationality is a male-focused, male-invented code. So-called logic is often insanely illogical, but it's still called logic because it works within its own system. Like formalist or Minimal art is popularly supposed to be logical because it looks like it should be, while work with a more obviously psychological basis is called illogical. I'd like to see those terms forgotten and have people look at everything according to a new set of criteria, criteria that don't imply value judgments through the use of certain code words or phrases. When I write that something is illogical in art, and I like it, I have to add "marvelously illogical" or it will be seen as a put-down. Not so with logic, which I often think is "merely logical." R. D. Laing pointed out the same thing about subjective and objective; he said it was always "merely subjective." I'm constantly called illogical, and I don't care, because for me it's logical, according to my own system.

*Crazy lady.*

Maybe, but I know that a certain kind of fragmentation, certain rhythms, are wholly sensible to me even if I can't analyze them. I find that fragmentation more and more often in the art—written and visual—of women who are willing to risk something, willing to let more of themselves out, let more of themselves be subject to ridicule according to the prevailing systems. Part of the energy that emerges from that impetus is sexual. Part is intellectual in a new way. Of course there's still an endless stream of art by women who are copying the old way, who are scared to alter the mathematics or geometry or logic or whatever it is they're interested

in toward a new and perhaps more vulnerable model. I'm certainly not saying that any of those things should be tabu for women's art. But I'm convinced that women *feel* them differently and *that* either does come out or should come out in the art. Like the way so many women artists are using geometry or the grid primarily to blur its neat edges, to alter its meaning, to subtly screw up the kind of order that runs the world. The most convincing women's art I see, of any style, is very personal, and by being very personal finds a system of its own.

*But you're so* vague.

I know. On one hand I don't want to draw any conclusions. I mistrust conclusions because they get taken for granted and stop the flow of things. On the other hand, even if I wanted to, I couldn't draw conclusions on this subject now because I don't know enough. And because society hasn't radically changed yet for women, so what we're seeing is a mixture of what women really want to do and what they think they should do. . . .

(Left) Martha Wilson: *I Make Up the Image of My Perfection/I Make Up the Image of My Deformity.* May 1974. Photo-documentation of performance. (Below) Nancy Kitchel: *Covering My Face: My Grandmother's Gestures.* 1973. From series of 22 photos, 1 page of text. 8½" × 11". "Traces the origin of a particular gestural characteristic to a strong connection with my Grandmother in a critical period of identity formation. The photographs document the pushing and exaggerating of my gestures until they become identical to my Grandmother's, my hands become hers, my thoughts are hers, my whole personality becomes merged with hers."

# The L.A. Woman's Building<sup>*</sup>

At night, the Woman's Building at 743 Grandview, Los Angeles,[1] in an "ethnic" neighborhood near McArthur Park, is bathed in pink floodlights. In its closets, the tools are painted pink. It opened last fall in the former Chouinard Art Institute building, exactly eight decades after the inauguration of its namesake, the Woman's Building of the World's Columbian Exposition in Chicago in 1893, which was designed by a woman and included murals by Mary Cassatt, and whose catalogue declared:

> The great work of the world is carried on by those inseparable yoke-mates man and woman, but there are certain feminine touches in the spiritual architecture which each generation raises as a temple to its own genius, and it is as a record of this essentially feminine side of human effort that the Woman's Building is dedicated.

Today this might be stated in different terms; eighty years have turned those "gentle touches" into blows for justice. The new Woman's Building (managed by Edie Gross) shelters an impressive group of feminist organizations:

Womanspace, a community art gallery and center, directed by Marge Goldwater, that was the prototype for the

* Reprinted from *Art in America*, 62, No. 3 (May–June 1974).
[1] In December 1975 the Woman's Building reopened at 1727 North Spring Street, Los Angeles, having been forced to move when the old building was sold.

whole project when it opened at another location last year;

The Feminist Studio Workshop, a small, far from conventional art school, founded by art historian Arlene Raven, designer Sheila de Bretteville, and painter Judy Chicago, that will receive accreditation next year from the International Community College;

The Center for Art-Historical Studies, an affiliate of the Feminist Studio Workshop run by Raven and art historian Ruth Iskin that includes the Los Angeles West-East Bag slide registry;

Gallery 707, a private gallery owned by Anait Stevens that is also a forerunner of the Woman's Building;

Grandview Galleries 1 and 2, cooperative galleries representing forty women artists of every conceivable style and intention;

Sisterhood Bookstore, a branch of the original feminist store in Westwood;

The Performance Project, an organization headed by Liede Gray that coordinates women's performing groups;

Women's Improvisation, a theatre workshop;

The Associated Women's Press, publisher of five magazines—*Sister, Momma, Womanspace Journal, Lesbian Tide,* and *Women and Film;*

The Los Angeles chapter of NOW;

The Women's Liberation Union.

Also getting underway are a Women's Graphic Center for printing and printmaking, and a restaurant.

The Woman's Building is still primarily a middle-class institution, although its groups are exploring ways to open it to more minority participation, among them a recent consciousness-raising dialogue with men and women from the Studio Watts Workshop and, projected for next year, the Feminist Studio Workshop's extension program of classes in the Los Angeles community. Lectures and panels are held with participants from other fields, and the auditorium is rented to other women's groups. While some of the events are for women only, the building itself, the exhibition openings and a large percentage of the events are open to mixed audiences and are well attended on that basis. Five thousand people came to the Grand Opening in late 1973, though numerous Los Angeles art-establishment figures, from artists to museum curators, have yet to darken the doors, which, considering that those doors open to five exhibitions a month, not an inconsiderable part of Los Angeles' total, is rather a dismal showing.

Why was it Los Angeles, of all places, that came up with the first efficient and encompassing alternate structure for women's art? Contributing factors may be the macho life-styles and art establishment, the geographical isolation of artists from each other and, to quote Nancy Marmer (in *Art News*, Summer 1973), "the city's aping-after syndrome . . . exacerbated by the anxious provinciality of the California scene and its discernible inclination to stand at attention facing east." When the women's movement was taking hold in 1970 and 1971, Judy Chicago had already begun the first women's art program in the area, at Fresno. In the spring of 1971 the Los Angeles Council of Women Artists launched a massive complaint against the Los Angeles County Museum of Art, whose "Art and Technology" exhibition catalogue had just come out "with fifty men's faces on the cover" (no women's). Supported by activist women film-makers, the Council published a list of proposals for the museum to increase hiring of women (from guards to trustees) and to exhibit women's art; it made the front page of the *Los Angeles Times* because the statistics were so damaging (over a ten-year period *one* one-artist show out of fifty-three was devoted to a woman; less than one percent of all work on display at the museum at that moment was by women; only twenty-nine of seven hundred and thirteen artists in group shows had been women). The museum's statement in defense was to the effect that women were no good, so they didn't have to deal with them.

One of the organizers of the Los Angeles Council of Women Artists feels that, although some gains were made, the County Museum "is such a white elephant" that it was absurd to think it could be used to promote an alternate system. But after the protests came the California Institute of the Arts Feminist Art Program (headed by Miriam Schapiro and Judy Chicago), members of which built the extraordinary 1972 environment, *Womanhouse;* a year later came Womanspace, then in its own small building in Culver City, co-directed by Gretchen Glicksman and Ruth Iskin with Chicago as advisor. Womanspace raised funds and other support from the women's community of Los Angeles (not necessarily from the art community, which had hardly welcomed women artists). Last spring Womanspace had over seven hundred members. It has now taken its "open wall" (where any $16-per-year member can hang her work) to the Woman's Building, where it will hopefully be a wedge into still broader participation.

The scope and warmth of the Woman's Building are immensely moving. For a one-day visitor, at least, a sense of responsive life and community pervades the place; whatever the problems are, aside from money, I didn't get to them. Just for the record, the "quality" and variety of the art shown there are better than average. I saw a "geometric" show, a neon show, a figurative show, an abstract and somewhat expressionist show, a Conceptual show, a performance, and the Feminist Studio Workshop studios. Most of the exhibitions are geared toward subject matter, and there seems to be room for all points of view—social (e.g. Black and lesbian shows) and esthetic. I learned a basic lesson about the elusive quality of "quality" a few years ago at a showing of the (then) approximately fifteen hundred slides of the Women's Art Registry in New York. Every slide that came up, virtually without exception (and this is a completely open file), was greeted by *someone* with great enthusiasm and desire to know who did it and how. While my own taste leaned one predictable way, I was gratified and surprised how often others' tastes veered other ways. Recently I was asked by students in New York whether women's work shouldn't be screened for "quality" more carefully than men's. Wasn't it bad for women artists and for their "image" to show "bad art" in public? But men have always shown bad art. Until recently, *most* of the bad art shown has been made by men. We should have less privilege?

What is perhaps most interesting is that *art* is the focus of such a place as the Woman's Building. Though in part due to the intensely committed and energetic women who started it and who happened to be involved in art, this may also indicate some of art's potential for effecting real change. The less an alternate structure is in competition with the commodity art world, the better. I sadly doubt if New York, whose art world is too large, too powerful, too competitive, will ever succeed in having a single-focused center like the Woman's Building; New York lends itself to many separate institutions, often overlapping ones. (At the moment there are the Women's Interart Center, the closest we have to the Woman's Building; A.I.R. and SoHo 20, nonprofit women's galleries; the Women's Art Registry, the slide file; and various political and consciousness-raising groups, both organized and informal.) I suspect we'll need such rooms of our own for some time. The difference between talking to a mixed art-school class and one made up solely of women has to be experienced to be believed, but there sure as hell *is* a

difference in the way women open up, become smart and imaginative and assertive—and better artists. Those who denounce such situations as "separatist" should just get a glimpse of the sense of purpose and the relaxed exhilaration at the Woman's Building. There, everything seems possible —including a nonseparatist future.

# Making Up: Role-Playing
# and Transformation
# in Women's Art*

A New Life, or the Unnecessary Betrothal of Frau Holle
with the Shaman, a series of photographs by Christiane
Möbus in which the artist, dressed in giant feathered wings,
dances across a landscape, perches in a tree.

✦

A series of booklets by Athena Tacha dealing with aspects
of her self and life, including an illustrated one detailing
her physical features according to heredity, and one on the
emerging effects of age on her body.

✦

The Haube, a video tape by Ulrike (Rosenbach) Nolden
of herself in her kitchen wearing the obsolete headdress
worn by European women in the Middle Ages "originally
designed to denote possession by the husband, and develop-
ing through usage to be the symbol of her self-confidence
and equality."

✦

A series of photographs by Renee Nahum showing people
first in working uniforms, then in their "own" clothes.

✦

Shocking, bloody "rape tableaux" performed by Ana Men-
dieta with herself as victim.

* Reprinted from Ms., 4, No. 4 (October 1975). Published
under the title of "Transformation Art."

✿

*An exhibition by "Judy and Adrienne" of memorabilia from their own pasts, from baby pictures to prom corsages to divorce papers.*

✿

*Judith Stein proposes a name change, solicits suggestions, then publishes them, but reasserts her own identity by not changing her name.*

✿

*Susan Mogul's very funny video stories, in one of which she proceeds from disrobed to robed, reminiscing about the history of each item of clothing.*

✿

*Laurie Anderson's series of photographs of men in her neighborhood, taken by her as they accosted her or commented on her appearance, with captions describing each situation.*

✿

*A "father-daughter piece" by Joanne Seltzer—a montage of herself as a ballerina over a grid of checks paid by her father for ballet lessons and supplies.*

✿

*Handwritten cards detailing the life of one Anne Chapman Scales. I receive them almost weekly and come to know her quite well; later I am informed they are sent by a Joseph Gabe. I am disappointed because I could have sworn they were by a woman; next I am informed that J. G. is only a name used "at certain times when I am not making art, but thinking about it," by Mary Jean Kenton. (I think she's real.)*

✿

The pieces listed above are among a growing number of artworks by women with the self as subject matter.[1] The turn of Conceptual Art toward behaviorism and narrative about 1970 coincided with the entrance of more women into its ranks, and with the turn of women's minds toward questions of identity raised by the feminist movement: What Am I? What Do I Want to Be? I Can Be Anything I Like but First I Have to Know What I Have Been and What I Am.

---

[1] Since this article was written, in the summer of 1974, the number has grown still more phenomenally—here and in Europe —resulting in a far more complex picture; see pp. 121–138.

Laurie Anderson: *Object, Objection, Objectivity.* July 1973. One of a series of texts and photographs. "When I passed this man, he was unloading a cardboard box into the trunk of his Chevrolet. 'Hey Cutie,' he said. When I asked to take his picture, he began to question me: Who was I? What did I think I was doing? Was I a cop? etc. While he was talking, an unlit cigarette, stuck to his lower lip, kept bobbing up and down."

Conceptual Art—inexpensively written and/or photographed or taped pieces in which the idea is usually more important than the visual object—provided a direct outlet for private journals and relics, undared performances, self-revelations that had until then been mostly "closet art." Many of these artists chose themselves as their subject matter, a natural outcome of the previous isolation of women artists and of the general process of consciousness raising. Some chose an autobiographical method; many chose to concentrate on a self that was not outwardly apparent, a self that challenged or exposed the roles they had been playing. By

means of costumes, disguises, and fantasies, they detailed the self-transformation that now seemed possible.

The first manifestation of such transformation was not intended as art; it was an announcement of painter Judy Chicago's show at California State College at Fullerton in 1970, and of her simultaneous name change (she had to procure legal permission from her husband, whose name she had never used). Chicago appeared as a prizefighter, leaning arrogantly in her corner; there were those, of course, who instantly misread her statement as a Lesbian, rather than an across-the-board feminist, challenge.

Four years later, Lynda Benglis, also living in California (where an honored macho tradition is the exhibition announcement showing a photograph of the artist—usually featuring a cigar, cowboy boots, a truck, or a dog—rather than his work), deliberately took her image as a serious sculptor in vain, with four consecutive published photographs: the first (an exhibition notice and ad) showing her as a child dressed in a skirted Greek soldier's costume; the second (an ad) showed her leaning against a car, short hair plastered back, looking mean; the third (a long color postcard announcing an exhibition) showed her in a cutie pinup pose, coyly peering over her shoulder, nude except for her jeans around her calves over platform boots; and the fourth, which must be the climax, was a full-color advertisement in *Artforum* magazine showing the artist in shades but nothing else, belligerently and flirtatiously sporting a gigantic latex dildo.

The series has, needless to say, been wildly controversial. A group of *Artforum*'s editors played into Benglis's hands by writing a pompously irate letter in which they condemned her ad as "an object of extreme vulgarity . . . brutalizing ourselves and . . . our readers," making at the same time a mealymouthed claim that the magazine had "made conscious efforts to support Women's Liberation." Readers' responses to the letter were largely in favor of Benglis: art historian Robert Rosenblum voted "three dildos and a Pandora's box" to the artist and bemoaned the fact that the editors hadn't been "around to protest when Dada and Surrealism let those arty people run amok and do unspeakably vulgar things." Another reader was shocked that the editors were shocked. On the other side, one man pettishly noted, "I don't care what she is doing with that dildo, and furthermore I don't even like her artwork," while another tried to

vandalize an abstract sculpture by Benglis in the Philadelphia Museum of Art.

Benglis herself intended the series as a "mockery" of role-playing, and the dildo ad as a "media statement . . . to end all statements, the ultimate mockery of the pinup and the macho." Certainly it was a successful display of the various ways in which woman is used and therefore can use herself as a political sex object in the art world, and it was thus that the series was generally understood by the audience to whom it was directed in the first place—younger women artists.

Of the virtually hundreds of women here and abroad working with self-transformation as art, five who have been doing so with particular effectiveness are Eleanor Antin in San Diego, Adrian Piper in New York-(now Boston), Martha Wilson in Nova Scotia (now New York), and Nancy Kitchel and Jacki Apple in New York. They speak about their work in terms of expanding identity, of an "awareness of the boundaries of my personality" (Piper), "moving out to, into, up to, and down to the frontiers of myself" (Antin).

Antin had made biographies of women from objects and words before turning primarily to photography. In *Domestic Peace,* she documented with texts and graphs the transformation of herself into the "good daughter" while staying a few weeks with her mother, "so she would leave me alone to pursue my real interests." In *Carving: a Traditional Sculpture,* she peeled away the flesh in search of her own Michelangelesque core, documenting a ten-pound weight loss over thirty-six days with one hundred and forty-four nude photographs.

In video pieces, Antin has projected four selves: The Ballerina (every little girl's dream?), The King, The Black Movie Star, and The Nurse, discovering in the process that "a human life is constructed much like a literary one," and that her characters—hybrids of autobiography and fiction—began to lead their own lives. "Autobiography in its fundamental sense," says Antin, "is the self getting a grip on itself. . . . [It] can be considered a particular type of transformation in which the subject chooses a specific, as yet unarticulated image and proceeds to progressively define [herself]. . . . The usual aids to self-definition—sex, age, talent, time, and space—are merely tyrannical limitations upon my freedom of choice."

The "drag syndrome," which goes back to Duchamp's female avatar "Rrose Selavy," is inherent in any exploration of sexual role-playing. Antin thought herself "in drag" when she wore a skirt for the first time in two years. Martha Wilson's photographic *Posturing: Drag* was a double transformation in which she became first a man, then a man dressed as a woman. Perhaps such trying on, or trying out, of different roles is the opposite of disguise. A woman who assumes a primary or "male" role is not (as is presumed) "in drag." Wilson began in 1971 to concretize her fantasies through makeup, clothes, and facial expression. She dyed her hair, became a glamor queen, recorded the emotional grimaces made before a mirror and a camera, comparing these two images of self-consciousness. (How often have we all "practiced" for some scene or confrontation to see how we'd look when? Or dressed up or changed our hair with only ourselves as appreciative audience?)

Wilson discovered during this period that "artmaking is an identity-making process. . . . I could generate a new self out of the absence that was left when my boyfriends' ideas, my teachers', and my parents' ideas were subtracted." When she and Jacki Apple met, they found they had been working in a similar direction and they began to collaborate, creating "Claudia: a composite person who exists in the space between ourselves, a fantasy self—powerful, gorgeous, mobile—who is the result of the merging of the realized and the idealized self."

One Saturday, six New York women who shared this "fantasy of omnipotence" dressed up fit to kill and lunched at the Plaza as Claudia; then they took a limousine to the SoHo galleries, engendering admiration and hostility along the way. "By manipulating elements from the culture to our own ends," they discovered an expansion of the self, "power over destiny, choice of and responsibility for one's own actions."

"How others see me" and "how I see myself" are two of the basic themes that lend themselves to Conceptual media. Makeup (Pretend) is in turn one of the basic tools. In 1972, "Léa's Room" at the Cal Arts Feminist Art Program's *Womanhouse* was occupied by a lovely young woman sitting before a mirror, day after day, putting on makeup, wiping it off in discontent, beginning again, dissatisfied again. When Apple had herself "redone" as an artwork at a department store in a free cosmetic advice session, she came

out looking just as she makes *herself* up. A fashion designer already equipped with a strong sense of identity, she works mainly with the effects of disguise on other people, or in relationship to herself. She has concentrated on three themes: "Transfers/Exchanges (exploring [Freud's idea of] the four people in every relationship between two)"; "Identity Exchange (changing roles with another person)"; and "Identity Redefinition (many views of myself as defined by others' perceptions)." Wilson and Apple solicited opinions about themselves and their appearances from acquaintances and documented them, evolving a new form of the self-portrait.

The effect of events or the personality of others (especially relatives) on oneself is a major aspect of this concern. Nancy Kitchel, who has worked frequently with secrets and disguises, has made two pieces involving her complex interaction with her mother—one documenting changes in the artist's physiognomy during a visit home, and the other an eerie telephone tape "seen" by earphones. She also made a series of photographs—*Identity Piece I*—showing the gestures and mannerisms she had inherited from her "rebel grandmother." These pieces led Kitchel "to think that the mental processes of one person are available to another through physical clues and can be at least partially understood through the reenactment or re-creation of . . . physical attributes."

Since then Kitchel has continued the *Identity Piece* series and has worked on *The Intruders*—"pieces which refer to penetration anxieties, jealousy, rejection fears, and territorial concerns." Two of the most poignant of *The Intruders* pieces deal with the exorcism—first literal, then figurative—of the women who were with her husband after she was, and with her lover before she was.

Exorcism—of an imposed sex role, of authority figures, of social expectations, or of childhood hang-ups—might in fact be said to be the subject of much of these artists' work. For instance, a much more drastic example of disguise was offered by Adrian Piper in the *Catalysis* series, which involved her appearance in public looking "mutilated" in some way: riding the subway in clothes that had been soaked for a week in a mixture of wine, cod liver oil, eggs, and milk, or with her clothes stuffed with Mickey Mouse balloons; in the Metropolitan Museum blowing gum bubbles and leaving the remains on her face; in a library with tape-recorded burps going off every few minutes. At the time of the action she neither talked nor provided any explanation to passersby for



her bizarre conduct, though later she substituted conversation for costume as her instrument. No immediate distinction was thus made between art and madness except in her writings, published in art contexts.

Among other things, she was protesting that art was imprisoned within its own world and did not reach into the real world: "I needn't live my art-object life in the presence of an art audience in order to make it aesthetically valid, although I did when I went to art school and presented and discussed my work with teachers." She realizes that being a woman (and of mixed racial background, though seemingly white) has a great deal to do with this aggressive use of her own face and body to disorient society. "At times I was 'violating my body'; I was making it public. I was exposing it. I was turning me into an object," but an object that was rebelliously more repellent than attractive. Also relevant is the fact that Piper was once a model—the epitome of professional role-playing, of the transformation of a woman into whatever someone else thinks she (and everyone) should look like, with the resulting loss of identity. Still in her twenties, Piper is now on scholarship at Harvard, getting her doctorate in philosophy, a field she has found "siphons off all my abstractions," and makes her "feel much more concrete" about her art.

All of this work may be seen as the visual counterpart of the "confessional" and "diaristic" literature that many women writers so unjustifiably disavow. The artists claim it in defiance of what is expected of art and of them. Although clearly related to conventional self-portraiture and straight photography (Diane Arbus' work, for instance), as well as to literature, the examples here belong in the flow of an expression at one less remove from real life, real time, real experience, than the traditional fine arts. If narcissism is not always redeemed by esthetics, these artists have, nevertheless, brought a flood of psychological insights to the nature of all art as a transformational process, to the relationship between artwork and artist. Art is, after all, a fantasy, for all its imagined "new realisms," and the artist is a fantasy figure made up by herself/himself in collaboration with society and legend.

# Points of View:
# Stuart, De Mott,
# Jacquette, Graves *

Michelle Stuart impregnates fields of paper with the spirit
of a place, making low reliefs by pounding her surfaces with
rocks, then coloring and polishing them with powdered
earth pigment. Helen De Mott peruses scientific literature
for visual stimuli, stands on piers and beaches, studies and
charts water surfaces and wave structures for her paintings
and video tapes. Yvonne Jacquette, from a small plane, re-
cords her dual experience on and over the land, noting shifts
in color, shape, angle, and atmosphere for larger canvases.
Nancy Graves, working from satellite photographs and maps,
converts still greater distances into dense tapestries of
stratified color and space.

These women are explorers of a new landscape art. Their
"paintings" combine the esthetic and sensuous attraction to
natural phenomena characteristic of the traditional land-
scapist with the abstract perception of the contemporary
artist and a greed for information inspired by scientific re-
search. Using overlay and exchange, they make work that
is both specific and general, both confined to an object and
implying gigantic spans of geological time, galactic space—
micro- and macrocosmic views of nature. Their methods in-
clude notation and fragmentation, the notion of the map
and the network, the relationship of part to whole. While
each of these artists is very different, they all relate ob-

---

* To be published in a shorter revised version by *Ms.* (1976).
All quotations are from the artists unless otherwise cited.

Michelle Stuart: *Niagara Gorge Path Relocated.* 1975. Artpark, Lewiston, New York. Rocks and earth from site, muslin-backed rag paper. 420' × 62".

sessively to the earth and to the sea—not as places to conquer, but as places to identify, and perhaps to identify with, forming an associative web of factual and visual material.

<center>⚬</center>

Stuart's large scrolls, small "rock books" and site pieces, and her layered prints on beaten, tinted paper, are transferals from her own life and from the life of the earth's surface. As a child, she traveled in the dry interior of southern California with her father, an engineer looking for water and damsites. Later she lived in Mexico, where the Indian

culture is still in touch with the earth and its mythologies. Still later she discovered the arid history of New Mexico and its early inhabitants. Having supported herself for several years as a topographical draftswoman, the surfaces and contours of mapmaking eventually made their way into her art; earlier erotic drawings and box sculptures evolved into lunar landscapes and finally into a more abstract style, still determined by a sensuous accord with the land. While the figure has long since disappeared from Stuart's work, there is a clear relationship between the female body and Mother Earth in her paper pieces, not only in the physicality, the rhythmic rubbing, of the working process (hard labor; the body too is a place) but in the tactile surface that results. This is particularly noticeable in those pored and pocked expanses that are colored by pinkish and reddish powdered rock. At exhibitions, she says, "people creep up and touch. . . . As the paper becomes worked, to me it feels like skin, the most delicate, soft, and warmest of surfaces."

Stuart's interest in geology is recorded in a private book (or diary) of brief texts, photographs, and old postcards of places close to her; it is called *Return to the Silent Garden,* and its subject is "folds, faults, intrusions. . . . The earth lives as we do, elastic, plastic, vulnerable. . . . [Rock is] bone under the flesh of soil in the body of earth. . . . Stone is self. Return stone to land. . . . The only way to reach is by repetition, all the rocks make a mountain, all the sand and gravel a desert, repetition is unbounded it has no time no end. . . ." She sees her art as connected to ancient rituals—finding the rocks that represent the place, crushing them, grinding them, merging them with the heavy absorbent paper (mounted on muslin for strength). At work Stuart resembles a primitive woman at her daily chores. When the scrolls are completed, they are a microcosm of the huge time and space that produced their components. Eight to ten feet tall, they loom over us, but they also roll welcomingly out to embrace us, hiding their continuity in a roll of paper on the floor. Stuart transforms the horizontal viewpoint (landscape, map) to the vertical (art or pictured view); the horizontal process (rubbing, polishing on the floor) to the vertical experience (standing before them as we might stand under a cliff and stare at its complex facade), and the result is a curiously delicate reflection of vast volumes, intensely conveying the earth magic that attracts her.

Recently the more intimate medium of the book has pre-

occupied Stuart. Now the "pages," or strata, can be handled, touched, stroked, caressed by the viewer as well as by the artist. The secret aspect of a book, the need to open it, to explore it in time, also appeals to her, as well as the visual metaphor relating back to the way the earth was formed, and the literary metaphor relating to knowledge, narrative, though in this case it is sensuous knowledge that is offered. The pages of the "rock books" are frequently stained, ragged, sometimes fringed. The paper has been torn so that dark stains invade its pages like gullies and crevasses in the earth, or for that matter, like aerial views of rugged country. They are often tied with a dusty string, like a gift. In these, as in the large works, a specific place becomes a general surface; and at the same time, a general concept of nature and space is contained within a specific field of vision.

°

Helen De Mott was for many years a relatively conventional landscape painter. One of her favorite subjects was the sea, but as she became dissatisfied with a merely exterior approach, she began to draw "just the ocean" as a wall of water, and then to delve into the essential components of wind waves, their mathematical and physical properties, their molecular structure—the wave from "inside and outside." In 1968 her researches yielded the symbol which has been the core of her wave canvases—the open square—the square and the ellipse within the square in latticelike structure, which is the crystalline structure. This in turn led her to more theoretical wave theories of the liquid state, which include "the hole theory, the tunnel theory. . . . jumping spaces." She has worked out a kind of equation: "The open square equals the wave FORM; the white lines of writing [the interstices] equals ENERGY (kinetic and potential); the color equals the FIELD (water)."

From this module, De Mott has developed a series of paintings on the spilling wave, on the tidal bore, on river waves. Her increasing knowledge of the physics of wave motion consistently confirms what first occurred to her solely through a painter's intuition. "What interests me totally," she says, "is the description of a physical reality, a physical reality that I find happens to be bonded by mathematical validity. Wind waves at sea can be seen, heard, tasted, and touched. Something of this tactile quality must come through in the paintings, or they will become merely dry diagram-

Helen De Mott: *Wind Force Five* #2. 1969. Oil on canvas. 72″ × 96″.

matic exercises." It does, and they are not. *Wind Force Five,*
for example, conveys not only an accurate translation of
oceanographic conditions, but also the beauty and com-
plexity of how the particles' activities come to represent the
flow and fullness of all oceans.

Like the surface of the earth, the surface of water is al-
ways the same and always different. The universal human
fascination with watching waves break and water flow is De
Mott's subject. The wave ("a *state* of matter and not matter
itself") incorporates the whole life cycle—growth, peak, decay.
Where Stuart's earth surfaces encapsulate distant time but
are embodied by a fragile, impermanent material, De Mott's
canvases encompass the most mobile of the elements, but
do so in a static medium. She finds that this, paradoxically,
gives her paintings "more mobility: The information can't
be linear; it has to be contrapuntal." The fragments must
imply the whole. "Once you delve into the structure, it be-
comes *more* descriptive of what you see than before, so I
know the motif is valid, sound. I walk to the pier, look at
the water, and get pictorial ideas because I know what the
structure is. I'm trained to see, and I see."

De Mott has recently been working at the Henry Street
video workshop because the hypnotic quality of video tape,
and its "grayness," are perfectly suited to her subject. Video
exists in time, like music, and is itself the product of wave
action, of rhythm, motion, light, and sound. The breaking
of surf on a beach is the result of vibrations, the same vibra-
tions that occur when a cellist bows his instrument (a
comparison subtly expanded upon in her tape *Wave Notes*).
Musical notation, De Mott has found, also visually resembles
the plotting of tidal records and wave breaks. Her two video
tapes, which will be shown simultaneously on two monitors,
interweave these associations and facts from the physical
world and the world of the arts, offset by a marvelous text
by Leonardo, historical epitome of such a conjunction. The
long shots of water surfaces patterned by light and move-
ment eerily reflect her paintings and drawings, which bear
only structural references to their source.

Next, De Mott wants to approach the human body, to
work with a dancer, to explore what seem to be the endless
possibilities in wave motion. She has found a metaphor with
which to see the world, and equates her feeling as a painter
of ocean waves with that of the mathematician and the
surfer: "For a mathematician a wave is a solution to a wave
equation, the means by which the motion of a medium can

be described by a single quantity—the wave amplitude. For the surfer, the wave is an allegory of life and creation—when you are in the center of a wave, it is like being in the center of the world."

 ❖

For two years now Yvonne Jacquette has been going up in a small plane during her summer stays near Belfast, Maine, and making photographs, pastels, and pencil notations of the land below that later articulate the completed canvas. Her involvement in aerial landscape began with several years of painting clouds, first from the ground and then on a jet trip to California as seen from the window of a jet. A paucity of clouds forced her to concentrate on the layers of atmosphere and the ways they affected the land and transformed its image. The first series of pastels were framed by the distinctive shape of the plane's window, but the next summer, when she began chartering a small plane and pilot and was "right *out* there," the inside-outside framework disappeared. Because of the speed of the jet, Jacquette was first forced to make composite landscapes, sketching an interesting aspect of the land, then filling it in, then waiting for another site to come along that would work with the previous one. In the single-engine plane she was able to circle her selected site and found this far more satisfying: "One place has its own reasons, its own sense of existence." Now she superimposes what she knows of the ground (from walking there, from knowing what the spaces or buildings are used for) upon what she sees from the air: "It's like having a mental map in my head." Knowing the feel of the place from both points of view, she is able to combine intimacy and distance, experience and memory of experience.

When Jacquette first began flying, she painted from a totally vertical viewpoint, looking directly down and making, in effect, a map. When she began to augment sensory information with government mapping data, she realized that this was too abstract and flattened, that she wanted a sense of more literal space, so she began to tip the maps, made a shelf, studied them from different angles, "practicing" seeing from a plane, from new perspectives. *Passagassawakeag* —the major painting to date—is seen from a vertiginous tilt that brings the viewer to the landforms below in a far more engaged manner than a vertical viewpoint would. The horizon curve, known from greater heights, is retained, and the background is somewhat blurred, by speed as much as by

Yvonne Jacquette: *Passagassawakeag VII.* 1975. Oil on canvas. 56″ × 64″.
Photo: Rudy Burckhardt.

distance perception. The brilliant blue river curve literally *plunges* toward the viewer, toward the sea, formally withheld only by two bridges and a group of bobbing boats which, for this reason, are larger than in reality.

The height of flying is important. In a jet "you have a sense of *more* than the land, of other forces." But colors gray out at extreme heights, so she prefers the small plane's one thousand feet. Flying has had other than conceptual

effects on her style; in earlier cloud paintings, interiors, and cityscapes she had used a smooth realist technique. After working from the air, the actual vibration of the plane and the atmospheric veils led her toward a more painterly, pointillist technique, even though the canvases remain extremely compact, tightly knit, compositionally intricate. The way things look from a plane makes Jacquette "want to break things down into small parts," and this has affected the paintings she does in the streets as well: "Even the buildings aren't so solid anymore, they're more *relative*." The cinematic aspect of flying and drawing also appeals to her; she has made one film—*Sunline*—and wants to make more. The multiple viewpoint (as the plane moves over and around a site) and the difficulties of tying down into a single image what is in fact a series of impressions, of emphasizing the sensation of being aloft (those slight shifts of viewpoint, the circling, the zeroing in), combined with the study of the stereo photo-pairs in the United States Military Academy's *Atlas of Landforms*, which has fascinating juxtapositions of maps and photographs, have led to her latest project—a pair of paintings of the same site, differing perhaps fifteen percent in angle, and in light and/or color.

In addition to the two-dimensional work, Jacquette has made several small, pale, flesh-colored clay reliefs of aerial city views—paradoxical in that they are three-dimensional versions of what is seen two-dimensionally, horizontal views of the vertical which are then placed vertically on the wall to become "pictures" (though she now plans to make some intended to be looked down upon, and will work from them). The sculptural and sensual perception of the landscape was an important impetus in the development of her aerial work. When she first began flying, she had a very strong impression of the body part associations in the land below; sometimes they were obvious and sometimes she would realize them only later, in a dream. Now Jacquette will combine this insight with the aerial view as a "visual way to understand human and geographical systems, and their interdependence." She wants to balance this aspect and the "more primitive responses: color, shape, volume, and space" —a process that she feels she is just beginning, despite two years of painstaking work.

°

The aerial angle produces a multiple viewpoint also found in Chinese Sung landscapes, where atmospheric depth was

eliminated, but different perspectives were used convincingly to impart all the vital information about each landform and its spatial envelope. Nancy Graves is similarly concerned with movement and light, different layers and levels of density, the relationships of parts to wholes. In her case, the result is more abstract than Jacquette's; she has made some of the opposite decisions, choosing to work, for instance, from maps and highly technical NASA satellite photographs without the element of direct experience. Graves responds formally, at one remove, though her technique, after a delicate pointillist period, has become increasingly dense and painterly. Like De Mott, Graves is intelligently aware of scientific data in her current "field"; like Stuart, she is interested in anthropology and natural history and is able to work from both "primitive" and "scientific" sources. Her earlier work includes a large series of lifelike camel sculptures; later abstract "fetishistic" work simulated bones, feathers, skins, and twigs.

Graves has made five films. The three major ones are on the camel (*Izy Boukir*), on two species of birds with different shapes, colors, and flight patterns (*Aves*), and on the lunar surface as seen by a camera moving over several hundred black-and-white still photographs taken from the Lunar Orbiter (*Reflections on the Moon*). Her interest in light and motion, which also led her into film, has encouraged an approach in terms of fragments, overlays, series. One group of "shaped relational" canvases from 1974 consists of several bandlike panels attached to or spaced near each other to form eccentric diagonal outlines on the wall. They are drawn directly from catalogues of Nimbus weather satellite photographs in which cameras responding to different aspects of day/night transitions took simultaneous pictures. Graves selected those with more eccentric contours, where the cameras "made more mistakes." The rather harsh juxtaposition of unlike elements is a challenge she sets out for herself in most of her paintings. For instance, a very large new work, *Painting: U.S.A.*, in a Department of the Interior Bicentennial exhibition, deals with drastic changes of scale. A map of the United States is shattered and reconstructed in four large panels; different areas are seen from extremely varied distances so that the eye bounces back and forth over the fluctuating spaces, from a hazy map shape to the sharp focus path of the Mississippi River, to compartmented details of a single place, then back out into a wholly different

section of the continent. The painting does not resemble a map, its underlying accuracy having been sacrificed to a supralogical fragmentation that puts itself together again as "elsewhere."

Using a slash-and-point technique that becomes freer and freer, Graves creates levels of density that are rearticulated but never totally remeshed, paralleling the rapidly moving, serially snapping process of the satellite cameras from which she garners her raw material. Thus her view of nature, despite its basis in fact, does not reproduce actual experience of land, water, ice (she is fond of such *terrae incognitae* as the moon, Antarctica, Mars, ocean beds measured through water from huge heights). Its point of departure is technology, shifted and "fictionalized" into unfamiliar visualizations. As Robert Arn has remarked, Graves might have chosen to work from maps because they "so obviously are both figurative and non-figurative representations, but equally, abstractions designed to emphasize certain classes of information" (*Artscanada,* Spring 1974).

✿

Like all of these artists, Graves is interested in the way the earth and sea have been seen and traveled over the ages. She has written about the wooden pocket maps whittled by Eskimo fishermen to show how many bays from home they are: "It is simply their shapes—the feel of them—that makes them maps. . . . A good map has mastered the complexities of nature and idea and resolved them so as to form a necessary—utilitarian—design." "Art," on the other hand, also has another function—content. The central Australian aborigines made colored drawings (originally on the ground and on bark, now on canvasboard) which resemble the most advanced Western abstract paintings. Actually, they map the conjunction of place and event; tribal past is tied to the present. At the same time, to the inhabitant of that small area of desert, hills, treelines, watercourses, and water holes, the pictures are totally recognizable in their geographical specificity. Another tribe, farther south, made small carved sticks called *toas* as indicators, signposts to those coming after the maker, but also as commemorations of natural features or episodes (a shooting star, a snake aroused, an emu sleeping) occurring during the legendary wanderings of a group of half-human, half-supernatural beings called *Mura* who, having risen from the earth, first

gave the places their names. These, and the bamboo and shell charts made by native Pacific navigators, and endless other so-called primitive arts, record the ways in which humans have tried to cope with nature, and to *remember* nature, for maps are tangible, visible memories.

Such art is a model for the work discussed above in the sense that Stuart, De Mott, Jacquette, and Graves have all rejected the kind of sterility much recent abstraction has fallen into and have gone "back to nature" for content. At the same time, they are aware of and using their own contemporary knowledge of their environments. Not coincidentally, all four have moved outward from conventional art in another sense. In the summer of 1975, Stuart made *Niagara Gorge Path Relocated,* a temporary commemoration of the original site of Niagara Falls, at Artpark, a state park where the audience is made up of ordinary family tourist hordes rather than the usual middle-class culture seekers. De Mott has made two outdoor murals based on the river wave, to recall to inner-city dwellers that Manhattan is in fact surrounded by rivers and faces the Atlantic. Jacquette for some time has worked *en plein air* amid the raunchy crowds of East Fourteenth Street, and they became a real part of her in-process audience. Graves has worked with specialists at NASA, in observatories, in science museums, and her films are shown to public high school audiences as well as in museums. The fact that these artists are concerned with more or less scientific information coming from outside the art world has brought their work naturally rather than self-consciously into the public domain. Yet for all that they have in common, each of the four emphasizes a different aspect of nature, and different aspects in different ways and to different degrees, so that their art, when brought together, has little visual similarity. Like their subject matter, they are all the same at the same time that they are all different.

# The Pains and
# Pleasures of Rebirth:
# European and American
# Women's Body Art*

When women began to use their own faces and bodies in photoworks, performance, film, and video, rather than being used as props in pieces by men, it was inevitable that body art would acquire a different tone. Since 1970, when the women's movement hit the art world, it has; and the questions it raises concern not only form and content, but context and political climate. Although the Western world is habitually considered a cultural whole, varying points of view on women's body art have emerged on both sides of the Atlantic, on the two American coasts, and particularly from the two sexes.

I have no strict definition of "body art" to offer, since I am less interested in categorizing it than in the issues it raises and in its relationship to feminism. Early on, the term body art was used too loosely, like all art labels, and it has since been applied to all performance art and autobiographical art rather than just to that art that focuses upon the body or body parts—usually the artist's own body, but at times, especially in men's work, other bodies, envisioned as extensions of the artist him/herself. The differences between men's and women's body art are differences of attitude, which will probably be neither seen nor sensed by those who resist or are simply unaware of the possibility, and ramifications, of such an approach. I am not setting out, therefore, to draw any conclusions, but to provoke thought and discussion about

* Reprinted from *Art in America*, 64, No. 3 (May–June 1976).

sexual and gender-oriented uses of the body in Conceptual Art by women.

As Lea Vergine has pointed out in her book *Il Corpo Come Linguaggio* (Milan: Prearo, 1974), body art originated in Europe, although not with the expressionist happenings of the sadomasochistic Viennese school in 1962, as she states, but with Yves Klein's use of nude women as "living brushes."[1] In the U.S., something like body art was an aspect of many happenings from the late 1950s on, but bodyworks as entities in themselves only emerged in the late 1960s as an offshoot of Minimalism, Conceptualism, film, video, and performance art. Virtually no women made body art in New York during the late 1960s although it was an important element in the overall oeuvres of Carolee Schneemann, Yayoi Kusama, Charlotte Moorman, Yvonne Rainer, Joan Jonas, and others. In the early days of the new feminism, the first art by women to be taken seriously and accepted into the gallery and museum structure rarely differed from the prevailing, primarily abstract styles initiated by men. If it did reflect a different sensibility beneath an acceptable facade, this was hardly noticed by either men or women.

Bodyworks by women, and art dealing with specifically female and feminist issues, materials, images, and experience, no matter what style they were couched in, became publicly visible with more difficulty than mainstream art and have therefore acquired a "radical" image in some circles. Although such "women's work" eventually suffered a brief vogue, it was initially considered clever, or pretty, but not important, and was often relegated to the categories of naïve art, or craft. This, despite the fact that the autobiographical and narrative modes now fashionable were in part inspired by women's activities, especially consciousness raising. Indeed, since much of this women's work came out of isolation and feminist enclaves, rather than from the general "scene," and since it attempted to establish a new iconography, it was justifiably perceived as coming from an "other" point of view, and was frequently labeled retrograde for its lack of compliance with the evolutionary mainstream.

In a parallel development, the concept of "female imagery"

---

[1] The Gutai Group in Japan also made similar events in the late 1950s and Carolee Schneemann's *Eye-Body* (Nude in Environment) dates from 1963.

arose on the West Coast through the ideas and programs of Judy Chicago and Miriam Schapiro. The initial notion (central-core abstraction, boxes, spheres, ovals) emphasized body identification and biologically derived forms, primarily in painting and sculpture. It met strong resistance when it reached the East Coast, and in New York—the Minimal/Conceptual stronghold—these images were diffused into more deadpan styles and "avant-garde" media. Nevertheless, all kinds of possibilities were opened up to women artists here who had recently espoused feminism, wanted change in their art as well as in their lives, and were mustering the courage to deal publicly with intimate and specifically female experience. If the results on the East and West coasts were somewhat different, the motivations were the same. Now, six years later, body art combined with a feminist consciousness is still considered more subversive than neutralized art by women that ignores the sexual identity of its maker and its audience.

In Europe, on the other hand, the opposite situation seems to have developed. "Neutral" art made by women still has little chance of making it into the market mainstream, while the male establishment, unsympathetic to women's participation in the art world as equal competitors, has approved (if rather patronizingly and perhaps lasciviously) of women working with their own, preferably attractive, bodies and faces. Most of the handful of women artists who currently appear at all in the vanguard European magazines and exhibitions deal with their own faces and figures. This was borne out by last fall's Biennale des Jeunes in Paris. I have been told that both the male editor of an Italian art tabloid and a male French neo-Duchampian artist have discouraged women from working in any other area by publicly and powerfully applauding women's art that limits itself to these areas. Perhaps, as a result, female critics like Catherine Francblin have had negative reactions to women's body art. In an interesting article in *Art Press* (Paris, September–October 1975), she sees it as a return to infantilism and an inability to separate one's own identity from that of the mother, or subject from object. She blames these artists for "reactivation of primitive autoerotic pleasures. For what most women expose in the field of art . . . is just the opposite of a denial of the woman as object inasmuch as the object of desire is precisely the woman's own body."

The way I see it—obviously controversially—is that due to their legitimate and necessary desire to affirm their female

experience and themselves as artists, many European women have been forced into the position of voluntarily doing what the male establishment wants them to do: stay out of the "real world" of sales and seriousness. To extricate themselves, they have the tragic choice of rejecting the only outlet for their work (the magazine and museum systems) or of rejecting their feminist consciousness and its effect on their work and, by implication, rejecting themselves. This does not affect the quality of the art being made, but it does crucially affect how it is perceived and interpreted by the general audience.

The alternative, of course, might be the foundation of art outlets based on solid political feminism, but this too is difficult in a culture where Marxism has successfully overrun or disdained feminist issues, so that the apolitical artist has no place to turn and the political artist has only one place to turn. One does not call oneself a feminist in polite art society in Europe unless one wants to be ridiculed or ignored. All of this must be partially due to the lack of an organized feminist art movement in Europe and of any alternative galleries or magazines for women artists. In the resultant void, middle-class, generally apolitical women have ironically become the sole purveyors of what, in another context and with a higher level of political awareness, might be seen as radical feminist imagery. This happens in the U.S. as well, but here at least there is a broad-based support and interpretative faculty provided by the women's movement.

It is no wonder that women artists so often deal with sexual imagery, consciously or unconsciously, in abstract and representational and conceptual styles. Even now, if less so than before, we are raised to be aware that our faces and figures will affect our fortunes, and to mold these parts of ourselves, however insecure we may feel about them, into forms that will please the (male) audience. When women use their own bodies in their art work, they are using their selves; a significant psychological factor converts these bodies or faces from object to subject. However, there are ways and ways of using one's own body, and women have not always avoided self-exploitation. A woman artist's approach to herself is necessarily complicated by social stereotypes. I must admit to a personal lack of sympathy with women who have themselves photographed in black stockings, garter belts, boots, with bare breasts, bananas, and coy, come-hither

glances. Parody it may be (as in Dutch artist Marja Samsom's "humorous glamour pictures" featuring her alter ego "Miss Kerr," or in Polish artist Natalia LL's red-lipped tongue and sucking "Consumption Art"), but the artist rarely seems to get the last laugh. A woman using her own face and body has a right to do what she will with them, but it is a subtle abyss that separates men's use of women for sexual titillation from women's use of women to expose that insult.

It was not just shyness, I suspect, that kept many women from making their own body art from 1967 to 1971 when Bruce Nauman was "Thighing," Vito Acconci was masturbating, Dennis Oppenheim was sunbathing and burning, and Barry Le Va was slamming into walls. It seemed like another very male pursuit, a manipulation of the audience's voyeurist impulses, not likely to appeal to vulnerable women artists just emerging from isolation. Articles and books on body art include frequent pictures of nude females, but few are by women artists.[2] Men can use beautiful, sexy women as neutral objects or surfaces,[3] but when women use their own faces and bodies, they are immediately accused of narcissism. There is an element of exhibitionism in all body art, perhaps a legitimate result of the choice between exploiting oneself or someone else. Yet the degree to which narcissism informs and affects the work varies immensely. Because women are considered sex objects, it is taken for granted that any woman who presents her nude body in public is doing so because she thinks she is beautiful. She is a narcissist, and Acconci, with his less romantic image and pimply back, is an artist.

Yet Vergine has noted that, "generally speaking, it is the women, like Joan Jonas, who are the least afraid to know their own body, who don't censor it. They make attempts at discovery beyond acculturation" (*Data,* Summer 1974). I must say I admire the courage of the women with less than

---

[2] This continues. Max Kozloff's "Pygmalion Reversed" in *Artforum* (November 1975) is the latest example. A few women body artists are mentioned and no women are reproduced in twelve illustrations. He also seems unaware of the existence of a large selection of such art by women and complains that there are "very few artists exploiting dress, ornament and headgear. . . ."

[3] In the course of my research in European art magazines I found: a woman with her blouse open, a woman's body signed as art, a woman with a gallery announcement written on her two large bare breasts, a provocative 1940s pinup captioned "Subscribe to me —I'm Extra" to advertise an "artists' magazine" of that name.

*Glamour Girl* ✳

beautiful bodies who defy convention and become particularly vulnerable to cruel criticism, although those women who *do* happen to be physically well-endowed probably come in for more punishment in the long run. Hans Peter Feldmann can use a series of ridiculous porno-pinups as his art (*Extra*, No. 5), but Hannah Wilke, a glamor girl in her own right who sees her art as "seduction," is considered a little too good to be true when she flaunts her body in parody of the role she actually plays in real life. She has been making erotic art with vaginal imagery for over a decade, and since the women's movement, has begun to do performances in conjunction with her sculpture, but her own confusion of her roles as beautiful woman and artist, as flirt and feminist, has resulted at times in politically ambiguous manifestations that have exposed her to criticism on a personal as well as on an artistic level.

*Body Beautiful* ✳

   Another case in point is Carolee Schneemann, known in the early 1960s as a "body beautiful" because she appeared nude in Happenings—her own as well as those of Oldenburg and others, though for years she was labeled more comfortably "dancer" than "artist"—"an image, but not an Image-Maker, creating my own self-image" (1968). Her work has always been concerned with sexual (and personal) freedom, a theme still generally unacceptable from a woman; she intends to prove that "the life of the body is more *variously* expressive than a sex-negative society can admit. I didn't stand naked in front of 300 people because I wanted to be fucked, but because my sex and work were harmoniously experienced [so] I could have the audacity, or courage, to show the body as a source of varying emotive Power (1968). . . . I use my nude body in *Up To and Including Her Limits* [a recent mixed-media performance in which Schneemann reads from a long scroll removed from her vagina] as the stripped-down, undecorated human object (1975). . . . In some sense I made a gift of my body to other women: giving our bodies back to ourselves. The haunting images of the Cretan bull dancer—joyful, free, barebreasted, skilled women leaping precisely from danger to ascendancy, guided my imagination" (1968).[4]

---

[4] The 1968 quotations are taken from Schneemann's book *Cézanne She Was a Great Painter* (1975); the 1975 quotation was from another self-published book, *Up To and Including Her Limits* (1975).

A similarly defiant narcissism or "vulgarity" resulted when Lynda Benglis confronted the double standard head on in some advertisements for herself, which provided the liveliest controversy the art world has had for years. A respected sculptor (whose imagery is, incidentally, as abstract as it is sexual[5]) and video artist (whose imagery is autobiographical and autoerotic), she published a series of photographic ads that included: herself in a Greek boy's skirt; herself leaning Butch on a car; herself as a pinup in a famous Betty Grable pose, but with her jeans dropped around her ankles; and finally—the *coup de grâce*—herself as a greased nude in sunglasses, belligerently sporting a gigantic dildo. The uproar that this last image created proved conclusively that there are still things women may not do. The notion of sexual transformation has, after all, been around for some time. No such clamor arose in 1970 when Vito Acconci burned hair from his chest, "pulling at it, making it supple, flexible—an attempt to develop a female breast," then tucked his penis between his legs to "extend the sex change," and finally "acquired a female form" by having a woman kneel behind him with his penis "disappearing" in her mouth (*Avalanche*, Fall 1972).[6] Nor was there any hullabaloo when Scott Burton promenaded 14th Street in drag for a 1969 Street Work, or when he flaunted a giant black phallus in a static performance in 1973; or when William Wegman made his amusing trompe-l'oeil "breast" piece (on video, with his elbows); or when Lucas Samaras played with himself in front of his Polaroid camera.

It has often been remarked that body art reflects the "role crisis" in contemporary life. The urge to androgyny, in fact, has been frequently expressed by artists of both sexes, although more often by men than by women (odd, given the advantage of being male in this society, but not so much so when one sees it as a result of "birth envy"). Urs Lüthi, the  Viennese who makes campy transvestite photodramas starring himself, says that ambivalence is the most significant aspect of his work, and that he sees himself as a stranger. Katharina

---

[5] Benglis' wax totems are acknowledged labial imagery; her sparkle-covered knot pieces are named after strippers and all the knot pieces have sexual connotations.

[6] Susan Mogul, in Los Angeles, has made a delightful feminist parody of Acconci's masturbatory activities in her vibrator video piece.

Sieverding, in Düsseldorf, has made photoworks on "Aspects of Transvestism," which she sees not as a pathological phenomenon, but as "communications-material," exposing roles, repression, ambiguity, possibility, and self-extension; "The conquest of another gender takes place in oneself" (*Heute Kunst,* April/May 1974). Such a positive approach has more in common with the traditional (Platonic, Gnostic, etc.) myth of the androgyne as two in one, "the outside as the inside and the male with the female neither male nor female,"[7] than with contemporary art's emphasis on separation over union of the two sexes. A woman working with androgyny these days would not be "accused" of being a Lesbian because gay women clearly no longer want to be men, but see themselves as the last word in woman-identified women.

In 1972 in Halifax, Martha Wilson made a "drag" piece in which she transformed herself into a man, and then into a man dressed as a woman. In Montreal Suzy Lake transforms herself into her friends, both male and female, in two stages—cosmetic and photoretouching. In *Suzy Lake as Gary Smith,* the documentation is organized "with reference to a binary logic: The first row = female, augmentation, transformation done on the actual subject; the second row = male, diminution, transformation done at a distance on the photo image" (Paul Heyer in *Camerart,* Montreal: Galerie Optica, 1974). In "Annette Messager, Collector"'s albums of found photographic images from women's lives, she has created *femmes-hommes* and *hommes-femmes* where the disguise is lightly laid over the dominant characteristics; men are still men (although with long lashes and red lips) and women are still women (although with beard and moustache). Jacki Apple's *Identity Exchanges, Transfers,* and *Redefinitions* also involve impersonation of both sexes and "the relationship between the many views of a single person and the varying positions of the viewers to the object" (catalogue of *c. 7500,* 1973). Eleanor Antin's several art personae include one man— the seventeenth-century king, in whose beard, boots, cape,

---

[7] This is a quotation from Gnostic mysticism in "The Myth of the Androgyne" by Robert Knott (*Artforum,* November 1975). The subject is also treated in the same issue by Whitney Chadwick, who notes that throughout the nineteenth century "the myth of 'the man/woman' . . . emblemized the perfect *man* of the future" (my italics), thus absorbing the female altogether, which seems to be the point of most male androgynous art.

and sword she visits her subjects on the streets of Solana Beach, California. Adrian Piper too has a male ego—the "Mythic Being," with Afro, shades, and moustache, who also walks the streets, in a continuation of Piper's several years of exploration of the boundaries of her personality; ("The fact that I'm a woman I'm sure has a great deal to do with it . . . at times I was 'violating my body'; I was making it public. I was exposing it; I was turning me into an object . . ." *The Drama Review*, March 1972). Dressed as the Mythic Being, she reenacts events from her own life but experiences them as a man. One of the many things the Mythic Being means to his creator is: "a therapeutic device for freeing me of the burden of my past, which haunts me, determines all my actions . . ." ("Notes on the *Mythic Being*, I," March 1974).

For the most part, however, women are more concerned with female than with male roles and role models.[8] Ulrike Nolden Rosenbach (Germany) has made a series of video tapes of herself dressed in the high hat, or *haube*, worn in the fourteenth century by married women and in the Renaissance made a symbol of self-confidence and equality; she uses it "to transcend the conventional erotic context of contemporary women." In a 1974 performance called *Isolation Is Transparent*, dressed in a black net leotard, she combined erotic "coquetry with the female body" and "man's work with hammer and nails," weaving a rope skirt around herself from the corners of the space until she became "the center of the earth" (*Avalanche Newspaper*, May 1974). Also in performance, Marina Abramovic (Yugoslavia) recorded her reactions after swallowing pills intended to cure schizophrenia. Two cameras, one pointed at the artist and the other at the audience, emphasized the subject/object relationship and the perfectly natural desire to see yourself as others see you. Camera and video monitor have indeed become the mirrors into which for centuries women have peered anxiously before going out to confront the world. Cosmetics pieces were common in the early 1970s, when consciousness raising began to bring those mirrors out before public scrutiny. One of the early instances was "Léa's Room" in the Cal Arts Feminist Art Program's *Womanhouse* (1971), where a lovely young woman made herself up, wiped off the cosmetics, made herself up again, took them off again, dissatisfied.

---

[8] I have written on costume, autobiographical, and role-playing art by women in "Transformation Art," see pp. 101–108.

To make yourself up is literally to create, or re-create, yourself. In two color photographs of herself—*Perfection* and *Deformation* (1974) Martha Wilson explored her dual self-image, and did so again (fat and thin) in a black-and-white video variation in 1975, accompanied by the passage from *Alice in Wonderland* about eating mushrooms that make Alice large and small. Mary Beth Edelson has transformed her photograph into those of two admired role models—Georgia O'Keeffe and Louise Nevelson. Nancy Kitchel has also made "disguise" pieces and studied the physiological results of psychological stress on her own face in several "exorcism" pieces involving her family and love affairs. Athena Tacha has dealt with her family, heredity, and, in an ongoing piece called *The Process of Aging*, is cataloguing in detail its effects on her body. Annette Messager has drawn the ravaging lines of jealousy on a photographed face, while other women, among them Marisol, Yoko Ono, Joan Jonas, and Faith Ringgold, have used masks in the place of cosmetics.

The psychological emphasis, the need for a profound level of transformation of the self and of others, is subtly reflected in the work of two Italian women. Diana Rabito deals with "Retinal Cannibalism," "talking with the eyes," comparing in one piece the signs of hypertension produced in a woman's face to the *craquelure* of antique Chinese porcelains. Ketty La Rocca, unable to break into the male art world with her art or her writings, made a highly expressive book in 1971 using her hands ("they could not cut off my hands"). Until her recent death, she worked in a complex matrix of word and abstracted autobiography. Her *You, You* series shows her hands juxtaposed against X-ray images, presenting, for instance, the skull as a mask, the face as "pantomime made by language," the skull as fetal image with the hand—the language symbol—about to burst out of it, the image outlined by the handwritten word "you" repeated around its boundary.

Transformation is also the motive for cooler variations in which body is subordinated to art, exemplified by Martha Wilson's antiprurient *Breast Forms Permutated* (1972), in which nine pairs of breasts stare out of a grid, wondrous and humorous in their variety; or by Rita Myers' laconic *Body Halves* of 1971, where her nude photo is split vertically down the middle and reversed, revealing the minute discrepancies between the two halves; or by Antin's *Carving*, a series of clinically naked self-portrait photos documenting the artist's

weight loss. Austrian artist Friederike Pezold's video tapes use her body abstractly, but the most "ordinary" (i.e., not erogenous) zones, such as elbows, feet, knees, shoulders, evoke extraordinary images of sensuality—more erotic in their disguise than the parts simulated would be in reality. She

Ketty La Rocca: *You, You.* 1974. Photograph. 7″ × 8½″.

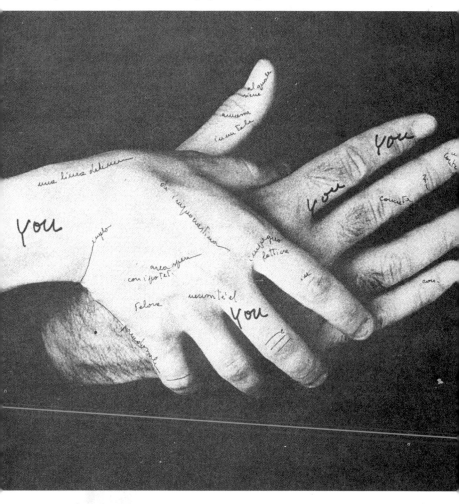

Friederike Pezold: *Between.* 1974/75. Photographs. 3½″ × 7″.

manipulates video monitor and subject to create patterns of light and dark that are pure form as well as bodyscape, landscape, shifting shapes on a surface. Lauren Ewing, in a video tape, also uses ambiguously defined body parts in a suggestive manner; fingers slowly erase the words "She was forced to consider the Message after it was over" from an apparently erotic zone.

From 1971 to 1974, French artist Tania Mouraud used the object-self/sex-object relationship in objective, philosophical statements illustrated by subjective autobiographical images and nude body parts, as in *Mine Not I, People Call Me Tania Mouraud. Which of These Bodies Are They Referring To?* Her photographic mandalas reached out from the center, which is herself, to concentric rings of family, friends, and increasingly distanced relationships or environments. Mouraud is an ardent feminist; however, in the last year or so, in response to the circumstances surrounding women's art in Europe, she has abandoned all female subject matter in favor of the same perception-word-concept form based on a wholly neutral vehicle—the wall.

Women do not often use men's bodies in their work, although Renate Weh (Germany) did a piece in which a man  is dressed and undressed like a paper doll, and Verita Monselles (Italy), who is trying in her photo series to "objectify woman's existential crisis, her rebellions against a codified behavior," has reached what she calls "the negative moment in her analysis" where man is represented as "a dummy, or as a son [also a doll] petrified in his privileges as a petty speculator exploiting mother love." Her work is particularly interesting because of its overt anti-Catholicism, a burning issue for Italian feminists. Hannah Wilke has also used one of the great symbols of male domination in her *Jesus Christ Supert-art* performance, although the feminist crucifixion aspect was intended to overwhelm the religious satire. Wilke has also made a *Samson and Delilah* video tape in which she cuts the hair of a former lover.

Men, however, when not using themselves, are using women. Vergine has written about the "acute gynephobia"  demonstrated in much male body art, and sees many of its manifestations as an "envy of the uterus as capacity for creation." Hermann Nitsch, in a destructive male imitation of the constructive female ability to give birth, smears blood and animal guts on himself and others, calling this a "birth

. . . like a crucifixion and resurrection together."[9] Stanislao Pacus seems to speak for many of his colleagues when he declares: "Woman annuls creativeness. She is the dualistic model of love-hate in which the artist loses himself and from which, with intellectual effort, he escapes. To reconquer his professional conscience the artist derides the loved-hated woman's nakedness" (Vergine, *op. cit.*). Vettor Pisani chains women in his performances and archaically equates the female with "darkness." Such statements are parried by Tania Mouraud, who has written that "Women, who create, know what creation is. I started to paint after bringing my daughter into the world; the male argument which sees the maternal sensibility as an obstacle to creation seems inverse. On the contrary, the male's fixation on his sex, the fundamental fear which animates him of one day finding himself impotent, has completely falsified the very notion of art. Women do not act out of fear, but out of love and knowledge" (*Actuel*, No. 3, 1974).

European men, less conscious of feminism than Americans and less intimidated by women's consciousness of themselves, are particularly guilty of exploitation of women's bodies in their art, but the U.S. is not far behind. Acconci has tied up and otherwise manipulated women psychologically and physically; James Collins, as his own voyeur hero, "watches" women as erotic objects on film; Roger Cutforth makes pallid films that use naked women as though we still lived in the Renaissance; Chris Burden has thrown burning matches on his wife's nude body in performance. In fact, it is difficult to find any positive image whatsoever of women in male body art.

Much of the work discussed above clearly rises from a neurotic dissatisfaction with the self. There are exceptions on both sides, but whereas female unease is usually dealt with hopefully, in terms of gentle self-exploration, self-criticism, or transformation, anxiety about the masculine role tends to take

---

[9] Nitsch, quoted in Max Kozloff (*op. cit.*). The Knott article (*op. cit.*) cites the relationship of androgyny and "countless fertility myths" that employ violent dismemberment. Chadwick (*op. cit.*) sees debasement of women and androgyny as ways male artists have used to "desexualize the female . . . as a defense against a severe castration anxiety," responsible for "violent attacks on the female's natural procreative functions"—from sadism to the making of art as competition with the mother and her ability to create the artist himself.

a violent, even self-destructive form. Acconci and Oppenheim
burned, scarred, irritated their own bodies around 1970;
Burden has taken the lead since then by having himself shot
in the arm, locking himself in a baggage locker for five days,
nearly electrocuting himself, nearly immolating himself, nearly
being run over, and so forth. Although lacking the horror-
show theatricality of the Viennese S & M school, the deadpan
masochism of American male body artists has a decidedly
chilling effect.

Almost the only woman who engages in such practices is
Gina Pane (Paris), who has cut herself with razor blades,
eaten until she was sick, and subjected herself to other
tortures. Her self-mutilation is no less repellent than the
men's, but it does exist within a framework which is curiously
feminine. Take, for instance, her *Sentimental Action*, a per-
formance she describes as the "projection of an 'intra' space"
activated by the sentiments of "the magic mother/child re-
lationship, symbolized by death . . . a symbiotic relationship
by which one discovers different emotional solutions." Using
her body as a "conductor," she takes apart "the prime
image—the red rose, mystic flower, erotic flower, transformed
into a vagina by reconstitution into its most present state:
the painful one" (Pane in Vergine). Photodocumentation
shows the artist dressed in white with her face hidden in a
bunch of roses and her bleeding arm, pierced by a line of
tacks, stretched out before her.

If few women artists inflict pain on their own bodies, the
fear of pain, of cruelty and violence, surfaces frequently in
their work. Hannah Wilke's *S.O.S.* ("Starification Object
Series," and, not incidentally, "Help!") include a perform-
ance in which, shirtless, she flirts with the audience while
they chew bubble gum, when she then forms into tiny loops
resembling vaginas and sticks in patterns on her nude torso.
She calls these "stars," in a play on the celebrity game, but
they are also scars, relating on the positive side to African
rituals through which women gain beauty and status, and
on the negative side to the anguish of the artist's real "internal
scarification." In Rebecca Horn's strange, mechanically erotic
films, her body is always protected by bizarre contraptions
resembling medieval torture apparatus; she makes contact
with objects or people, but only at a remove. In her elongated,
stiff-fingered gloves, tickling feathered headdresses, cages,
and harnesses, she achieves a curiously moving combination
of potential sadism and tenderness.

Iole de Freitas: *Duel*. 1973. Photographs. 7″ × 10″.

Iole de Freitas (a Brazilian living in Italy) combats the archetypal female fear of the knife by wielding it herself in cryptically beautiful photo pieces, sometimes combined with fragments of her body seen in a framelike mirror on the floor, as though in the process of examining and reconstructing her own image. One recalls Maya Deren's image of the knife between the sheets here, as well as in the film *Sentimental Journey*, by Italian artist Valentina Berardinone, which concerns "the anthropomorphism of the rose . . . transformation . . . intense persecutory anguish . . . and tunnels; its dominant theme is murder." In Iowa City, Ana Mendieta has made brutal rape pieces, where the unwarned audience enters her room (or a wooded area) to discover her bloody, half-naked body. She has also used herself as a symbol of regeneration in a series of slide pieces. In one she is nude in an ancient stone grave in Mexico, covered by tiny white flowers that seem to be growing from her body; in another she lies nude over a real skeleton, to "give it life"; and in another she makes herself into the "white cock," a Cuban voodoo fetish, covered with blood and feathers. She has traced her skeleton on her nude body to become "Visible Woman," and ritually outlined her silhouette in flowers, flames, earth, and candles.

A good deal of this current work by women, from psychological makeup pieces to the more violent images, is not so much masochistic as it is concerned with exorcism, with dispelling tabus, exposing and thereby defusing the painful aspects of women's history. The prototypes may have been several works by Judy Chicago—her *Menstruation Bathroom* at *Womanhouse*,[10] her notorious photolithograph, *Red Flag*, a self-portrait from the waist down showing the removal of a bloody Tampax (often read by male viewers as a damaged penis), and her rejection drawings, which demand: "How Does It Feel to Be Rejected? It's Like Having Your Flower Split Open." In a recent two-woman exhibition at the College of St. Catherine in Saint Paul, Betsy Damon and Carole Fisher showed *Mutilation Images: A Garden* and *Self Images: Terrible Mother of the Blood River*, many of which took, however, the hopeful shape of the female transformation

---

[10] Leslie Labowitz and Friederike Pezold in Germany have also made menstruation pieces, as have Judith Stein, Jacki Apple in a terrifying autobiographical text, and Carolee Schneemann in her important orgiastic Happening, *Meat Joy* (1964).

symbol par excellence—the butterfly (also introduced into feminist iconography by Judy Chicago). Its visual resemblance to the Great Goddess' double-edged ax is not coincidental, for Chicago has made a series of china-painted plaques that deal with the "butterfly vagina" and its history as passage, portal, Venus of Willendorf, and so forth. Mary Beth Edelson, in photographs of herself as a symbol of "Woman Rising" from the earth, from the sea, her body painted with ancient ritual signs, adapts these images to a new feminist mythology. She also incorporates into her work stories written by the audience of her shows: mother stories, womankind stories, heroine stories, menstruation and birth stories, all of which are part of the search for ancient woman's natural, shameless relationship to her body.

One curious aspect of all this woman's work, pointed out to me by Joan Simon, is the fact that no women dealing with their own bodies and biographies have introduced pregnancy or childbirth as a major image. Sex itself is a focal point; Edelson has done ritual pieces with her son and daughter (as has Dennis Oppenheim); a *Womanhouse* performance included a splendid group birth scene; women photographers have dealt fairly often with pregnant nudes, but for individual Conceptual artists this mental and physical condition unique to women exists in a curious void. Is it because many of these artists are young and have yet to have children? Or because women artists have traditionally either refused to have children or have hidden them away in order to be taken seriously in a world that accuses wives and mothers of being part-time artists? Or because the biological aspect of female creation is anathema to women who want to be recognized for their art? Or is it related to narcissism and the fact that the swollen belly is considered unattractive in the male world? But if this were so, why wouldn't the more adamant feminists have taken up the theme of pregnancy and birth along with monthly cycles and aging? None of these explanations seems valid. The process of the destruction of derogatory myths surrounding female experience and physiology appears to be one of the major motives for the recent surge in body art by feminist artists. Perhaps procreativity is the next tabu to be tackled, one that might make clearer the elusive factors that divide body art by women from that by men.

# The Women Artists' Movement
## —What Next?*

This year's Paris Biennale includes approximately twenty-five female participants out of one hundred and forty-six artists. This dubious triumph is cause for at least some celebration, since previous ratios have presumably been far lower. It is interesting that the percentage of women in this show is a little lower, but close to what seems to have been made the gender quota by the Whitney Museum of American Art's Biennials and by a few other American organizations. The Whitney, which was struck by and responded to demands by women artists in 1970, raised its percentage by four hundred percent and then stopped dead in its tracks. No figures are available on the international artists' population, so it is anybody's guess whether only twenty percent of the artists in the world are women. However, I suspect that this figure marks a barrier rather than a fact, a barrier which will have to be a target of the next wave of the women artists' movement—should there be such a wave.

I say "should there be," because it appears that for many women artists this figure is satisfactory. Attitudes range from successful elation to modest pleasure to uneasiness, to bitterness, depending on the effect the women's movement has had (1) on their lives, and (2) on their careers. The great danger of the current situation in America (presumably less so in Europe where the women artists' movement is just be-

---

* Reprinted from the catalogue of the 9th Biennale de Paris, 1975.

Alice Aycock: outside and inside of *Simple Network of Underground Wells and Tunnels.* 1975. Far Hills, New Jersey. Earth, timber, concrete. 28′ × 50′; interior 32″ × 28″; 3 entry wells 84″ deep. One can crawl from entry well to entry well through narrow tunnels; 3 other wells are permanently covered.

ginning) is that this barrier will be accepted, that women artists will be content with a "piece of pie" so long dominated by men, satisfied with the newfound luxury of greater representation in museums and galleries (though not yet in teaching jobs, not yet in the history books) rather than continuing to explore alternatives. These alternatives will, hopefully, change more than mere percentages, more than the superficial aspect of the way art is seen, bought, sold, and used in our culture. The pie so eagerly sought after is, after all, neither big nor tasty enough to satisfy all appetites. The pie, in fact, can be seen to be poisonous. Women artists entering the system for the first time after many years of painful struggle can hardly be blamed for not noticing this. Pie is pie for the starving. Nevertheless, it is crucial that art by women not be sucked into the establishment and absorbed by it. If this happens, we shall find ourselves back where we started within another decade, with a few more women known in the art world, with the same old system clouding the issues, and with those women not included beginning to wonder why. The worst thing that could happen at this time would be a false sense of victory. Some things have changed a little, most have not.[1] For this reason I have mixed feelings about the increased number of women in the Paris Biennale this year, and, hopefully, following years.

It is no coincidence that the women artists' movement emerged in a time of political travail and political consciousness, nor that the artworld tendency toward behaviorism and content and autobiography coincided with the women's movement and its emphasis on self-searching and on the social structures which have oppressed women. Ideally, the

---

[1] Now, some eight months after writing this text, I feel a good deal more optimistic about the health of the New York feminist community. The fall of 1975 saw a renewed surge of energy directed at specific projects, among them three new periodicals, a school, and reactivated political activity.

women artists' movement could provide a model for the rest of the world, could indicate ways to move back toward a more basic contact between artists and real life. One of the major obstacles to consolidating the gains made since 1969 has been a lack of real consciousness raising within the middle class, which makes up the bulk of the women's movement. Subsequently there has been a lack of identity with and support for other women artists, except in such special advanced situations as the Los Angeles Woman's Building. It is certainly important that there be role models for younger women artists, that they be able to see women in the classrooms, the museums, the history books, so that their own progress does not seem utterly impossible. But it is still more important that the community forged in the early days of struggle not be diminished when a few are successful. Each woman artist who "makes it" into the establishment must feel responsible on some level for those who have not been so fortunate. But still more so, it is important that we do not adopt the criteria set by the existing structures, but insist upon the individuality of what women have to offer as women, that we revise and revolutionize criticism and exhibition and market procedures in our own image.

This is perhaps the most controversial question in the women artists' movement today: Is there an art unique to women? Another way of putting it, which alters the ramifications, is: Is there a feminist art? The two intersect interestingly. On the first question, I, for one, am convinced that there are aspects of art by women which are inaccessible to men and that these aspects arise from the fact that a woman's political, biological, and social experience in this society is different from that of a man. Art which is unrelated to the person who made it and to the culture that produced it is no more than decorative. It would be ridiculous to assert that the characteristics of the female sensibility which arise from this situation are not shared to some degree by some male artists, and denied by numerous women artists. The fact remains that certain elements—a central focus (often "empty," often circular or oval), parabolic baglike

Mary Miss: *Sunken Pool.* 1974. Greenwich, Connecticut. Wood, steel, water. 13' high inside; 10' high outside; 20' diameter.

Patricia Johanson: detail of *Cyrus Field*. 1971 to the present. Buskirk, New York. Cement block. 8″ × 4″ × 3,200′. Cumulative sculpture now 3 miles long. Photo: Hans Namuth.

forms, obsessive line and detail, veiled strata, tactile or sensuous surfaces and forms, associative fragmentation, autobiographical emphasis, and so forth—are found far *more often* in the work of women than of men. There are also, of course, characteristics far more subtle and more interesting that cannot be pinned down in one sentence, and any such simpleminded listing should raise opposition. Yet anyone who

has studied the work of thousands of women artists must acknowledge its veracity.

What is more provocative than the mere fact that a female sensibility exists is the questions it raises. For example, is this common imagery the result of social conditioning or of something deeper? Is it more likely to result from conscious awareness of one's experience as a woman, or from the unconscious experience of isolation? It has been noted that the work of women artists was more blatantly "female" when barred from the art community, hidden away in the closet—probably because of immunity to artworld fashions and pressures; as a woman's work matures and gains a broader public, it seems to refine these unconscious images into more subtle variations and sometimes discards them completely. On the other hand, the opposite process is also at work. Women who have become feminists under the influence of consciousness raising have moved from a neutralized to a formidably overt contact with their own experience (and frequently to a focus on sexual experience). Which provokes the question: Is feminist art necessarily concerned with female experience and/or sexual experience? There are many women artists who consider themselves feminists but who work from other sources. Art by women is not necessarily feminist art. The problems that interest many of us most at the moment are how do we define a feminist art; how do we make the distinctions?

Part of the resistance on the part of some women artists to identification with other women artists is the product of years of rebellion against the derogatory connotations of the word "feminine" applied to art or any other facet of life. Until very recently, most of the women over the age of thirty in the art world have been survivors. Sufficiently early in our lives we learned to identify with men rather than with women, to be "one of the boys," to be accepted. With the advent of the women's movement it was suddenly possible to stop being ashamed of being a woman, but "inferior" has not changed to "superior" overnight, and many artists are still understandably reluctant to be identified with other women. It has been argued that by emphasizing our femaleness, women artists are just playing into the hands of the men who have stereotyped and downgraded us for years. "My art has no gender" is a common statement. Of course art has no gender, but artists do. We are only now recognizing that those "stereotypes," those emphases on female ex-

Bonnie Sherk (with Howard Levine): *Portable Park.* June 1970. San Francisco, California. Live grass, hay, live tree, cows (in street).

Athena Tacha: details of *Charles River Step-Sculpture I and II.* 1974. Model 96" long; scale = 1:48.

perience, are positive, not negative characteristics. It is not the quality of our femaleness that is inferior, but the quality of a society that has produced such a viewpoint. To deny one's sex is to deny a large part of where art comes from. I do not think it is possible to make important or even communicable art without some strong sense of source and self on one hand and some strong sense of audience and communication on the other. I do not agree, obviously, with Agnes Martin's statement that "the concept of a female sensibility is our greatest burden as women artists." Only when we have understood that concept will we be released from the real burden—the strictures that make possible in the first place qualitative distinctions between men's and women's art. Women's art has not yet been seen in its own context. In 1966, I wrote for the "Eccentric Abstraction" catalogue that metaphor should be freed from subjective bonds, that "ideally a bag remains a bag and does not become a uterus, a tube is a tube and not a phallic symbol, a semisphere is just that and not a breast." At that time I neither cared nor dared to break with that attitude, which was part of a Minimally and intellectually oriented culture in which I was deeply involved (though I was seeking in that exhibition a way back to a more sensuous experience for abstract art). I can no longer support the statement quoted above. I am still emotionally and contradictorily torn between the strictly experiential or formal and the interpretative aspects of looking at art. But the time has come to call a semisphere a breast if we know damn well that's what it suggests, instead of repressing the association and negating an area of experience that has been dormant except in the work of a small number of artists, many of them women. To see a semisphere as a breast does not mean it cannot be seen as a semisphere and as endless other things as well, although the image of the breast used by a woman artist can now be subject as well as object. By confronting such other levels of seeing again, we may be able to come to terms more quickly with that volcanic layer of suppressed imagery so rarely acknowledged today. And such a confrontation can only produce a deeper understanding of what makes women's art different from men's art, thereby providing new and broader criteria by which to evaluate the concerns of half the world's population.

# PART II: MONOGRAPHS

# Irene Siegel[*]

It is only in the past few years that lithography has become other than a means of reproducing drawings, as silk screen is generally a means of reproducing paintings. (There is nothing wrong with this unless one wants the drawing or painting and can only afford the print, and keeps comparing the two.) Both media are more suited to the flat, harsh colorfulness of currently prevailing styles than are the intaglio methods. The fact that American lithography has emerged with a challenging graphic quality of its own is in large part thanks to the establishment, over the last five years or so, of several first-rate lithographic workshops, among them Tamarind in Los Angeles, where Irene Siegel's prints were made last summer (1967).

It is difficult to pinpoint exactly what it is that makes Siegel's prints so impressive. They can be related to the work of other contemporary artists, so novelty is not their trump. Probably it is as simple as their being direct and honest and, at best, very strong. From a technical point of view this strength can be traced to their substance, the exacting weight and graininess of the line, the way the formidable blacks work over an intense, saturated color, and this is partly due to the excellence of her printer. The regularity imposed by lithography on stone and zinc makes prints by a lot of good artists curiously dull; they either seem to overcompensate and the line becomes wispy, or to overemphasize and it becomes

* Reprinted from *Art Scene* (Chicago), 1, No. 8 (May 1968).

mechanical. The line Siegel uses in the lithographs is the same one she uses in her drawings, but the fat path of the grease pencil enhances instead of flattening or overworking the billowing forms she favors. The summer's work seems to have crystallized an imminently mature style.

Mastery of line, after all, doesn't make an artist, which is why most artists don't like to be thought of as printmakers or draftsmen even if they have, like Siegel, pretty much for-gone painting for the time being. Thus while the finer, lighter line that predominates in her earlier drawings is perhaps superior from a connoisseur's point of view, it is less well integrated with the kind of form, design, and content she offers. The line is the vehicle that binds together the myriad details and bulging undulations of figure and environment. Her real success is that the line and the forms are both sculptural and graphic. Whether she is treating a bed, a building, or a body, it is not so much the surface textures one senses, as the way it would feel to encounter that particular volume. The California work confronts this cushiony effect with sharp, rapid decorative forms drawn from a "Hollywood Modern" vocabulary—heavy streaks of lightning, stylized shooting stars, wavy tonal striations that look as though the ornament from Rockefeller Center had been translated into stuffed vinyl. Oldenburg is suggested at times, as he is in the fine drawing of two steam irons battling it out. A prime source of her peculiarly robust fantasy is suggested by the huge nine-section drawing based appropriately enough on a Brueghel—*The Rich Kitchen;* from the initial scene, this expands into a conglomerate still-life interior in which pattern, some color, and jaggedly abutting and exaggerated spaces are tightly woven into an overall design that is stronger than any of its individual parts.

Irene Siegel's approach is unquestionably sensuous, and often sensual. Like Richard Lindner's iron-, plastic-, and leather-clad amazons (the second contemporary reference I can't avoid mentioning), her women are bigger and brawnier than life; their men pale beside them, despite their snazzy ties. But compared to Lindner's mechanical brides, Siegel's women are more approachable, a little tousled, a little undone, past the moralizing and primping stage. (The simile "like an unmade bed" comes to mind not just because one of the best drawings is precisely that.) All this makes her work sound like an ad for knockout drops, but one of its major virtues is the fusion of intimacy and a primitivizing

Irene Siegel: *Unmade Bed* series: *Pink Still Life.* 1968. Pencil and colored pencil. 30″ × 40″. Photo: Arthur Siegel.

vigor, or toughness. Toughness is a word that has become passé from overuse, but it implies a special kind of no-nonsense, un-arty attitude. A deliberately indelicate handling of both shape and line is not uncommon in twentieth-century art, especially in American art. Some of Philip Evergood's drawings from the 1930s and 1940s have the same deter-mined crudity, a freshness that derives from more than in-nocence, a crudity with a touch of cruelty in its insistence on the graceless and awkward in people.

I know very little about Irene Siegel's artistic training and less about the Chicago milieu that presumably nurtured her. What we in the East think of as the Chicago style fuses, or

confuses, *horror vacui* compositions, rough expressionist brushwork and color, a Surrealist or childlike lack of conscious artistry, and particularly a grotesquerie that has earned for it an unpopular generic term—the "Monster School." Irene Siegel is not entirely separate from all this, but what delivers her from its dangerous excesses is the extremely clear, even synthetic structure or design that strictly organizes and controls her best work. She allows her line to proliferate (and its power depends to some extent on its proliferation, or obsessive repetition); now and then the detail gets fussy, but usually the viewer is hard put to resist being drawn into and clearly guided through the enigmatically mad events and locales Siegel depicts. The work I preferred was a large brilliantly yellow lithograph—interior-exterior (a rug below and a blue sky above), focusing on an image that recalls the gaping arch of a freeway tunnel: its organic-industrial aspect has sinister as well as sexual overtones. Among the drawings I was struck by the portraits of Red Grooms and his wife, Mimi, flanking a life-size landscape rendition of his *Chicago* construction, a rendition that is more Siegel than Grooms, but that points up the relationship between his zany, playful sets and her more brooding, blackly humorous approach.

George Sand — 19th century writer, feminist, political activist. She wrote 110 books, 80 of which are novels, few of which are in print. She strikes me as a woman of great energy.

Plate 1. Judy Chicago: *George Sand*, from *The Reincarnation Triptych*. 1973. Oil on canvas. 60" × 60". Collection Susan Rennie and Kirsten Grimstad, Los Angeles. Photo: Frank J. Thomas.

Plate 2. Ellen Lanyon: *Thimblebox*. 1973. Acrylic on linen. 48" × 60".
Courtesy Richard Gray Gallery, Chicago.

Plate 3. Lee Bontecou: *Untitled*. 1970. Vacuum-formed plastic. 30" × 21" × 52". Courtesy Leo Castelli Gallery, New York. Photo: Eric Pollitzer.

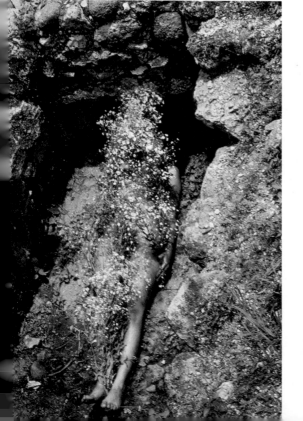

Plate 4. Christine Oatman: *A Child's Garden of Verses*. 1972. Mixed media. Life-size. Installation at Connecticut College, New London, Connecticut.

Plate 5. Ana Mendieta: *Untitled*. 1974. Slide piece.

Plate 6. Ree Morton: *The Plant That Heals May Also Poison.* 1974. Celastic, lights, paint, wallpaper. 47″ × 66″ × 3″.

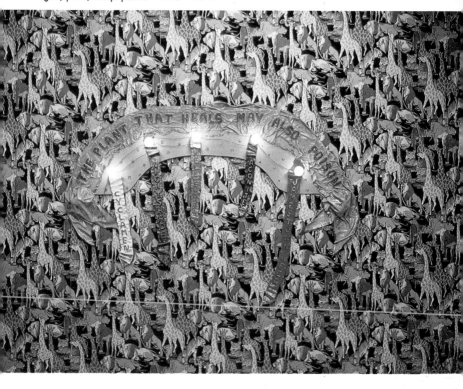

Plate 7. Nancy Graves: detail of *Painting: USA*. 1974/75. Acrylic, oil, gold leaf on canvas. 5' 4" × 26' 8". Panels 1 and 2 of 5. Courtesy Janie C. Lee Gallery, Houston. Photo: Eric Pollitzer.

Plate 8. Joan Snyder: *Small Symphony for Women.* 1974. Paper, papier-mâché, ink, pencil, oil, and acrylic on canvas. 24" × 72". Photo: Larry Fink.

Plate 9. Cynthia Carlson: *Untitled*. 1970. Oil on canvas. 60" × 42".

# Eva Hesse: The Circle*

> *Man is nothing else than his plan; he exists only to the extent that he fulfills himself; he is, therefore, nothing else than the ensemble of his acts, nothing else than his life. . . . When we say "You are nothing else than your life," that does not imply that the artist will be judged solely on the basis of his works of art; a thousand other things will contribute toward summing him up. . . . When all is said and done, what we are accused of, at bottom, is not our pessimism, but an optimistic toughness. —Jean-Paul Sartre*

Eva Hesse died of a brain tumor at the age of thirty-four last June. In the five previous years she had produced a body of work—sculpture and drawings—unique in its fusion of formal and emotional intensity. In 1964–1965, when she began to make reliefs, building out tentatively from the biomorphic images of a Gorky- and de Kooning-derived painting, Hesse was living temporarily in a small German town. In her work she was expressionist by both nature and training. Her talent and seriousness had been acknowledged at the Art Students League, Cooper Union, and Yale; her drawings had been seen in a one-woman show in New York. But she had yet to place herself in the art world or in her own mind. A fundamental insecurity affected her personal life and her work, augmented by the fact that as an attractive young woman and wife of an older, more confident sculptor, she

---

° Reprinted from *Art in America*, 59, No. 3 (May–June 1971).

faced the disadvantages met by most women artists. Isolated
in Germany, however, a country from which she had fled as
a child, she was forced into a painful but fruitful confronta-
tion with herself. In a journal entry from December 1964,
she quoted Simone de Beauvoir's *The Second Sex:* "What
woman essentially lacks today for doing great things is for-
getfulness of herself; but to forget oneself it is first of all
necessary to be firmly assured that now and for the future
one has found oneself."

The process began for Hesse when she followed into three
dimensions the organic machinelike images of a group of
drawings. The shapes were those with which she had always
been obsessed—irregular rectangles, parabolas, trailing linear
ends, curving forms, and circles bound or bulged out of
symmetry; they appear in her drawings from at least 1960.
Of the work done in Germany, she noted: "They are becom-
ing real *nonsense.* . . . Have really been discovering my
weird humor and maybe sick but I can only see things that
way . . . one cannot be cool when one constantly feels fear.
. . . Everything for me is glossed with anxiety." Yet her
own mature work, like that of Jean Dubuffet and Claes
Oldenburg, whom she admired, often offered a wry, self-
deprecating wit which showed up in the fourteen reliefs and
thirty-six drawings that comprised her first one-artist show, at
the Kunstverein für die Rheinlande und Westfalen in Düssel-
dorf, August 1965. The salient materials were cord—tightly
wrapped or loosely hanging—and plaster: "I have always
loved the material. It is flexible, pliable, easy to handle in
that it is light, fast-working."

When Hesse returned to New York in the fall of 1965, so-
called Minimal Art had just begun to be publicly acknowl-
edged. Encouraged by her friends' reception of the three-
dimensional work, she began to refine and clarify her forms
and, simultaneously, to generalize considerably the emotions
provoked by them. While the visceral and erotic associations
of the early reliefs ("It looks like breast and penis, but that's
OK," she wrote from Germany of the first construction)
related to Surrealism, Hesse's irrationality, undeniably rooted
in the subconscious, never approached Dada, as has the work
of colleagues such as Bruce Nauman, Richard Serra, and
Robert Morris; in this, her proximity to Sol LeWitt and
Carl Andre is particularly noticeable. From this time on,
LeWitt, whose planar structures had been shown at the John
Daniels Gallery in May 1965, was her strongest supporter. His

serial permutations, theoretically logical and often visually illogical, though always starkly geometric in style, were a counterpart of Hesse's introduction of chance and randomness into much looser but still systematic frameworks. In various ways, Mel Bochner, Robert and Nancy Smithson, Ruth Vollmer, and Robert Ryman were also important to her development.

The years 1965 to 1968 were a period of personal trauma alleviated by increasing esthetic success. By March 1966 Hesse had completed a large group of small sculptures combining a tubular or spherical motif with straight or tangled line. The most important of these was *Hang-Up* (January 1966)—a rectangular frame, six by seven feet, bound in cloth, with a great metal loop protruding about ten feet; it was gray, a graded purple relief several months earlier having been the last "colored" piece she made. She described *Hang-Up* as "the first time my idea of absurdity or extreme feeling came through. . . . The whole thing is absolutely rigid . . . the colors on the frame were carefully gradated from light to dark—the whole thing is ludicrous. It is the most ridiculous structure that I ever made and that is why it is really good. It has a kind of depth I don't always achieve and that is the kind of depth or soul or absurdity or life or meaning or feeling or intellect that I want to get" (interview by Cindy Nemser, *Artforum,* May 1970). *Hang-Up* was followed by three other large pieces incongruously combining a rectangular or grid structure with looped or free-falling materials: *Laocoon,* a tall "bandaged" cage filled with a mass of wrapped cords; *Ennead,* a rectangular relief covered by a curtain of cords extending into a knotted, trailing end hooked up onto a perpendicular wall; and *Metronomic Irregularity,* three gray panels with a grid of tiny holes into which are inserted white cotton-covered wires leading in and out of each surface. In the "Eccentric Abstraction" show at the Fischbach Gallery in 1966, the last hung next to an earlier work—a hanging group of lanky black sausage shapes whose unassuming posture was in sensibility close to the pile of rubber streamers dumped on the floor across the room by Nauman. Both anticipated what Max Kozloff was to call two years later, when anti-form arose, an "absence of formal prejudice" and an "indifference to style" (*Artforum,* February 1969).

The thing that was so impressive about Hesse's work at that time (and it impressed some very differently oriented people) was the fact that the modular and serial frameworks

Eva Hesse: *Hang-up.* 1965/66. Acrylic, steel, wood, cloth, cord. 72″ × 84″ × 78″. Courtesy Fourcade, Droll, Inc., New York. Collection Mr. and Mrs. Victor Ganz.

never interfered with, or veiled, or stultified the intensely eccentric core of the work. Always more interested in adding than subtracting (see her titles), in overlapping the visual accretions of her own anxiety, she accepted the much abused "system" for something as simple as it was. Where most expressionist artists with a nostalgia for the organic in either texture or image are ideologically unwilling to accept an ordered framework, or are unable to subject themselves to its rigorous discipline, Hesse intuited early that this approach would mitigate her inclinations to fetishism. Until 1965 her obsessive inner-directedness had lacked a method of commensurate precision. The expressionist works had, in a sense, been over too quickly. The impact of raw gesture which had worked for de Kooning and Kline, the ambiguous atmosphere in which Gorky's formal tragedies took place, and the sheer momentum of Pollock's traceries did not work for such a painstaking and self-doubting personality. Hesse's Abstract Expressionist drawings were freer than her paintings, but it was the rather awkward early reliefs that provided a more measured response to the feelings she wanted to express.

At the same time, the system was only an armature; her geometry was always subject to curious alterations, her repetitions to a tinge of fanaticism. In reference to *Addendum* (1967) she wrote: "Series, serial, serial art, is another way of repeating absurdity"; and three years later: "If something is meaningful, maybe it's more meaningful said ten times. It's not just an esthetic choice. If something is absurd, it's much more exaggerated, more absurd if it's repeated." Where her "primary structurist" friends tended to utilize repetition for energy drain (Smithson), visible conceptualism (LeWitt), neutrality or singleness of purpose (Donald Judd), a gestalt measuring device (Morris), or an ongoing process (Andre), Hesse found in it the vehicle for subtle variety that permitted her to distract the modules from their expected norm while placing them in a context for which expectations were quite different. Sometimes within the viewing process itself an ordered armature is transformed into chaos; often the fact that the units are at first glance identical is the only order in the piece, its boundaries being infinitely alterable, as in the lopsided "buckets," poles, spheres of 1967 and 1968. For example, the hundred-odd unattached slitted spheres in *Sequel,* or the one hundred and forty-four demispheres in *Schema,* lie on square mats of the same material and are laid out, respectively, in "no order," and in a delicate impermanent grid

Eva Hesse: *Repetition 19 (III)*. 1968. Fiberglass. Each unit approx. 20″ high × 12″ diameter. Collection The Museum of Modern Art, New York. Gift of Charles and Anita Blatt. Photo: John Ferrari.

which is highly vulnerable to interruption. Due in part to the fact that these pieces cannot be the same twice, the space is fluctuating, unfixed—what Hesse once called "wild space." Her ideas are here somewhat akin to the "potential kineticism"

of Oldenburg's soft sculpture or Andre's particle theory. Though she did not want "audience participation," she emphasized that "there is not one preferential format, other than the specific ideas inherent in the specific piece." When I was installing *Accretion* in a 1969 show, she told me just to lean the fifty translucent fiberglass tubes against the wall without worrying about spacing or arrangement.

Hesse's involvement with materials has been overemphasized because of her public association with other artists who are more dependent upon the accidents of physical phenomena. Her main interest in fiberglass, latex, and other rubbery synthetics was their near-ugly delicacy and textures, their potential for fusing regular shape and irregular disposition, as exemplified in *Area* (1968), a modular wall piece that folds and flops incongruously from wall to /floor. Such pieces conveyed emotion by strangely flawed images, as though striving for a perfection they were destined not to meet. When a critic wrote in 1966 that the mood of Hesse's work was "both strong and vulnerable, tentative and expansive," her stepmother said it sounded as though Eva herself were being described. In fact, the core of her art was the core of Eva's self; the two were inseparable for her and for anyone who knew both the work and the artist. Those who did not come into personal contact with her know more about her than they realize, for to reach out to her work, or to be reached by it, was to be in touch with Eva's most profound aspirations. The tightly bound, imprisoned quality of so many pieces, the complementary structural strength supporting trailing linear elements can inevitably be connected with the truly anguished young woman who wanted to be a child again, and at the same time managed a disastrous life with such basic toughness and maturity that she triumphed through her work. Eventually even she came to realize that the self she was finding through her work was really worth something. In her emphasis on absurdity, however, she remained an existential artist:

> I could take risks. . . . My attitude toward art is most open. It is totally unconservative—just freedom and willingness to work. I really walk on the edge. . . . Art and work and life are very connected and my whole life has been absurd . . . absurdity is the key word. . . . It has to do with contradictions and oppositions. In the forms I use in my work the contradictions are certainly there. I was always aware that I should take order versus

Eva Hesse: *Contingent.* 1969. Fiberglass and rubberized cheesecloth. 8 units, each 14' × 3'. Courtesy Fourcade, Droll, Inc., New York. Collection The National Gallery of Australia, Canberra.

> chaos, stringy versus mass, huge versus small, and I would try to find the most absurd opposites or extreme opposites. . . . It was always more interesting than making something average, normal, right size, right proportion.

*Contingent,* shown at Finch College in early 1970, was one of her last and most successful syntheses of beauty and "ugliness" (meant here as the unexpected rather than the repulsive). It is eight glowing rectangular composites of rubberized cheesecloth and fiberglass run through various proportional and textural changes, the light catching each in a different way. Philip Leider called it "the only piece in the exhibition that has nothing to scream about, no manifesto to adhere to and no theory to back it. It is Abstract Expressionist sculpture of a higher order than I would have thought available to a younger artist. Her work here struck me as being as stumbling and as deeply felt, as expressive and inchoate as, say, a work like Pollock's *She-Wolf*" (*Artforum,* February 1970).

In 1960 Hesse had written that she wanted to work "against every rule" but was at the same time frustrated by her inability to follow through with at least some self-imposed goal ("I get distrustful of myself, renege, cancel out—To be able to finish one, a series, and stand ground"). By the mid-1960s, when so many artists were busy concocting superficial rules, she said and did what many were scrupulously repressing. She was respected for her commitment to pushing herself to the edge, to process and exploration opposed to the prevailing trends, because the results were so clearly genuine. In 1966 Smithson wrote: "The art of Eva Hesse is vertiginous and wonderfully dismal. Such 'things' seem destined for a funerary chamber that excludes all mention of the living and the dead. . . . Nothing is incarnated into nothing. Human decay is nowhere in evidence" (*Arts,* November 1966). At the same time she was in the vanguard (with Nauman, Smithson, Frank Viner, Joseph Beuys, Jan Dibbets, and

Richard Long) of the as yet unrecognized anti-form tendency, though at its public debut in 1968 it was announced as the product of Robert Morris alone. In the exhibition he organized at the Castelli warehouse early in 1969, Hesse's works (*Aught,* a rubber-mat wall piece, and *Augment,* a series of overlapping latex-on-canvas mats on the floor) were decidedly formal compared to several wholly impermanent accumulations and dispersions by other artists. Yet they also looked cool, clear, confident, and *sculptural,* a quality shared by a rolled-lead tube holding a lead plaque onto the wall, an early "prop" piece by Serra.

It may be curious and/or forced to invoke similarities between Hesse and Serra, even though the two were certainly sympathetic to each other's ideas. Some of Hesse's works have more in common with those of Keith Sonnier. In fact, the interrelationships between these three and Nauman, Andre, and Morris, during the years from 1967 to 1969, provide a fascinating network, too tangled to decipher here, but worth mentioning, especially since this network ran between the East and West coasts (via Serra and Nauman) and blurs the usual dichotomy set up between tough, plain New York Minimalism and finish-fetish Los Angeles Minimalism and subsequent events. There was a point in early 1968 when Serra, Morris, Hesse, and Sonnier, more or less unknown to each other, were making rough, troughlike or sectioned wall and floor pieces that were conceptually and visually very close; at one point Serra, Nauman, and Sonnier were also working with neon in a similar fashion. By now, of course, each has gone his own direction—Sonnier into the light and extended theatre, which is a natural outcome of the grubbily diaphanous quality of his best sculpture; Nauman to a whole span of performance-oriented activities, where he has occasionally been joined by Serra and Morris; and Morris to sculpture, to Conceptual Art and earthworks (at which point Smithson crosses the network too). Behind some of these forays looms the detached and single-minded example of Carl Andre, whose choice of a "clastic" (capable of being taken apart, or fragmented) over a plastic art (as "repeated record of process") was highly influential, as was his choice of a consistently horizontal rather than a vertically anthropomorphic idiom. In the midst of all this Hesse stood as a kind of pivot between apparently opposing directions. And while the look, and aspects of intention, of Serra's work has changed frequently over the two years it has been in the public eye,

its intellectual aggressiveness has remained the same, and its primary purpose has seemed to be, finally, sculptural, like that of Hesse, Andre, and the surprisingly few other survivors of the "sculptural renaissance" of the 1960s. Their work stands by itself, for itself, in a kind of nakedness that results from *risk*—a favorite term of the 1950s, implying then a determined mindlessness, even sacrifice, in the heat of creation. Now the risk, or the gesture, rather than being made by the artist from the inside out, as a direct expression of himself, is an "act" of the sculpture, almost independent of the creator, its scale and meaning deriving from its materials, context, and situation rather than from any psychological necessity. Serra uses gravity, weight (explored by others as physiological identification, phenomenalism, didacticism or naturalism), as pure physical *risk*.

Serra has noted, as have various critics, that "the crucial problems confronting sculpture today are the avoidance of concerns properly belonging to architecture and painting" (*Arts*, February 1970). While I can respect the need for a "problem," without which the earnest modernist is hard put to explain his activity, I can't help wondering if Morse Peckham isn't more realistic when he says that we are now in a period which definitely has a "high level of discontinuity" characterized by the "self-imposition of increase in the number of rules, a good many of them in conflict." There is no question that much of the "new sculpture" has stemmed from pictorial rather than traditionally sculptural concerns, though the connection with architecture is usually superficial, having to do with outsized planar sculpture rather than with the spatial concerns that actually define architecture. In any case, the pictorial question was much discussed in 1965/66, when it was generally pointed out how important abstract painting was to the primary structures and how so many of the new sculptors had formerly been painters. Reviewing the "Eccentric Abstraction" show, Hilton Kramer contended that Hesse's imagery was "secondhand" because it derived from painting, especially Pollock's: "Here, as elsewhere, the prose of literal minds effectively displaces the old poetry" (*The New York Times*, September 18, 1966). The Pollock reference has since been more intelligently reiterated by Morris (*Artforum*, April 1968), and less so by *Life* magazine (February 27, 1970). In 1967 I replied indirectly to Kramer that new materials had liberated forms previously "used up"; perhaps naïvely, I declared that "three-dimensional objects can, I be-

lieve, return to the vocabulary of previous painting and sculpture and, by changing the syntax [the space] and the accents, more fully explore avenues exhausted in two dimensions or conventional materials and scale without risk of being unoriginal or reactionary" (*American Sculpture of the 60's,* Los Angeles County Museum of Art, 1967).

What has happened since then is that the pictorial impetus in sculpture has been dematerialized and has often taken the form of drawing, either literally, on surfaces (LeWitt, Bochner), in space (Robert Barry's nylon threads; Hesse's "icycle," *Right After,* and her last piece; Bill Bollinger's ropes), or on the "ground" (Hesse's mat pieces; Andre's plaques, his *Lever* and related outdoor pieces; Smithson's, Michael, Heizer's, and Dennis Oppenheim's monster-scale landscape sketches), and so forth. The question is, and I can't answer it, whether such drawing or pictorial effects in real space are essentially bad, dishonest, untrue to the internal necessities of something called sculpture, or whether the "problem" has a way of defusing potential "solutions." Maybe today painting and sculpture are in the same predicament as poetry and the novel. Real "newness" is impossible, but there is still, somehow, a need for these arts, and people who have a need to make them, to exteriorize their own visions in these media, or to see them made visible by those better able to achieve a moving experience. Hesse's work, fundamentally a synthesis, is especially visible in times like these when it is freed from the exigencies of hectic group activities and can be seen for itself, instead of as related to incongruous company. She was acutely aware of her work in reference to that of her peers and worried about it as much as everyone else does. But her real ambition was to invoke "what is not yet known, thought, seen, touched but what really is not and what is"— which is, after all is said and done, the real problem of any art. *Right After* (1969), a shimmering skein of clear plastic lines, made her apprehensive because it "left the ugly zone." She wanted it to be "very, very simple and very extreme," like "a really big nothing." At the end of her life she was working on a similar idea in a heavier, less ingratiating material.

# Catalysis: An Interview
# with Adrian Piper*

*Last year, Adrian Piper did a series of pieces called* Catalysis.
*They included:* Catalysis I, "*in which I saturated a set of
clothing in a mixture of vinegar, eggs, milk, and cod-liver oil
for a week, then wore them on the D train during evening
rush hour, then while browsing in the Marboro bookstore on
Saturday night";* Catalysis VIII, *a recorded talk inducing
hypnosis;* Catalysis IV, *in which* "*I dressed very conserva-
tively but stuffed a large red bath towel in the side of my
mouth until my cheeks bulged to about twice their normal
size, letting the rest of it hang down my front, and riding the
bus, subway, and Empire State Building elevator";* Catalysis
VI, "*in which I attached helium-filled Mickey Mouse bal-
loons from each of my ears, under my nose, to my two front
teeth, and from thin strands of my hair, then walked through
Central Park, the lobby of the Plaza Hotel, and rode the
subway during morning rush hours";* Catalysis III, "*in which
I painted some clothing with sticky white paint with a sign
attached saying 'WET PAINT,' then went shopping at Macy's
for some gloves and sunglasses";* Catalysis V, "*in which I
recorded loud belches made at five-minute intervals, then con-
cealed the tape recorder on myself and replayed it all full
volume while reading, doing research, and taking out some
books and records at the Donnell Library";* Catalysis VII, "*in
which I went to The Metropolitan Museum's "Before Cortes"
show, while chewing large wads of bubble gum, blowing*

---

° Reprinted from *The Drama Review*, 16, No. 1 (March 1972).

Adrian Piper: *I Embody*. November 1975. Poster. 18" × 24".

*large bubbles, and allowing the gum to adhere to my face . . . (and) filling a leather purse with catsup, then adding wallet, comb, keys, etc.; opening and digging out change for bus or subway, a comb for my hair in the ladies' room at Macy's, a mirror to check my face on the bus, etc.; coating my hands with rubber cement, then browsing at a newspaper stand . . ." And so on.*

I hold monologues with myself, and whenever anyone passes near me, within hearing distance, I try to direct the monologue toward them without changing the presentation or

the content of what I'm saying. Usually, when I know that someone is approaching me, I find that I'm psychologically preparing myself for their approach. I'm turning around to meet them, and I have a whole presentation for their benefit, because they are there, and I'm aware of them. I'm trying *not* to do that. I'm not sure whether or not I'm involving myself in a contradiction. On the one hand, I want to register my awareness of someone else's existence, of someone approaching me and intruding into my sense of self, but I don't want to present myself artificially in any way. I want to try to incorporate them into my own consciousness.

*Do you look at them?*

Yes. That's another thing I've been trying to work with. When I started doing this kind of work I found I was really having trouble looking people in the eye while I was doing it; it was very hairy. I looked odd and grotesque, and somehow just confronting them head on was very difficult. It makes me cringe every time I do it, but I'm trying to approach them in a different way.

*This is much subtler than the things you were doing last year. Are you still in that context?*

Yes. These came out of them. Not formally, but through the kinds of experiences that I was having when I was doing these things. I feel that I went through some really heavy personality changes as a result of them.

*Just to be able to do them at all, in the first place . . .*

Well, a lot of things happened. I seem to have gotten more aware of the boundaries of my personality, and how much I intrude myself upon other people's realities by introducing this kind of image, this facade, and a lot of things happen to me psychologically. Initially, it was really hard to look people in the eye. I simply couldn't overcome the sense that if I was going to keep my own composure and maintain my own identity, it was just impossible. I would have to pretend that they weren't there, even though I needed them. Then something really weird happened; it doesn't happen all the time. Something I really like. It is almost as if I manage to make contact in spite of how I look, in spite of what I'm doing. There was a piece I did last summer that was part of the work I was doing before. I had on very large knit clothes and I got a lot of Mickey Mouse balloons, which have three shapes, with the two ears. I stuffed them into the clothes, so I was not only very obese, but I was also bulging out all over; it was very strange. I was on the subway and the

balloons were breaking and people were getting very hostile because I was taking up a lot of space, and it just occurred to me to ask someone what time it was. So I did, and they answered me in a perfectly normal voice. This was very enlightening. I decided that was a worthwhile thing to go after. Somehow transcending the differences I was presenting to them by making that kind of contact . . .

*How often do you do it?*

Maybe two or three times a week in different kinds of situations; wherever I find myself. I haven't started cataloguing the kinds of reactions I have gotten . . . The scary thing about it for me is that there is something about doing this that involves you in a kind of universal solipsism. When you start realizing that you can do things like that, that you are capable of incorporating all those different things into your realm of experience, there comes a point where you can't be sure whether what you are seeing is of your own making, or whether it is objectively true.

*Because you begin to have almost too much power over the situation?*

Yes. You know you are in control, that you are a force acting on things, and it distorts your perception. The question is whether there is *anything* left to external devices or chance. How are people when you're not there? It gets into a whole philosophical question. I found that at times it's exhilarating, too. It is a heady thing, which has to do with power, obviously . . .

*What do you think it has to do with being a woman? Or being Black? It's a very aggressive thing. Do you think you're getting out some of your aggressions about how women are treated? Is it related to that at all?*

Well, not in terms of intention. As far as the work goes, I feel it is completely apolitical. But I do think that the work is a product of me as an individual, and the fact that I am a woman surely has a lot to do with it. You know, here I am, or was, "violating my body"; I was making it public. I was turning myself into an object.

*But an object that wasn't attractive, the way it was supposed to be; instead it was repellent, as if you were fighting back.*

In retrospect, all these things seem valid, even though they weren't considerations when I did the pieces.

One thing I don't do, is say: "I'm doing a piece," because somehow that puts me back into the situation I am trying

to avoid. It immediately establishes an audience separation—"Now we will perform"—that destroys the whole thing. As soon as you say, this is a piece, or an experiment, or guerrilla theatre—that makes everything all right, just as set up and expected as if you were sitting in front of a stage. The audience situation and the whole art context makes it impossible to do anything.

*Don't you feel that this is kind of infinite? That you have to cut it off someplace so that it is a piece, and not life? If you're making art, you have to have a limit.*

I really don't know. For quite a while I felt absolutely unanchored in terms of what I was doing. I'm not sure I can describe that. Now I feel certain of what I'm doing because it is necessary for me to do it, but I do not feel terribly certain as to what my frame of reference is. It seems that since I've stopped using gallery space, and stopped announcing the pieces, I've stopped using art frameworks. There is very little that separates what I'm doing from quirky personal activity. Except I've been thinking a lot about the fact that I relate what I'm doing to people. Occasionally, I meet somebody I know while I'm doing a piece, and it seems OK to me, because it affirms what I'm doing as art. That gives me some kind of anchor. But when I just tell people what I'm doing, I don't think it has the same effect. What it does is reaffirm my own identity as an artist to me. If you ask me what I'm doing, I'll tell you I'm doing this, rather than saying, well, you know, I'm not doing any work lately, but I've been doing some really weird things in the street. I subscribe to the idea that art reflects the society to a certain extent, and I feel as though a lot of the work I'm doing is being done because I am a paradigm of what the society is.

# Color at the Edge:
# Jo Baer*

It seems incredible that there has never been an article written on Jo Baer, that she has had only three one-woman shows since arriving in New York from California in 1960, that the only institutional recognition of her stature has been a National Endowment grant several years ago. Incredible because she certainly has one of the most impressive "underground" reputations in New York among artists and those who listen to artists. True, some of this can be attributed to Baer's own combined integrity and recalcitrance. She has known for a long time what she wants and has been willing to wait for it. A small show was finally planned at the Whitney for this year, but she canceled it when the museum cut in half the space available to her. Another exhibition at Pasadena was canceled for bureaucratic reasons. Her exhibition of work from 1962 and 1963 at the School of Visual Arts Gallery in 1971 was stunning in its subtlety and assurance, one of the most beautiful (i.e. strong and exhilarating) shows I saw that season; the most attention it received was a longish review in *Artforum*. Since 1966 Baer has been in such museum shows as the Guggenheim's "Systemic Painting," "Documenta IV," the Corcoran Biennial, the Whitney Annual. Paintings are in the collections of The Museum of Modern Art and the Guggenheim. She has published a few rigorously intelligent (and again, recalcitrant) statements and articles. Her work and her head are respected and admired by artists and critics

---

* Reprinted from *Art News*, 71, No. 3 (May 1972).

Jo Baer: *Untitled.* 1962. Oil on canvas. 72" × 72". Courtesy Richard Bellamy, New York. Photo: Robert E. Mates and Paul Katz.

as diverse as Kenneth Noland, Sol LeWitt, Donald Judd, Richard Serra, Jack Wesley, Clement Greenberg, Dan Graham, and me. Why, then, is hers still an underground reputation? It is not *just* because she is a woman, and a woman who can take care of herself better than many men. For any sort of explanation one has to turn to the obvious source— her work.

Baer's paintings should not be as hard to take as they apparently are. From 1962 through 1969 she worked within a single scheme: a flat white (or very pale gray) painted canvas with a narrow black border either intricately broken by fine color lines in the upper, heavier margin, or evenly lined with a narrower inner border of grayed (though often intense) color—a luminescent shadow rather than a direct contrast. This inner border serves as a binding agent for the whole painting. It mediates the encounter of dark edge and light field, while adding an almost imperceptible tension; and it deters the white center from recoiling into space and becoming a window. These paintings (and a 1963 set of "graph-paper" canvases) are serial in the sense that they often were painted and hung in groups so that the colors of the different inner borders could quietly relate to each other as a multiple experience. The color, however, is not chosen by any hard system. Baer has always worked intuitively and her art has been misunderstood in the light of other, far more systematic artists, whose Minimalism relates visually to hers.

In the spring of 1969 Baer began a set of canvases in which the fully enclosing border was abandoned for a more complex scheme that wrapped around the side edges. The white-gray surface remained the same, but these edges (always a fundamental concern) took on a new weight, and the surface acquired a new tautness. Each side edge is banded by a vertical black rectangle, not reaching to the top or bottom margin, enclosing a second rectangle outlined by thin lines of color, off-center, so that the side-to-front surface reads: color line, wider black inner rectangle, stretcher edge, color line, black border. Writing about Baer in 1966, I said she did not seem greatly interested in space, at least as an active element. The 1969 decision to move around the edges and thus to remark further the object quality of the stretched canvas proves me wrong, as do the five new paintings (1969–1971) that are the direct results of this more

blatant manipulation of spatial properties, the instrument of which remains color.

These "transitional" sets with wrap-around edges, still restricted to a single color per canvas, were in fact made simultaneously with the first of the new works, and Baer had also attempted something similar with earlier work. It took her about a year to adjust to a still freer format. I was quite shocked when I first saw the exotic colors, the diagonal and curved forms, and the almost sculptural placement of the canvases on the wall. Eventually I realized that this was not a "style change" in any sense, but simply a radical extension of long-standing concerns. The first completed painting, a long horizontal called *H. Pandurata* (the titles obliquely refer to Baer's passion for orchids, which she grows), is hung one inch (the width of the lumber) above the floor. The series alternates between horizontal and vertical, as though Baer were forcing herself to tackle new problems every time she might have verged on solving old ones. The verticals hang four inches (the depth of the stretcher) off the floor, and the effect is the same—the darkly shadowed area of wall between the lower edge of the canvas and the floor becomes an integral part of the painting.

This curious installation is not new for Baer. She has hung all her shows much lower than the conventional eye-to-center level practiced in most museums and galleries, so that the authoritative symmetry of the configurations is balanced delicately against an asymmetrical placement in the larger white space of the room. The effect with the older work was, of course, to understate the absorbent potential of the central "void" and to focus the viewer's gaze on a crucial point of the painting—the upper border where black, color, and white meet.

With the new work, a very low installation is particularly necessary, because the frontal surface is again de-emphasized, this time by the intensity of the activity on and around the edges. *H. Pandurata* is an extended shallow box, at first glance very simply and perhaps arbitrarily altered by a small black rectangle at the upper left (its own lower edge lined by a grayed pink), which becomes a triangular cut across the top edge's surface and a second triangle on the left edge. Next to it is an attenuated olive-green triangle that reverses the procedure by becoming a rectangle on the top surface; a third triangle moves around an edge to become a black rectangle.

Altogether the feeling is much like that of the old work, with
the same crisp and compact tensions occurring where black
and quiet color lines move against the central field. Like all
of Baer's paintings, *H. Pandurata* is about color and what the
most minute amount of color can do in terms of power. But
it is also, and this is new, about distance. It forces perceptual
insights further than the older work. And there is this jazzy
look to be dealt with—the triangles which are so attenuated
that they seem to bow out and curve the surface, the shapes
which turn with such ease into lines.

The second painting, *V. Speculum,* also appears relatively
simple, though perhaps less successfully. I tend to like the
three horizontals in the series better than the two verticals, a
response I mistrust, knowing my own proclivity for hori-
zontal spaces, but one which is, I think, also borne out by the
fact that there is something anthropomorphically awkward
about a vertical "box." But Baer has always avoided a land-
scape space by painting the surface in vertical strokes. *V.
Speculum* consists of two chunky truncated triangles and
some very complex linear breaks and shadow effects (on the
right side edge there is a double shadow that is cast on the
wall when the canvas is hung correctly a bit away from the
wall). In none of these works do the accenting lines on the
front follow around the corner, and this brittle disjunction
verges at times on fussiness, though it would clearly have
been too easy and too unambiguous (for a painter like Baer)
to have had them coincide with the larger forms. Here again
the effect is of a curved surface, perhaps partly due to a
strong sense of movement *around* the corners.

The third painting is *H. Tenebrosa.* At this point Baer
seems to have become much more at ease with the diagonals
and their effects, to the extent that she had to watch out for
slickness (which she did successfully; the avoidance of that
imminent danger intensifies the experience). It incisively
exploits the knife edges, the graceful rapid diagonal. A cen-
tered, edge-to-edge and extremely extended triangle along
the bottom edge has virtually no apex; this superrefinement
makes it as much a curve as any shape I've seen that isn't a
curve. The use of line here is almost punning—for instance a
white line along the edge of the top right that remarks and di-
vides a brown form. Only two surfaces are painted; there is
nothing on the sides, but the top surface is so complex I
despair of describing it, and can say only that it concerns
color and light acting on surfaces in various situations. Baer's

white frontal field is unassuming and by all rights should read negatively. But it doesn't. It is, finally, the most powerful element in the paintings. Although the eye first rushes to the sides where the forms and lines provide food for perception and thought, it always returns, apprehensively, toward the center. I had the curious impression that the frontal space was a great passive "victim," like a queen ant, dependent on but totally sovereign over her victimizers, through sheer detachment.

*V. Lurida,* pale and wan, is the strangest of the set. I didn't like it at all when I first saw it about a year ago, partly because its unassuming colors, lack of strong contrasts, and plantlike shapes repelled me in relation to what I expected of Baer's work; partly because I was not (am still not) sure it works; partly because I associate those colors and circle segments with Art Deco, and maybe with Jo's orchids. This is somehow a *slyer* painting than the others, although perhaps I was fooled by the others' immediate impression of forthrightness; they are, after all, quite sly too, just not so openly. In any case, *V. Lurida's* yellows, grays, gray-greens, and pale blues, roughly painted but a little too prettily delineated by darker lines (necessary so the colors don't wash into each other), perform an exercise in arcs; the circle drafted on the left is reversed on the right, and moves around the corners at different points on the two sides for further alterations. The colors change very subtly for different light effects; shadows seem particularly important in this canvas. (*I keep staring at its serpentine shapes and the fact that the surface is vertically banded in five almost imperceptibly graded whites, and I still don't like it, though I grudgingly admire its eccentricity. I turn away, drink some coffee and talk, then turn around again toward the painting, from a distance, without meaning to look at it, and suddenly I look up and, caught unaware, like it for the first time. I don't know why—an irrational act directly instigated by the work itself.*)

*H. Arcuata,* the most recent work (though it was done over a period of two and one half to three years), is a fast, clean, luscious painting, even brilliant. It makes *H. Tenebrosa* seem austere and withdrawn. The shapes curve unashamedly over the top surface and the top of the front plane. The two shapes seen frontally are simultaneously discordant and gracefully at ease with each other. There is a curious incongruity between the *kind* of shape on the left (blunt, bright, aggressive) and on the right (subtle, almost deceptively bland, smooth as a

Jo Baer: *H. Arcuata.* 1971. Oil on canvas. 22″ × 96″ × 4″. Collection the artist. Courtesy Richard Bellamy, New York. Photo: Frank J. Thomas.

bladed wing). The transition is made effortlessly on the top surface where the blunt shape becomes graceful and the graceful one becomes oddly neutral. The colors too are consciously at odds and then reconciled, providing a constant play between bright and dulled, well lit and shadowed, rapid and slow: The thin lines come into their own as a prime vehicle of formal wit as they move through value and hue changes. The brick red turns an edge into vibrant orange; the gray-green becomes a lurid mint deftly manipulating the light inherent in the paints and in the installation, as though

.he artist were able to make the sun go in and come out on different areas of the canvas. Altogether *H. Arcuata* is a warm painting, with a clearly cream-colored plane. A strange effect on the right side makes that cream appear dark at the top (as it is), but when below it turns to the same value as the lighter frontal plane, there is absolutely no dividing line, not even a perceptible shadow effect.

This ability to make a change so subtle (straight to curve, light to dark) that it does not so much fool as wholly convince the eye is something Baer has always had, but now she has cut it loose from geometrical moderation. For those with the patience to look and look, she can provide endless delights on the level of significant detail. (It also explains why five paintings took three years to make.) One is also forced to deal spatially with three surfaces at once, wherever one stands; and to deal as well with the knowledge that there is still a fourth surface that will alter what one thinks one sees from *this* angle. In addition, each painting has twice as many colors in it as meet the eye, since each color is altered according to its circumstances and each color, changing, provides a different kind of encounter with the others, a fact one recognizes only dimly because these effects are so finely drawn by compensation for and with lighting.

The edges of *H. Arcuata* are twice invisibly changed by fine black wedges that slice off thin sections of the supports, merging with the real shadows between canvas and wall in a perceptual distortion so unexpected it is almost unrecognizable. Writing this, I am reminded of writing several years ago on "Perverse Perspectives" (Frank Stella, Charles Hinman, Park Place group—work that was later labeled "Abstract Illusionism") not because there is any direct relationship between what those artists were doing and what Baer is doing, but because the experience is so different. There is nothing perverse about these five paintings. Illusionism is not what they are about. Whatever spatial complications operate around the physical properties of the support, the surface plane is never made to look like anything but what it is; the colors lie on the same plane. These canvases are the products of a long-standing commitment to *painting,* a commitment that has been unfashionable during the 1960s (see Baer's reasoned argument with Morris' and Judd's evangelical condemnation of painting in favor of three-dimensional art, *Artforum,* September 1967) but now is respected again in this aimless time of no movements, no bandwagons to

jump on. The positions of artists like Robert Ryman, Robert Mangold, and Baer, who resisted the "escape" into sculpture or colorful illusionism in the mid-1960s and followed their own obsessions with little overground encouragement, today seem exemplary.

# Joan Mitchell*

When an artist triumphs over discrimination against women, over years of self-imposed exile from New York, over almost two decades of life with another artist, as well as over inevitable esthetic problems, and comes out with her own artistic identity intact, she has survived against formidable odds. Joan Mitchell's twenty-fourth one-woman show at the Martha Jackson Gallery in May (1972) can be seen as a celebration of this survival. Her new work has presence, conviction, and a downright joy of execution which make that of most of her colleagues in the so-called second generation of Abstract Expressionism seem inert by comparison. If their laurels piled up much earlier than hers (she has just had her fiirst museum show at the Everson Museum of Art in Syracuse[1]), they have also faded faster, while Mitchell's huge new canvases, especially *Wet Orange* (1972), confirm a vitality that has increased rather than diminished over the years since the New York School was apparently buried beneath a Minimal tombstone.

It is not her age that qualifies Joan Mitchell as a survivor—she is a slim, youthful, assured forty-six—but her vocation. She is not "first generation" only because she was so young when she started. But her first show was in 1951, only a year after Franz Kline's first. Raised in Chicago, the daugh-

---

* Written in 1972 for *Ms.;* unpublished.
[1] Since then Mitchell also had a major show at the Whitney Museum of American Art, March 26–May 5, 1974.

ter of a doctor and a poet, she went to the progressive Francis
Parker School, which she considers a great influence on her
life. Then she attended Smith College for two years, mainly
a waiting period until her parents felt she was old enough to
go to the School of the Art Institute of Chicago. There she
was awarded a traveling fellowship [sic] to Europe. (She
won second place; a man who has not been heard of since
won the first.) Although her work has been consistently re-
spected by many in the art world since her arrival in New
York in 1950, Mitchell has known the setbacks and even
humiliations to which American society subjects all artists,
suspect as they are in their commitment to giving rather than
taking. She has also known the additional tribulations that
beset women artists in a society that considers them amateur
rather than professional workers. The very physical nature of
art—particularly of large canvases and sculpture—has been
used to discourage women all along. While Mitchell had oc-
casional good women teachers, she found no women in school
or in galleries to whom she could look as successful role
models. In the 1950s, as now, it was frequently and loudly
said that "there aren't any women artists." Those who tried
to disprove this were tolerated, rarely encouraged, often ruth-
lessly ignored and undervalued. Even Mitchell, one of the
rare ones, remembers "there were times when I really got
discouraged and thought why am I doing this, because I'm a
woman and women can't paint." She did, however, have the
advantage of knowing her mind and of being very aware of
prejudice against women from an early age. "I always knew
women were the second sex and I always got mad at women
who quit. My father was anti-women. I was supposed to
be a boy. I went out and won things for my father as a child,
like a skating championship, but the fellowship was the last
thing I won for him. My mother was a poet and edited *Poetry
Magazine*. She was a bit lost as a mother but a marvelous
woman—a real creative influence on my life."

The second generation of recognized American painters
did include two other women whose careers have followed
quite different courses from Mitchell's. Helen Frankenthaler
is a very fashionable color-stain painter; Grace Hartigan
(who painted as "George Hartigan" for many years) is living
in Baltimore, continuing to paint more or less "off the scene."
But for the most part the insidiously competitive spirit that
pervades the art "world" denied the women each other's
support.

I've always had close women friends and taken a special interest in younger women's work, but in New York in the 1950s women artists were very much against each other. I suffered from that. Men actually helped me more and would back me more than women. When I brought my painting in to the Ninth Street show [a now famous independent exhibition held in an empty store in 1951 as a protest against uptown rejection of the new art], Leo Castelli said he'd have to see if there was room, but de Kooning and Kline were there and they really liked it, so it was hung.

Mitchell lives near Paris with Canadian painter Jean-Paul Riopelle and, at times, with his two children. Her Everson show was called "My Five Years in the Country," referring to their house in Vétheuil, where Monet once painted. The work made there, shown in Syracuse and New York, has an unashamed breadth and generosity that puts the pallor of recently baptized Lyrical Abstraction to shame. In *Wet Orange*, a series of heavy, blocklike shapes in dark, earthy

Joan Mitchell: *Wet Orange*. 1972. Oil on canvas. 9' 4" × 20' 5". Collection The Carnegie Institute, Pittsburgh, Pennsylvania. Courtesy Fourcade, Droll, Inc., New York.

greens, reds, and browns line the lower margin and side edges, while the top and center open up to brilliant, airy patches of pale green, blue, and yellow—areas of sheer color-light. The whole vocabulary of expressionist technique is richly displayed: the weight of paint and the ephemerality of the brushstroke, dripped paint drenching and opening up the heavier forms, the underlying structure disintegrating before one's eyes only to reappear on another level at a different speed, replaying the act of painting itself.

Mitchell's new canvases have a scale and emotional strength that disqualify such adjectives traditionally used for "feminine" art as "delicate," "refined," "pretty." They are very "natural." They have conviction. Mitchell may have survived because she is convinced that she is good, that women *can* paint. The bad times have not diluted that conviction. Talking to her in the bright, quiet St. Marks Place studio she keeps for New York visits, my impression was one of cool—*real* cool, the kind of cool that is also warm. Mitchell has the clarity of a person who has confronted prejudice (vigorously at times, if her reputation is to be believed) and has remained assured of her passion, as an artist and as a woman.

# Hanne Darboven:
# Deep in Numbers*

In a way, Hanne Darboven's work since 1965 is "all one piece." Its beauty lies both in its wholeness and in its rhythmic, potentially infinite, expansion and contraction. The armature is provided by simple, but highly flexible number systems. Yet the content does not concern mathematics so much as the process of continuation—a process which takes time to do, which takes time as one of its subjects, and which takes from time (the calendar) its numerical foundations. Much of the work begins from the numbers that form a date (23.9.71, for example, add up as $23 + 9 + 7 + 1 = 40$; and 40 becomes the basis, or $K$ for *Konstruktion*, which in turn generates the work). The calendar is merely a vehicle, with no other meaning for the work, but by permutating its sequences of order (and leap-yearly disorder) through endless cross-sums and progressions, Darboven creates her own time. This time, or timelessness, is what one experiences when experiencing her art. It is a time in which she lives, a time to "write," as she calls her art activity. And like time, her art turns constantly back upon itself in a circular motion (the circles are sometimes small and sometimes immense); like time, it simultaneously extends an endless line forward, into physical space.

In Darboven's April (1973) show at the Castelli Gallery downtown, the whole front room contained fourteen huge frames, each containing thirty-five drawings, or pages, plus

---

* Reprinted from *Artforum*, 12, No. 2 (October 1973).

the index and initial sketches for this particular section. The smaller back room contained most of the indexes for the rest of the work, which, if executed on the scale of the section in the front room, would fill both galleries a hundred times over. There is, therefore, an ironic micro- macrocosmic relationship between the large physical space filled with work, which actually represents only a minute particle of the whole, and the much smaller, but denser, books that fill the artist's home outside Hamburg. Although a large group of the books were shown at the Guggenheim International in 1971, the New York public is still so little acquainted with Darboven's work that a combination of "wall" and "book" works (as in her two one-woman museum shows in Europe) would have been preferable to the wall works alone at Castelli. Her art goes so far beyond gallery walls, no matter how large the space used, that it is only by this combination of books and framed drawings ("all different, all the same," as Ad Reinhardt used to say of his own work) that the scope of her art receives its due. The books weren't here because they have been treated so badly when shown in America.

The Castelli show represented the partial execution of a piece begun in 1966/67 in New York. Sol LeWitt acquired the index for it at that time, and the system is delineated in line drawings on graph paper, which were the first works of Darboven I saw. This system, in turn, forms the basis for all the other work since then, the best known of which is that based on day, month, year, century—the digits added, multiplied, and interwoven until they become too large to be manageable, at which point they are resystematized into progressively smaller areas, which then suggest new larger areas, and so forth. *100 Years in One Year,* for instance, was shown from day to day over a year at Konrad Fischer's gallery in Düsseldorf in 1970; each month consisted of thirty or thirty-one books, and each day a different book extrapolated that date. Darboven was executing the piece while it was being shown, so that her personal calendar was synchronized with that of the work. Later it was shown as a film, extending the medium itself into real time.

This variety, and the extent to which everything is possible within Darboven's time-number frameworks, are indicated in the visual variations within her work. Her graphic vocabulary consists of handwritten numbers, typewritten numbers (and both for numbers spelled out in English or German), straight lines, squares (drawn or on graph paper), regular "brain waves" flowing ceaselessly over pages, and at times

red and black inks to distinguish two interwoven paths. Combine these with each number system, each combination producing a visually different page, and consider the extraordinary faceted indexes for each book or chapter or plan, and you begin to visualize the great tide of writing enveloping the artist, and finally the viewer. It recalls the pleasures of counting rhythmically out loud, especially in another language; the delight children take in endless songs, such as "One Little Two Little Three Little Indians," "Found a Peanut," or the circular "Row Row Row Your Boat" (van Gogh said life must be round); or the ultimate experience of the mandala (though Darboven is much opposed to any mystical impositions on her work: "My secret is that I have none"). To understand these things is to begin to understand the fascination of Darboven's page after page, book after book, stretching across space toward your own time. It is double-directional—expanding, then going back, "So I relearn where I came from. By doing it, it becomes not more and more, because it's already there, but clearer and clearer."[1] Darboven's systems are finite and she always finishes what she starts. But every time she finishes one set, an offshoot lurks behind it demanding to be executed too. "But I am the river, it is a tiger that mangles me, but I am the tiger; it is a fire that consumes me, but I am the fire. The world, alas, is real; I alas, am Borges" is a quotation she often adds to letters.

Darboven hates to read and loves to write. She says she can only read by writing, by reexperiencing the words or numbers physically. The time she spends writing is experienced visually by the viewer as a time span that is "read" rather than "looked at" the way drawings are usually seen. Most of Darboven's works *are* drawings, but she does not permit the eye to swim all over the surface. Even if one understands nothing behind the numbers one is reading (which is perfectly all right with the artist), one is still *reading*, left to right, horizontally, or in the case of indexes— in columns. It is impossible to look at her work without becoming physically involved in the process of writing. "I only use numbers," says Darboven,

> because it is a way of writing without describing
> (*Schreiben, nicht beschreiben*). It has nothing to do with

---

[1] All quotations not otherwise cited are from the artist in conversation, or in correspondence with either the author or Sol LeWitt.

7/5      Tafel 1      II,1

7 X 25 mm      index      1,75

5 X 35 mm

| 1 | 2 | 3 | 4 | 5 | 6 | 7 |
|---|---|---|---|---|---|---|
| 1 | 2 | 3 | 4 | 5 | 6 | 7 |
| 246 | 247 | 248 | 249 | 250 | 251 | 252 |
| 8 | 9 | 10 | 11 | 12 | 13 | 14 |
| 8 | 9 | 10 | 11 | 12 | 13 | 14 |
| 253 | 254 | 255 | 256 | 257 | 258 | 259 |
| 15 | 16 | 17 | 18 | 19 | 20 | 21 |
| 15 | 16 | 17 | 18 | 19 | 20 | 21 |
| 260 | 261 | 262 | 263 | 264 | 265 | 266 |
| 22 | 23 | 24 | 25 | 26 | 27 | 28 |
| 22 | 23 | 24 | 25 | 26 | 27 | 28 |
| 267 | 268 | 269 | 270 | 271 | 272 | 273 |
| 29 | 30 | 31 | 32 | 33 | 34 | 35 |
| 29 | 30 | 31 | 32 | 33 | 34 | 35 |
| 274 | 275 | 276 | 277 | 278 | 279 | 280 |

II,1

1,75

$1225 = 35 \times 35 = K$    $\overrightarrow{7} / 5\downarrow \ // 35 mm$

$1225 : \overline{V} = 245$    $\overrightarrow{7} \times 0,25 = 1,75 mm$

$I, 1\rightarrow7 = 7 \times 35 = 245$    $\downarrow 5 \times 0,35 = 1,75 mm$

$II, 1\rightarrow7 = 7 \times 35 = 245$    $F: 1,75 \times 1,75 mm$

$III, 1\rightarrow7 = 7 \times 35 = 245$    $7 \times 1,75 = 12,25 mm$

$IV, 1\rightarrow7 = 7 \times 35 = 245$

$V, 1\rightarrow7 = 7 \times 35 = 245$    $\overline{II}, 1 \ // \ 35$

II      280      1

Hanne Darboven: detail of *Untitled (Index 7/5)*. 1972/73. Pencil on paper.
69¾″ × 69¾″. Courtesy Leo Castelli, New York. Photo: Shunk-Kender.

Hanne Darboven: detail of *Untitled.* 1972/73. Pencil on paper. 69¾" ×
69¾". Courtesy Leo Castelli, New York. Photo: Harry Shunk.

mathematics. Nothing! I choose numbers because they are so steady, limited, artificial. The only thing that has ever been created is the number. A number *of* something (two chairs, or whatever) is something else. It's not pure number and has other meanings. If I were making it up I couldn't possibly write all that. It has to be totally simple to be *real* writing.

So the sea of numbers in which she has immersed her life since 1965, carefully structured and constantly revolving though it is, merely establishes a secondary aspect of her work. Counting is the most basic of progressions. What she does is take the stability of ordination and create in this block of numbers a diagonal fault, thereby creating a shift in the structure that by necessity creates its own supporting structure so as not to crumble. With the dates of the century, 1.1.0.0 = 2 provides the beginning construction; 12.31.99 = 61 provides the end construction. All of the constructions are then written out with their concomitant rises and falls in the process. In the Castelli piece this would have been particularly clear had it been possible to show the whole progression of "wave drawings," or at least more than one chapter, for in that case Darboven used the size of the paper for each "chapter" to express the progressions. In her sketched plan for the show, 3/3, a square, appears at bottom left as 9 × 9 centimeters; then 5/3 as 15 × 9; 3 × 5 as 15 × 25; 5 × 5 as 25 × 25; and so forth, from square to vertical to horizontal to square to vertical to horizontal back to square. The conceptual "shape" that this piece takes when written out appears in the middle of the page. From this simple and clear beginning, the interweavings of the paths begin, as expressed by the various indexes. As usual, the piece generates itself, and Darboven becomes, quite literally, the medium by which its convolutions are made concrete. Even the layperson for whom the systems are initially impenetrable (I speak for myself) can follow visually, if not comprehend conceptually, the pattern created by the faults in the surface, the interweavings of the various paths.

What I, as that archetypal mathematical layperson, find so immensely fascinating about these systems I can see but cannot analyze is the visual and intellectual beauty of Darboven's obsession. The indexes are impressive in a similar manner, because of the tremendous contraction they represent, and the springlike force implied by that contraction.

Perhaps because I am a writer, my favorite piece is one in progress which Darboven calls "fiction," "my novel," "a real book." It has already reached 15,000 typed pages and, except for the indexes, is all "written out," that is, the numbers are spelled, in German. Based on the 42–19 system used in many other pieces (including *100 Years,* but drastically cut after that particular usage), it constantly overlaps in each book, "so the last book is exactly where the first book would start again. It might have been the 43rd but it is the first again." There are 42 books with 19 chapters each; each chapter has 42 parts. All of these divisions constitute plus and/or minus quantities, so the text can be synopsized by visualizing a perfect diagonal S-curve meeting a diagonal line at the zero point. It is not a mirror image because it is not static, and continues to move back in on itself. ("The circle as symbol of infinity, everything. What is beginning, where? What is end, where?")

This "real" book has to be typed, partly because it is a real book rather than drawings and must therefore be printed, and partly because the number of pages if handwritten would be still more astronomical than the typed version. Nevertheless, Darboven wrote out the entire first book for the typists, and the rest of the books by shorthand ("1–10" instead of writing out all the intermediate ciphers; she typed the first pieces like this herself, but since this one is a book, "it would be perverse to type it myself"). Then she writes out all the corrections when the typing of any part is finished. Once it is completed, she will do the whole piece in numbers instead of words, and thus the piece will be reduced, or cut, again, since more numbers will fit on a page than words. In the book, the first line (the words *eins* through *zehn*) regulates the length of every other line, so words are cut unsyllabically wherever the end of the line falls. "There are no esthetic tricks. It *is* that way. No search, no research, just writing. But the complete thing must be done before the typing begins." She has been working on this book for four years now, but

> still each time I have to write, it becomes so calm and so normal. There is no story there, nothing to figure out, not a secret, but still exciting. I feel myself not thinking what other people think, but what I think. I write for myself, there is no other way. This is for me. Going on is the enormous thing I do.

Consistent with this attitude, Darboven will not show bits of unfinished sections, will not make "prints," and will not participate in group shows if she is in the midst of writing out a piece. She is very busy writing. She lives alone in a small house on the grounds of her parents' home outside Hamburg and works alone all day except for dinner. When, a few times a year, she goes to New York or somewhere in Europe for a show, it is pure "vacation," "the necessary contradiction to art." She has lived like this, in New York and in Germany, for years. Exhibitions are events that force her to "reduce" the work so she can expand again from a new base, a self-imposed valve on the relentless flow of her ideas. The work is there to do and, therefore, has to be done. To have something to read she has to be writing. But at times, even Darboven collapses so as to "rise again" in the rhythm of her work. "It's exhausting. It's good. It's idea. It's idea. It's good. It's exhausting," she wrote in one of her Gertrude Steinian letters. During one of these periods, she began reading-writing Homer's *Odyssey* instead of making all the work decisions confronting her. She wrote five hundred pages of it, very small, the same size as the paperback from which she copied. "It was *very* hard to do, which was an experience. I will finish it some day."

Hanne Darboven was brought up in Hamburg, the middle daughter of a manufacturer. After a complicated childhood and a brief career as a pianist, she spent four years at the Hochschule für bildende Kunst in Hamburg, taking the straight academic art course. She enjoyed the routine and the discipline, but was "never in touch with any kind of discussion or argument because it was just myself I was talking to." She intensified her isolation soon after leaving school by coming to New York in 1965. She was twenty-four and had never been on her own. She knew no one and met no one, but she did manage to find a small apartment on 90th Street and First Avenue and imposed upon herself another survival routine of daily rounds of work, galleries, and the art supply store, where she was considered eccentric and questioned about the reams of graph paper she bought. The independence partially balanced out the loneliness. Though rather a desperate time, it was one that brought her work to the point where it could sustain her intellectually and emotionally.

She had come to New York with some of the drawings done in Germany—black dots on white board following, less

explicitly, similar systems. The large graph-paper pieces with
numbers, words, points, and lines defining numerical rela-
tionships evolved as a task, or discipline, necessary to go on
making art, which was, in turn, necessary to going on with
life. Her own statements from this period reflect the pres-
sures and joys involved, as well as the fact that the work is
not about problem solving but about process and polarities:

> I build up something by disturbing something (destruc-
> tion—structure—construction). A system became neces-
> sary, how else could I see more concentratedly, find
> some interest, continue, go on at all? Contemplation had
> to be interrupted by action as a means of accepting
> anything among everything. No acceptance at all =
> chaos. I try to move, to expand and contract as far as
> possible between more or less known and unknown
> limits. At times I feel closer while doing a series, and at
> times afterwards. But whether I come closer or not, it is
> still one experience. Whether positive or negative, I
> know it then. Everything is a proof, for the negative that
> a positive exists, and vice versa. . . . I couldn't re-
> create my so-called system. It depends on things done
> previously. The materials consist of paper and pencil with
> which I draw my conceptions, write words and numbers,
> which are the most simple means for putting down my
> ideas; for ideas do not depend on materials. The nature
> of idea is immateriality. All things have plenty of varia-
> tions and varieties, so they can be changed.

She chose the systems because she had discovered in
school and in music that she was "too good at freedom," which
she found frightening and unsatisfying. During the first year
of working directly from the calendar (1968), Darboven
spoke of

> not knowing any more of days, time; just take every day's
> mathematical index, a great invention, fiction. No in-
> quiry, no exploration, just to search into something be-
> tween everything for a time while time is going on.
> . . . Nothing to write, nothing to read, nothing to say;
> something to do, contemplation, action.

One year is

> just a detail of an unknown quantity to register, or
> none/by using our math system to make or to speculate
> years (backwards → history → existence!) is and is no

more, was never/taking further relations to time with this known system time compensates time, time neutralizes time/No time at all/Time total/Within my limitation will have my stuff written as many times as possible/always writing/it's impossible.

John Anthony Thwaites ended an article on Darboven ("The Numbers Game," *Art and Artists,* January 1972) with a warning on the danger that such work "could easily degenerate into a kind of Higher Knitting, with the female quality of patience, detail, and not much else. A pioneer or a Penelope of the twentieth century?" Darboven's reaction was "I *prefer* Penelope. What an accomplishment!" There has always been in her work that element of absurdity that Eva Hesse mentioned as a positive factor in repetition, an element that is as poignant as the obsession and discipline engendering it. ("Serious, not serial," says Darboven.) When John Chandler and I saw the graph-paper drawings in the winter of 1966/67, we wrote that "the illegible but fundamentally orderly tangle of lines connecting point to point is *felt* by the mathematical layman more than it is understood rationally or visually." We also compared her drawings to Braille: "They pass directly from the intellectual to the sensuous." We grouped her with Sol LeWitt, which was obvious, and with Carl Andre and Hesse, as artists who "saturate their outwardly sane and didactic premises with a poetic and condensatory intensity that almost amounts to insanity" ("The Dematerialization of Art," *Art International,* February 1968). It was LeWitt who first recognized Darboven's kindred and genuine spirit. He met her in the fall of 1966 at an opening at Joseph Kosuth's and Christine Kozlov's Lannis Gallery (later the Museum of Normal Art, where Darboven first exhibited) and became her best friend and guide through the art world—the few corners of it she entered at all. His work and Andre's remain for her "the most complete." Her drawings, in return, must have been among those that inspired LeWitt's influential lines: "If words are used, and they proceed from ideas about art, then they are art and not literature; numbers are not mathematics" ("Sentences on Conceptual Art," *0–9,* No. 5, January 1969). In the catalogue of her show at the Westfälischer Kunstverein, Münster, West Germany, October 16–November 14, 1971, Darboven quoted this and Andre's "A man climbs a mountain because it is there; a man makes a work of art because it is not there."

In 1966 the experience of Darboven's work was not a

familiar one. I remember being extremely moved, but also bewildered by this serious and honest and naïve young woman deep in the infinities of choices presented by all those lines and numbers. The seven intervening years have made the form of the work more familiar but the experience is still unique. Because of my own preoccupations with why artists are making art today, and for whom, I have to force myself to answer the unspoken "So what," which may be the reaction of many who saw the show or are reading this. To begin with, I can't imagine anyone seriously confronting Darboven's work in any volume without being involuntarily absorbed by the activity it represents. This activity is exemplary. The systems are accessible, but the least interesting part of the work. What I come away with is a sensuous imprint on my experience and a provocation to think about what produced it, which is pretty much what art is about for me—that combination of physical and mental stress that ultimately affects the way I see and think and live. Perhaps what any audience, educated or uneducated to prevailing taste, comes away with from a good or great work or body of art is awe at the obsession, the total commitment, the time spent, the single-mindedness resulting in some kind of beauty. Despite the fact that this pleasure may not apply often enough or powerfully enough to condone the amount of money and time expended on art when virtually every other problem seems more pressing on humanity, I continue to think that these things in themselves, aside from form, color, content, produce a grand vision, a grand example, an envy, and a longing for such experience (even secondhand) in those not so endowed. When an artist is truly "inside" his or her own work, when the art comes directly from the artist's own needs and compulsions, the experience of that work is more direct and meaningful to others. Whether or not you "like" or "understand" the processes within the books and drawings, the mesmeric sincerity and vigor of Darboven's work can't be avoided.

# Ree Morton:
# At the Still Point
# of the Turning World*

She likes Raymond Roussel's *Impressions of Africa* because "the mental pictures are always changing; you can't make theme concrete. There's no frame of reference, no story line or location." Her own work offers a private sign language that engenders a private space partly constructed from memory, which accounts for the flavor of dislocation. I first saw Ree Morton's work in the 1970/71 Whitney Annual. It didn't look like everything else—a wood and screen "manger" with twigs and branches in and beneath it. She still works with containers and en-

Realize two spaces, or more.

Rearrange this space.

Rebel against that space.

Rebirth of frames.

---

* Reprinted from *Artforum*, 12, No. 5 (December 1973). This essay is a revised and expanded version of a text first published in the catalogue for "Made in Philadelphia" at the Institute of Contemporary Art, University of Pennsylvania, Philadelphia, March–April 1973. The title is taken from T. S. Eliot's "Burnt Norton"; the following quotation has hung above Morton's desk for several years:

> At the still point of the turning world.
> Neither flesh nor fleshless; Neither from nor towards;
> at the still point, there the dance is. But neither arrest nor movement.
> And do not call it fixity, Where past and future are gathered.

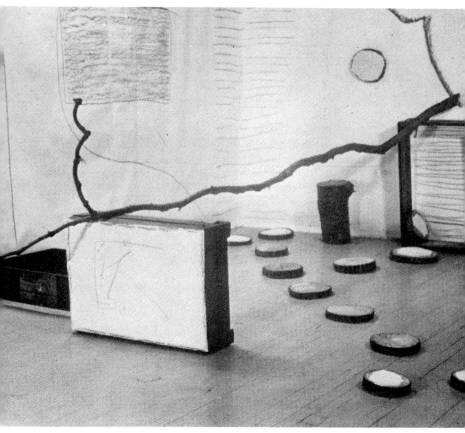

Ree Morton: *Untitled.* 1972. Mixed media. 84″ × 84″ × 132″.

closures, but after the neatly constructed screened racks, the object status became more ambiguous and, at the same time, innocent, obsessive, repetitive. Bundles of branches, cut logs, used more loosely, led her, later in 1971, into a curious area between painting and sculpture, between wel-

Rebound from weight.

Rebus flat and rounded.

coming "environment" and a closed, pictorial space.

Morton uses fences and paths and dotted lines, tables and platforms and panels to isolate forms and directions, to make new connections between them. What appear to be fragments are drawn together by shared shape or connotation into a common space. But once that space is established, it disappears by allusion from its boundaries. A large framed and gated and three-part piece shown in Philadelphia last year revolved around "Sister Perpetua's Lie" from Roussel. A series of drawings reflecting the shapes of the sculptural elements surround the quotation: "To the question, 'Is this where the fugitives are hiding?' the nun, posted before her convent, persistently replied 'No,' shaking her head from right to left after each deep peck of the winged creature." I harp on these literary sources because Morton's work conveys a highly abstract and hermetic narrative quality. Signs and shapes repeated again and again as though to say "*Now* do you see?" are islands in a landscape, things that seem imbued with meaning, but *what* meaning?

Most sculptors working in an area between sculpture and painting limit themselves to bending one or the other medium toward the other (e.g. box-like, planar, relief sculptures, or bulging, shaped or assembled canvases). Ree Morton, on the other hand, straightforwardly combines the two without altering the identity of either. Her drawn or painted sheets of paper on the wall could stand on their own as two-dimensional art, were they not enticed into real space to interact with

Rebut from wall.

Recall the sources.

Recast nature.

Recede from vision.

Recent centerings.

Recess inaccessible.
Recharge images.

Recite other places.

Reclaim other paths.

Recollect from the past.

Reconsider sculpture.

Reconvey drawing.

Record experience.

Re-create what happened here.

three-dimensional elements which, in turn, might stand on their own as sculpture, or as natural "finds." Often the sculpture provides the frame by unconventionally drawing it out from the wall, radically changing the scale of the hanging rectangle. The materials used to perform these sleights of eye are frequently wood—large gracefully sloping tree branches, logs, twigs, stumps, two by fours. (The lines of the branches resemble "drawn" lines without resorting to the forced naturalness of expressionism.)

(Other components: not quite arcs, not quite circles; posts, trunks, logs split lengthwise; dirt and wooden floor sections; the ubiquitous dotted line in two or three dimensions; flattened and rounded tree sections, clay patties, plaques, boards, stones; a rock, a dolly, benches, wheels, trunks that open on spindly legs, fence posts and lopsided pickets; doors, shelves, roofs; hanging, lying, leaning, supported, supporting; a lot of little objects rather plaintively lost in space and then found again echoed in drawings on wall or floor or remembered in similar shapes on the other side of the room —the most precarious aspect of Morton's work, dangerously close at times to fussiness, but usually conquered by associations and alienations clear enough to be provocative, not coy.)

Until recently, Morton's work has lined up against at least one wall, providing an almost Surrealist space by which the sculptural elements elude illusion, but bar entrance. Now some of the pieces lead from the dotted paths of pictorial space into real roads around and into the sculpture. The roofs, shelters, paths, gates, and yards

Recumbent then vertical.

Recur to the left.

Redouble to the right.

Not reduced.

Reenforce dispersion.

Reentry into the wall, then into the room.

Refill containers.

Refine heroics.

Reflect distance.

Reflex muscular consciousness.

Reform divisions between wall and floor.

Refract my associations.

imply architectural plans and an ambiguous area between interior and exterior space. In the multipartite piece shown recently at Artists' Space, based on materials and memories from a summer in Newfoundland, a Magrittean contrast between careful arrangement and natural materials, outdoors and indoors, was intensified by the diffused, artificial "daylight" and the black shuttered windows that pushed one back into the room. In the last two years the "places" have become more schematic, a necessity as they more ambitiously expand and fragment. The ritual quality is also heightened in newer works. The Newfoundland piece was all green and gray and white and natural wood and stone—clean and fresh and peaceful with an almost "homey" intimacy laid over the ominous clarity of a dream. Morton seems to be topographically mapping her own exposed zones, making Japanese gardens of her fantasies, within the limitations of her own loft and house life. The influence of memory is very strong (the stones on wooden pedestals ranged on a "table" in the Newfoundland piece look a bit like souvenirs in a gift shop).

All of Morton's pieces exist in that very controlled, but still dispersed and uncaptured space which hovers between the pictorial and the sculptural (not necessarily in respective relation to the drawn and three-dimensional elements). The space in both her sculpture and her drawings recalls that of the American Indian or of other so-called naïve artists. At the same time, my reference may be to the highly sophisticated use of mul-

Refrain.

Refresh porches, forests, fences.

Refuse constriction.

Regard clearly.

Regenerate where possible.

Regions familiar but unknown.

Rehearse the future.

Reincarnate the present.

Reiterate the last space, changing it.

Reject one order.

Rejoin illusion.

Relay reason.

Release, only so far.

Dotted lines relent.

Relief, sculpture, life, but

Remain still.

Remand order.

tiple viewpoint found in ancient Chinese and other Eastern landscapes. And there is also an openness that is rooted in repetition and "uniformity," the slight awkwardness or confrontational innocence that is an attribute of so much of the best American art. The spaces are compact but welcoming, like little shelters for the expanding imagination, the legendary door in the wall.

Remark the boundaries.

Remount hills.

Remember the last line.

Remote and self-contained.

# Jackie Winsor[*]

Her materials are plywood, pine, rope, brick, twine, nails, lathing, and trees. From them she makes compact objects, natural and easy in their physicality; unpretentious, but formally intelligent in their use of a tension between material and process, process and result. Their immediate impact comes from their scale, quite different from that of much current sculpture because it is so inherent, seems to depend so little on the space in which they are placed. Winsor's sculptures evoke the outdoors, not pictorially so much as by their tensile strength and crude vitality. Yet the process by which they are made is an obsessive, time-consuming one. The natural materials are bound and confined rather than gestural. The nature evoked is Northern in its rawness and rigidity, perhaps reflecting the artist's childhood on the bleak coast of Newfoundland, which "has been made barren both by civilization, when farmers cleared the land, and by nature, the wind and the sea." She admits to a "romantic nostalgic connection" with the place. "It's the scale that has interested me. Most places diminish in scale when you go back to them as an adult. This one didn't at all. New York is the only place I've lived since Newfoundland that has the same sense of scale and dealing with the environment."

Winsor lists her central concerns as "repetition, weightiness, density, and the unaltered natural state of materials." I would have added scale, obsessiveness, time, nature, and a

---

* Reprinted from *Artforum*, 12, No. 6 (February 1974).

visceral body reaction verging on the sensual. Coming into her first one-woman show at the Paula Cooper Gallery in October 1973, where ten pieces lay or leaned or stood about in that vast and pristine space, one's first sensation was of dislocation. The scale of the sculpture is both immense and intimate. For instance, *plywood square* (1973), in which no plywood is visible because it has been wrapped in rough twine until it has become a rounded *and* angular bundle with a surface bound into a cross-shape, first looks little, then when you think of it as little, it suddenly looks huge for something that's little, and you realize it's *big*. Actually, it's just medium size (4' x 4').

The same goes for *bound square* (1972), whose intimacy originates, I think, in an endearing awkwardness engendered by the fatly wrapped corners, then deemphasized by the lean barked trees that seem particularly straight and solid between the rounded corners. Or maybe they are fragile, since they've been bandaged into an "unnatural" form (the square is very rarely found in nature); nature in traction, nature only temporarily tamed. Winsor often refers to "muscle" when she talks about her work, not just the muscle it takes to make the pieces and haul them around, but the muscle which is the kinesthetic property of wound and bound forms, of the energy it takes to make a piece so simple and still so full of an almost frightening presence, mitigated but not lessened by a humorous gawkiness.

Repetition in Winsor's work refers not to form, but to process; that is, to the repetition of single-unit materials which finally make up a unified, single form after being subjected to the process of repeatedly unraveling, then to the process of repeatedly binding or to the process of repeatedly nailing into wood or to the process of repeatedly sticking bricks in cement or to the process of repeatedly gouging out tracks in plywood. Winsor's materials are often recalcitrant; there is an obsessive quality in the way she has to wrestle with them—remnants of a Puritan work ethic, perhaps. For me, the circular rope pieces have less inherent tension because rope does coil naturally (though not around itself). On the other hand, straight or almost straight lines, grids, or squares made from trees, heavy three-dimensional structures made from layers of slender lathing, a coiled piece made of flat inflexible lathing, a central trough gouged unnecessarily from a square of ten sheets of three-quarter-inch plywood— these imply a process that contradicts the basic "natural-

ness" of the materials. Therein lies the "art," since "process" per se was exhausted on a simplistic level some time ago. And some of the sculpture's large scale derives from that kinesthetic sense of how long it took to wrap the bound pieces and how independent the materials are. Energy surrounds and enlarges its fields. While weight and density are obviously important, the hidden elements are more provocative. *Nail piece* (1970), for instance, nine seven-foot planks dotted with nails on each face of each plank, is a physical embodiment of aggression, as is the newest work, the gouged or hacked and gradually recessed laminated plywood square, where, however, each gouge mark is plain to see and feel. In *nail piece,* Winsor was "interested in a feeling of concealed energy. I like the fact that each layer has tons of nails in it that can't be seen." It also has an autobiographical core. When she was around nine, her father planned a house and while he was away at work her mother built it. At one point, "my father gave me an enormous bag of nails and left, saying to nail them down to keep the wood in place. I did . . . and I used the whole bag of nails to do it. The part he told me to nail down needed about a pound of nails. I think I put in about twelve pounds. My father had a fit because I'd used up all his nails. They made such a fuss about it that it left quite an impression on me" (as did the role model her mother provided for an active female).

The basic order, or geometry, in Winsor's work is always thwarted by action or by nature, by the materials' or the process' inclinations toward their own identities. Many women artists working with geometry and obsessive repetition (at its extreme, fragmentation) have come into their own by using a rectilinear framework primarily to contradict it, or within which to perpetrate mysterious rituals of process or emotive content. There is a certain pleasure in proving oneself against perfection, or against the order that runs the world, despoiling neat edges and angles with "homemade" or natural procedures that relate back to the body and personal experience. Winsor's *bound grid* (1971/1972), for example, is a grid, but since the lines are saplings, they are not straight; their natural origins are further stressed by the fact that one of them forks in the center, so that there are ten poles at the bottom of the piece and eleven at the top, complicating the bound intersections and effectively altering the "real grid." The ball-like bindings, in turn, despite their lumpy and irregular shapes (some are smaller than others), return a kind

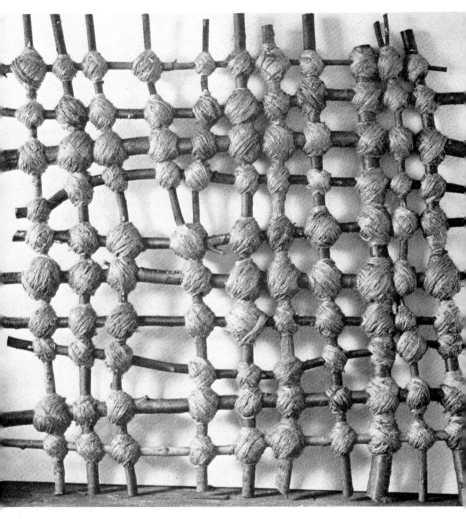

Jackie Winsor: *bound grid.* 1971/72. Wood and hemp. 84″ × 84″ × 8″.
Courtesy Paula Cooper, New York.

of order to the piece by implication; they are "all wrapped up," complete.[1]

The "twine" Winsor used is actually hemp, unwound in bunches from much larger rope, then knotted together, a laborious process which takes on a ritual quality in itself (I once helped unwind some, and can attest to the primitive, spinning-wheel monotony of the task). When I first saw Winsor's work early in 1968, this quality was centered in the image, which was fetishistic. She was working with latex and resin, and the unwound rope she used was fine, like hair. The larger pieces related to body scale, pieces knee-high, waist-high, etc. Then she began working with old, used rope, first covered with resin so it stood up by itself, then less posed, in coils, and rope wound around rope. Then she got hold of some huge rope with which she worked for several years. "I could barely move it, but just dragging it around the studio made it appeal to me much more than the thinner rope." She was pleased when a delivery man came in and saw *double bound circle* (1971), "gave it a tremendous kick and it didn't budge. . . . He seemed to understand its physical bruteness right away."

The sensuous, even sexual, properties of a heavy, languid, but willful line also inspired Winsor's only performance piece, executed in twenty minutes at 112 Greene Street, June 29, 1971. A quarter of a ton of four-inch rope was hauled up from one floor to another, through a hole, by a "long, lean male"; below was a "soft, rounded female" who was feeding it up to him. Then the action reversed and the rope was lowered onto the curled-up female until it covered her completely. "What I wanted to bring out was the kinesthetic relationship between the muscularity of the performers and the muscularity of the rope and the changing quality of the rope as it was being moved. The scale and weight of the rope forced the performers to conform to its properties rather than the other way around."

The performance could be seen from only one of two floors at a time, with the other half suggested. This hermetic aspect appears frequently in Winsor's work. In *brick dome* (1971),

---

[1] See the series of photographs of this piece in process, published in *Avalanche*, No. 4 (Spring 1972), accompanying an interview with Winsor by Liza Béar, from which most of the quotations in this article have been taken; others come from conversations between the artist and the author.

the bricks are stuck into the cement lengthwise, so only half of them makes up the prickly surface, the other half providing a buried core of weight. *Fence piece* (1970), a pen made of seven layers of lathing nailed inside and out, hides its contained space; you can't enter it and you can just see into it. *Four corners* (1972) almost succeeds in hiding the square of logs that is its armature, because the corners have been bulböusly gigantized by hemp wrapping to the point where the corners are really all there is—a contradiction of the square by an oppressively organic repetition. She has also planned an outdoor piece which echoes the performance, as well as Newfoundland's underground rock and often domed vegetable cellars. It is to be a brick tower aboveground leading to water belowground. "The inside would be accessible only by climbing up the chimney and the bottom half of the outside would be completely inaccessible—underground." As Liza Béar remarked, "The viewer would have to become physically involved to really experience the piece," which applies to other works of Winsor's, though in a sensuous mental rather than strenuous physical fashion.

"Indoors the size of a piece is somewhere between your own body and the scale of the room the piece is made in. And what was good outdoors was that I was much smaller than the surrounding space; that changed the relationship between myself and the environment. . . . The outdoor pieces are so specific." The two Winsor has been able to execute (two more are planned for Princeton and Fredonia this year) also imply hidden function. *30 to 1 bound trees*, made in a "very scrawny kind of area" in Nova Scotia in 1971, were giant bundles of somewhat stunted white birch trees bound singly and then rebound together. If one were to run across them accidentally, they might seem to be some local method of storing wood or winter fodder, some practical problem unknown but efficiently solved. The largest of the Nova Scotia tree series is centered around a live tree. "Otherwise how would this structure (20′ high × 5′ across) stand up with the wind blowing over the top of the quarry? It would blow over. They all stabilize each other. As I was making the piece, I got more and more concerned with the fact that the live tree was being nestled inside . . . I saw the live tree as the pivotal part of that work."

In May 1972, deep in the lush southern woods outside Richmond, Virginia, with the help of students, Winsor made a spindly "shelter" or high platform of saplings bound close

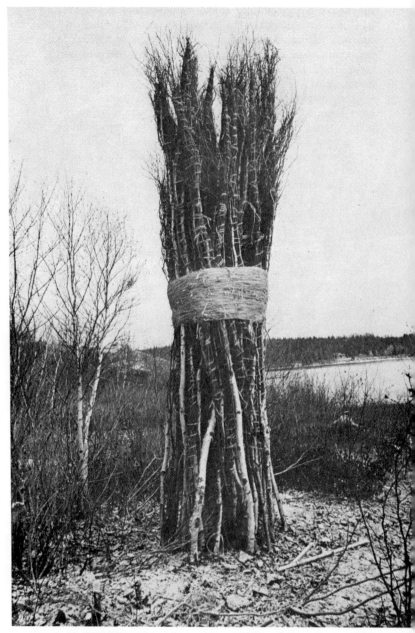

Jackie Winsor: *30 to 1 bound trees.* 1971. Halifax, Nova Scotia.

together with unwound rope. Here again, if one came upon
the piece it might seem to have been built for an extra-
esthetic purpose. Esthetically, however, its relationship to
its environment was highly succinct—at once so close to
nature, in that the raw materials surrounded the structure
made from others like them, and so far from it, in that some
of those small trees had been cut down and tied together to
make a clearly person-made place. More than most artists'
(especially those who just plunk an indoor sculpture down
in a plaza or field), Winsor's outdoor work is so finely attuned
to its natural surroundings that making sculpture outdoors
becomes, in turn, a natural process.

# Mary Miss:

# An Extremely Clear Situation *

Starting out from Battery Park to see Mary Miss' outdoor
piece on a landfill area along the Hudson River; slogging
through the weird pale sand, which had been sprayed with
oil to keep it from blowing away; scanning this black-and-
white "lunar landscape" for art; not knowing what to expect.
Miss has made several outdoor pieces involving "complete
integration between materials, idea, and place,"[1] all dif-
ferent. Accustomed to abstract sculpture installed on urban
sites which often eclipse it, either by overpowering or by
undermining, we spotted some wooden things that might be
construction markers or might be art. Approaching them
from the side—five flat, fencelike forms with holes in them—
I found myself vaguely disappointed, absorbing a row of
serial shapes, a familiar and for the most part exhausted
idea. As a longtime admirer of Miss' work, I should have
known better. Three years ago she had said that she felt
apart from (or "unengrossed by") much of the art that su-
perficially resembled hers. "While people were dealing with
encompassing theories or philosophies—like Minimalism—put-
ting the most theoretical weight on the least complicated
physical object—I have been interested only in looking for,
making, and expressing extremely clear situations."

---

* Reprinted from *Art in America*, 62, No. 2 (March–April
1974).

[1] All quotations are by the artist, from conversations and a
letter written to the author in January 1971.

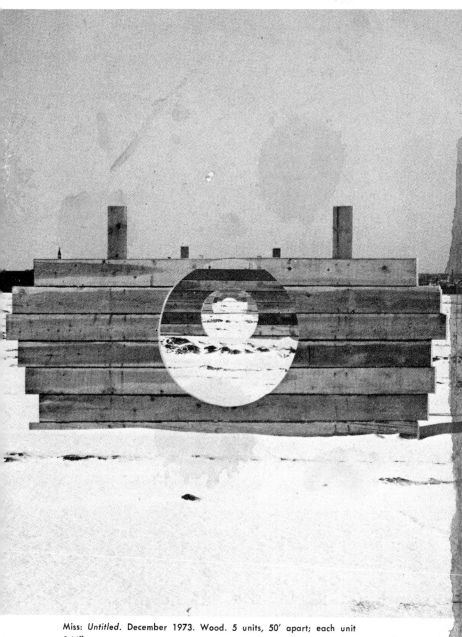

Miss: *Untitled*. December 1973. Wood. 5 units, 50′ apart; each unit 144″.

This piece happens when you get there and stand in front of it. Its identity changes abruptly. You look through a series of descending cutout circles, the first one set so high in the solidly boarded wall that only a line separates it from the sky, the last one only a shallow arc left above ground. The experience is telescopic. As the modestly sized holes (and the adjacent walls that these holes incorporate into your vision) are perceived, they expand into an immense *interior* space, like a hall of mirrors or a column of air descending into the ground. You are standing outdoors; you have approached something which appears flimsy and small in its vast surroundings, and now you are inside of it, drawn into its central focus, your perspective aggrandizing magically. The plank fences, only false facades nailed to supporting posts on the back, become what they are—not the sculpture but the vehicle for the experience of the sculpture, which in fact exists in thin air, or rather in distance crystallized.

Although the piece is about sight, the camera cannot catch it, because being there physically and seeing that sight is more important than perception in any abstract sense. I had supposed its impressive effect of huge scale resulted from a precise understanding and use of perspective, but it turned out that Miss didn't decide on the final distance between the sections until she got them out there and lined them up with the help of a friend who had studied architecture. They were fifty feet apart; each one was approximately 5½ feet by 12 feet. The spaces between the planks were sealed together with tar; these heavy black lines against the light wood echoed the dark-light patterns of the sand; their horizontality echoed the landscape—the sand, the river, and New Jersey setting up several strata. Miss envisaged the skyline hitting the top of the board and "tying the piece into the earth," or in a broader sense, into the site.

> The work I have done has always had a realistic physical motive rather than an abstract or conceptual basis. It uses particular instances of situations or material objects; the pieces are not dreamt up apart or away from circumstances. . . . Many of the things are in fact based upon very practical objects like fences and anchors. . . . If certain pieces take on a geometric aspect, it is not from any interest in this particular form. . . . In working I try to turn a vague impression into something definite. . . . Though there is a very physical basis to my sculpture, the desired result is not to make an

object. I am dealing with individual experiences of reality rather than grids or formulas, and the resulting works are traces of these experiences.

For someone less moved by this piece than I was, it might have been more difficult to waive imposed and formalized perceptions (relationship to better-known work, to programs, critical clichés, and "education" beyond the artist's control) in favor of a concentrated experience. As it is, my only complaint is about accessibility, or lack thereof. Current esthetics demands a certain kind of deserted and desolate or "used" site that allows the sculpture both space and a real isolation from both art and life. These no-man's-lands are particularly well suited to the insistent frontality and environmental incorporation of Miss' work, and if I were the artist, I wouldn't give up these advantages for increased visibility. This piece probably would have been less effective in another location—such as Battery Park itself. However, just because it was so effective, I wish more people could have had a chance to be lured into it.

# Judy Chicago,
# Talking to Lucy R. Lippard*

## I

*You've been showing your work for about eleven years now, but there's never been an article on it, so let's start from scratch.*

OK. When I first started my professional life, in 1963, I was making these very biomorphic paintings and sculptures; I went to auto-body school, because I wanted to learn to spray paint, and because it seemed another way to prove my "seriousness" to the male art world. While I was there, I put my very sexually feminine images on this car hood, which in itself is quite a symbol. Over the next few years, I retreated from that kind of subject matter because it had met with great ridicule from my male professors. There was no radical departure, just a slow moving away from a content-oriented work to a more formalist stance; then, much later, a slow moving back.

In 1965 I did *Rainbow Pickett*—six differently pastel-colored beams, progressively larger in size, leaning against the wall. From 1966 to 1967 I made a number of sculptures, some very large, like the cylinders that filled a room in the Los

* Reprinted from *Artforum*, 13, No. 1 (September 1974). The original taped conversations from which these texts were excerpted took place in Georgetown, Maine, September 1973; they were revised by artist and author in Los Angeles in February 1974. The italicized notes in the middle of the article are by L.R.L.

Angeles County Museum's "Sculpture of the Sixties," and some very small rearrangeable game pieces. I also did some environmental pieces with Lloyd[1] and Eric Orr. By this time I'd stopped using color, because I wanted to force myself to develop the form in the sculpture and, more negatively, because I felt forced to deny parts of myself, as I couldn't seem to fit into the existing structures. It's no accident that it was during this whole period when I was least overt about my womanliness—1965—that I made my reputation as an artist. It was a period in Los Angeles when no women artists were taken seriously. The men sat around Barney's and talked about cars, motorcycles, and their joints. I knew nothing about cars, less about motorcycles, and certainly didn't have a joint. They would not have appreciated my stories about my experiences with various joints, to say the least. A lot of the women artists I've talked to since had little conception that their isolation had anything to do with the fact that they were women. I refused to believe there was something wrong with me personally, and I think that saved me.

Still, as my own level of achievement rose, my career didn't go along with it. When I was twenty-three, I was an up-and-coming young artist and so were a number of other women. As I went along, there were less and less women. As I started getting better and the careers of most of my male peers were going up, mine was sort of staying at the same place. I found I could get somebody to really respond to *one* work; they'd think that *one* was fantastic and I'd get a whole lot of feedback. But no comprehension of my work in terms of a whole series of ideas. I began to realize that a woman can do a single thing—that's sort of an accident; but if she makes a coherent body of work that means she has to be taken seriously in terms of ideas, and that moves into another place in the art world.

*When did you get back to color?*

I'd reacted against having the color on top, like in *Rainbow Pickett*. In the fiberglass cylinders, the color was right *in* the surface. I couldn't have a lot of colors because it was too expensive, so I tried to make a color which, when light hit it, would seem to change. When I began the domes in 1968, I'd arrived at three as the irreducible number of units I could

---

[1] Lloyd Hamrol, a sculptor and the artist's husband.

use and still get the sense of relationship; it's also the primary family unit. With the domes I was trying to explore my own subject matter and still embed it in a form which would make it acceptable to the male art world—that sixties' idea of formalism. It was so frustrating in the art world. I moved outside for technical advice; I went to the du Pont people. They were always fascinated by a woman doing these things, so there was probably a little sexist bargaining going on, but I got by.

I began to lay out the spray patterns for the domes on flat plastic sheets and that led me back into painting. I wanted a framework which would be a parallel to the sense of risk I felt in the subject matter, so I chose a way of working that had a high degree of technical risk. For the next few years, the pieces were phenomenally hard to make. The solvent for the paint was the same as for the plastic. If I made a mistake, I couldn't take the paint off or I'd lose the plastic too. They could be lost at any moment, which also reflected my status as a woman artist. It had to do with violation too, because in some instances I could have gotten the paint off, but I couldn't stand to rub this lacquer thinner into the surface and see it get all gooey. It was somehow like my own skin.

Throughout this period I was also discovering that I was multiorgasmic, that I could act aggressively on my own sexual needs. The forms became rounded like domes or breasts or bellies and then they opened up and became like doughnuts, and then the doughnuts began to be grasping and assertive. I went from three forms to four and started the *Pasadena Lifesavers*. I was developing color systems which made forms turn, dissolve, open, close, vibrate, gesture, wiggle; all those sensations were emotional and body sensations translated into form and color. I called them lifesavers because in a way they did save my life by confronting head-on that issue of what it was to be a woman. And at the same time (January 1969), I started doing the *Atmospheres,* flares of colored smoke outdoors and in the landscape. They're all about the releasing of energy.

*And about the releasing of energy in nonobject terms— something you don't have to worry about or be responsible for after you've done it. You act it out and it goes away, right? And then in 1970 you went to Fresno to start the Women's Art Program.*

Yes. I lived away from Lloyd for a year and tried to begin to undo the damage I'd done myself competing in the male

art world. I wanted to make my paintings much more vul-
nerable, much more open. The *Fresno Fans* are based on a
body gesture, reaching from the center core or protuberance
or slit, from flesh to sky, like *Desert Fan.* "How do you fit
a soft shape into a hard framework?" was what I wrote on one
drawing. The confrontation really came in *Flesh Gardens*
the same year, where simple rigid structures melt into very
soft sensations. It had to do with feminine and masculine,
open and closed, vulnerable and rigid. But the paintings
were still very formalized, the content still indirect.

*Do you equate the incredible compulsiveness involved in
that technique with the attention to detail and obsessiveness
in women's work in general?*

Absolutely. Also, never allowing myself to make a mistake,
in being a superwoman in male society in order to avoid being
put down.

*Is it also a discipline and framework to work against? Is
that part of the hard-soft thing?*

It's very complicated. There are parts of it that have to do
with struggling against the confines of the male structure and
another part to do with the establishment of a new structure.
By then, I had also gotten to the point where I was very good
with a spray gun. It's difficult to work intuitively with a spray
gun if you're dealing with forms, especially balancing a care-
fully sprayed and rigid surface against a soft overlay, which
I could do later. There's something fantastic, though, about
that process, about playing on that edge; you can just push
it and lose it. It's so tempting, because it's trying to pursue
perfection, like the perfect orgasm, perfect pleasure, and you
know you always have to stop just before it's perfect; you
know if you just go one more second and try and make it per-
fect, you'll lose the picture.

*But recently you've been working on canvas instead of
plexiglass.*

I didn't want to hide the image behind a lot of trans-
parency and reflectivity, I wanted it right out in the open and
very plain. Canvas is much softer and more receptive too. It
doesn't fight me. Anyway, I had kept on thinking that if my
work got better, everything would change. I wanted it to
be seen as a body, so I had this big show at Cal State Fuller-
ton. I also changed my name at that time from Judy Gero-
witz to Judy Chicago, after my hometown. I wanted to
make a symbolic statement about my emerging position as a
feminist. And I wanted to force the viewers to see the work

in relation to the fact that it was made by a woman artist. Now I can see that the years of neutralizing my subject matter made it difficult to perceive the content in my work. Even for women.

I believe that if one allows oneself to meet my paintings on an emotional level, one can penetrate the plastic and the formalism and find that soft center I was trying to expose, though with difficulty. But I wasn't prepared for the total misunderstanding that greeted the show in 1970. I had to face the fact that my work *couldn't* be seen clearly in the male art world with its formalist values. So I was faced with a real dilemma. I wanted other women to profit from what I'd gone through and I wanted men to change their conception of what it was to be a woman, of how to relate to women, through my work. But where was I going to go? There was back to artmaking as it was done in the male community, or what? I thought I'd have to go off and exist as a recluse as O'Keeffe had done, simply wait for my work to be understood, but I didn't like the prospect. I think O'Keeffe was our real pioneer, the first woman to stand her ground and make a form language that could deal with the whole range of human experience. However, I think her work paid an enormous price because of her isolation. There's something almost inhuman about it. I picture her as a kind of iron rod —grim, straight, determined.

*And she doesn't want to think of herself as a woman artist at all.*

I don't blame her. Who *wants* to deal with one's situation as a woman artist? I felt the only thing I could do was to commit myself to developing an alternate community based on the goals and ideas of women, built out of all I'd discovered from our own heritage. So I went to Fresno and set up the women's program and a year later brought it back to Los Angeles and set up the Feminist Art Program at Cal Arts with Mimi Schapiro. These programs were the first step in building an alternate art community. We went from education to exhibition space to consciousness raising in the community, and then, finally, this year, to establishing a coherent alternative, the Woman's Building, which allows us to deal with the whole process—education, exhibition, criticism, documentation of feminist values. . . .

*Didn't you give up art at some point, though?*

At Fresno I found that the most natural and direct way for

the women to get at their subject matter was to act it out, and I worked with theatre and film. I thought to reveal my content directly I'd have to stop painting and sculpture completely. I came back to Los Angeles and gave up my large studio and worked in a house space. I cut off my hair. I did the Tampax lithograph and then the menstruation bathroom at *Womanhouse*.[2] I started writing my book.[3] I had already started to lecture and get out into the world. I was trying to violate all those preconceptions about what you're supposed to be as a woman artist, and I was opening up areas of material I could then begin to deal with visually.

Moving into the world helped me discover that people didn't drop dead when I expressed my struggles and experiences as a woman and that gave me a tremendous sense of confidence and turned my whole sense of self around. When I went back into my studio, I went back in a whole different way. I wasn't there to get approval, but because I wanted to express certain things I thought and believed. I realized that I could use the form language I'd already developed to make clearer images. So I plowed right back in, trying to speak more specifically about my subject matter. I'd gotten this image about where I was. I hadn't really moved to the other side. I was pushing at the boundaries, internalizing the idea that a woman could shape values, shape culture, upset society. To me, the flower in O'Keeffe stands for femininity, so moving through the flower is moving into some other place. With the *Through the Flower* series, I started to build on other women's work. Like the grid in the *Fleshgates* is built on Mimi Schapiro's paintings; I related to it as a kind of imprisonment. I wanted my work to be seen in relation to other women's work, historically, as men's work is seen. What we're really talking about is transformational art. In the *Great Ladies* series, begun in 1972, I tried to make my form language and color reveal something really specific about a particular woman in history, like the quality of opening, and blockage, and stopping, the whole quality of a personality. The *Great Ladies* are all queens—Christina of Sweden, Marie

---

[2] An entire house remodeled and made into environmental art by the students of the Feminist Art Program at the California Institute of the Arts during 1971 and 1972.

[3] *Through the Flower* (New York: Doubleday, 1975); reviewed by L.R.L. in *Ms.* (August 1975).

Antoinette, Catherine the Great, and Queen Victoria. There's a level of literalness in them, and a level of emotional meaning.

*It's one thing to have art that's just illustration, but it now seems clear that if it's "readable" on several levels, it's fuller, more communicable. What led to the writing on the canvas?*

As I went along, I began to be dissatisfied with the limits of abstract form language. I wanted to combine the process of working and the thoughts I had about all these women I was reading about, to force the viewer to see the images in specific context and content. So I began to write, at first on the drawings, which I'd done before but never brought all the way into my work. I thought it was fantastic when people told me it made them feel like they were right there with me while I was making the work. For me the real crux of chauvinism in art and history is that we as women have learned to see the world through men's eyes and learned to identify with men's struggles, and men don't have the vaguest notion of identifying with ours. One of the things I'm interested in is getting the male viewer to identify with my work, to open his eyes to a larger human experience.

In the *Reincarnation Triptych*, each 5-foot canvas is an inside square in relationship to an outside square; each is named after a woman whose work I really identify with—Madame de Staël, George Sand, and Virginia Woolf. The border around each picture has forty words on it about the woman. The change in the nature of the image in the three paintings reflects two things—the change of consciousness through the last two hundred years of women's history, and a stage in my own development. In *Madame de Staël*, the inside square is very bright; it's in front of a much softer color, hidden and protected by the bright one. It says "Madame de Staël protected herself with a bright and showy facade" and it stands for me protecting myself with the reflections and transparencies and fancy techniques in my earlier work. In *George Sand*, the inside and outside are more at odds, like the inside wants to come out and the outside is stopping it. A strong orange glow in the center represents her/my repressed energy. In *Virginia Woolf*, the central square is just a shadow behind the other. At first, I wondered if the third painting should have no square at all, and I decided that would be dishonest. I didn't come out of all that struggle undamaged.

That triptych is a real summation for me. I made these paintings twenty years after my father's death and ten years

after my first husband's death. It's really connected to re-birth. After that, I did the *Transformation* paintings, first the *Liberation of the Great Ladies,* and then *The Transformation of the Great Ladies Into Butterflies.* The writing between each set of images refers to my own feelings and is aimed at being embarrassing and exposed, because real feelings are embarrassing in our culture. Now I'm about to make a change in my work; it's overlapping. Probably because of my experience with so much death, I can't stand to separate. I always have to start something while I'm ending something. So for a year I've been studying china painting. Ten years ago I was in auto-body school—an entirely male-dominated scene—and now I'm studying china painting—an entirely female-dominated scene.

*And the images are closely related.*

Yes. The main difference is that the butterfly images ten years ago were imprisoned images, and the new ones are liberated images. This decade of my life has really been about that.

## II

*Chicago's leadership in the feminist art world has led to an amazonian public image and expectations that she is further along in her struggle than she could in any realistic way have been. When I went to California to see the new work for the first time outside of slides, I went with a certain trepidation, afraid of not liking it as much as I wanted to, because of the gap I had previously found between her ideas and her objects—a gap inevitable and still present, though narrowing, because of the grand scope of those ideas; a gap that is partially the result of her integrity, persistence, obsession, her refusal to do anything halfway. It has, she knows, slowed her down, and that has made the gap obvious outside her own community in a way that might seem unnecessary, since she is intelligent and art-knowledgeable and could have done things otherwise, abruptly imposing her ideas on her work rather than allowing the work to absorb the ideas at a more natural pace. Given her own code, she could only do what she has done.*

*I went and looked, and we talked about the gap—a somewhat agonizing experience for both of us. But looking, I realized that the new work made much of the older work look almost sterile, which meant to me that what I'd hoped*

*would happen was happening.* George Sand, *for instance, is a truly impressive painting by any standards, with a sparkling clarity and an easy, not rigid, compactness. The extremely subtle colors are less luscious, more grayed, than before; the handwriting here and in the other two paintings is an integrated formal element as well as the purveyor of added information.* George Sand *is in the middle of the triptych and it crackles, where* Madame de Staël, *before it, preens, and* Virginia Woolf, *after it, smolders.*

*Scrutinizing my reaction, I see that I like the puritan note in* George Sand—*the grays, the simultaneously immediate and reserved impact, and I suspect that some of the problems I've had with Chicago's work in the past are temperamental ones. I've never been particularly involved with color art (too pretty, decorative, not "hard" enough—results of temperament? ignorance? artworld conditioning?). We have a different experience of sexuality, as everyone does, and she is trying to make her own sexuality act as a metaphor for the metaphysical condition of an entire sex, an entire social potential. That is quite an undertaking.*

◦

*I saw a new series of what were to be prints, but remain working drawings because the man running the workshop irrationally decided not to go ahead with the project after two months of work. Chicago was distraught, and consigned her despair to the drawings—a group of six* Compressed Women Who Longed to Be Butterflies—*each one an entirely different image and different color scheme based on a circle beginning to open up into winglike halves. Each already contained writing, in the form of a very regular script worked into the images, about these women (some historical, some fictional), as well as marginal notes about the technical execution of the projected prints, which would not have appeared on the finished product. Now they contain as well the angry annotations of a foiled artist concerning the events leading to their abortion. These, ironically, enhance their effect. Where they would be the usual beautifully finished products as prints, the circumstances of their extinction have lent a warmth and passion always present at the core of Chicago's art, but not always fully accessible to the viewer of the completed work.*

*A second drawing series, done around the same biographically dismal time, are on the theme of rejection (the artist's own, by a Chicago dealer who "adored" her slides and*

**Judy Chicago:** *Female Rejection Drawing,* from *The Rejection Quintet.* 1974.
Prismacolor on rag paper. 40″ × 30″. Photo: Frank J. Thomas.

*promised a one-woman show but failed to "respond" to the
paintings when they arrived, and so canceled it). "How Does
It Feel to Be Rejected? It's Like Having Your Flower Split
Open" is written on the top and bottom margins of the
image, which is of just that. Here again, what is beautiful
for me is not merely the visual attractiveness (Chicago is a
mistress colorist), but her acceptance of, or insistence on,
the honesty of a life element without the consequent devalu-
ation of the image itself into sentimentality.*

<p style="text-align:center">❋</p>

I am beginning to see that although I have been put off
by a certain harshness and tightness in some of Chicago's
earlier work (Pasadena Lifesavers, *despite their gentle color,*
and Through the Flower, *despite its clear content), she will
have been wise to retain that quality rather than to abandon
it. Those polarities are important. My own taste leans to
works like* Desert Fan, *with its horizontal expansiveness, the
way the soft and floating color simply disappears into the
open air. At their best, Chicago's paintings are both tactile
and ephemeral.* Reincarnation Triptych *is tightly controlled
but also, somehow, relaxed—something to do with expansive-
ness again, or continuity, with the way the ripples in each
painting reach the border, but even then you have to go on,
reading words around the edges, turning (the way the* Pasa-
dena Lifesavers *turned retinally) and leading back into the
center, where it all began. In* Let It All Hang Out *too, the
hard divisions are overcome by intensity; it is knife-edged,
but it literally breathes in its gill-like center section. What I
tend to focus on, then, is the vibrations between centering
and expansiveness—the same feeling I get from an empty
land or ocean horizon over which the light is concentrated on
one point. The ease with which some of the softer works are
executed is voluptuous, but that ease is deceptive; all the
paintings still employ extremely complex and usually sys-
tematic spectral mixings and crossings. Others are repellently,
rather than welcomingly, tactile, an aspect that is more ef-
fective in* Heaven Is for White Men Only—*a brutal and
disturbing painting, with flesh turned metallic like hate
and hostility.*

<p style="text-align:center">❋</p>

*I was impressed with how controlled the* Atmospheres *were
when I finally saw the documentation, having only heard
about them before. I had pictured them as single puffs of*

Judy Chicago: *Gray Atmosphere*. 1969. Los Angeles, California. Pyrotechnics (flares). Photo: Lloyd Hamrol.

colored smoke, but some are composed like paintings, in different colors and times and spaces, orchestrated clouds of chroma. (Jules Olitski once wrote that he wanted to paint in midair; Chicago did it.) In others, the landforms are carefully taken into account and made the vehicle for an ecstatic release of color. Lights emerge from pockets of rock or earth and create their own contours. The Atmospheres, too, turn out to be about control and beauty—two fundamental elements of Chicago's work, which imply a certain need for perfection, or survival. I can see this as a metaphor for the depth

*of her commitment to the process of artmaking as well as to her content; still, perfection always carries with it the inherent danger of blandness, of the too perfect. There is also a basic problem about "opening up" from so controlled a base as a means of establishing "new structures," given all the ultra "free," magnificently or uselessly sloppy art there has been in America for the last three decades.*

*I am still in some senses caught between the two aspects of Chicago's work that are her own Scylla and Charybdis; seeing it as "art" as I have been trained to recognize it, and seeing it as a feminist myself, deeply committed to the possibility of women playing a major part in freeing "art" from the idiot products of its own incestuous conduct; this too involves training, if of a more voluntary type. I am wholly sympathetic to her struggle to integrate these two aspects and I love and admire the artist as a person. Such personal "admissions" will be seen by some as damaging, which just goes to show how far from emotional realities art criticism has drifted. It is an admission I might have made about most of the art and artists I've written about in the past, but did not, for obvious reasons.*

*So if Chicago's art is not yet "universal," neither is much (or anything?) else being made today. Like all art, for better or worse, it depends on the particular education, experience, and insights of the viewer. It may be that she is as subversive in that private place from which real art has always come, a place which makes its own goals, as she is in her role as feminist spokeswoman. She is putting herself in the position of trying to make a truly private art truly public—a highly vulnerable and generous position. The rewards are just beginning to come in from the female community in terms of communication—supposedly the prime point of art in the first place, but much neglected at the moment. Last fall's show at Grandview, in the new Woman's Building, where she wrote on the walls and around the paintings in the same fine script found on the work itself, was received with great emotion and enthusiasm by men and women alike.*

## III

I see the development of abstraction as very important in the development of a female point of view in art. Before that it was simply not possible to deal with certain areas of experience and feeling. Ruth Iskin has written about how

when women began to be able to study from the nude, they didn't reverse roles and deal with the male figure as a projection of their own sexuality, as men had. They dealt with women as people and simply left that area alone. I couldn't express my own sexuality by objectifying it into a projected image of a man, but only by inventing an image that embodied it. That is basically a feminist posture, and I don't think it was possible before the development of abstract form. And of course only by exposing the most truly human inside us will we be able to reach across and bridge the terrible gap between men and women which is five thousand years wide—the years men have been dominant over women.

*As you know all too well, a lot of people see your work as just more abstraction of a type they're already familiar with instead of as dealing with any new content in any new way. In the most superficial terms, the color and technique are "California things"; a Chicago friend says your obsessiveness is "a Chicago thing," and so on. How do you deal with that?*

It's not only the making of art but the perception of art that is too formalized in our tradition, and has to be opened up to a new human dimension. I had one problem making my art accessible to my nonart female audience, and another in terms of the art audience. I want to make some new bridge between artists and community. And I want to demystify the process of making art.

*What about your emphasis on central imagery, or "female imagery," which is wildly controversial, to put it mildly?*

In my mind if something wasn't named it didn't exist. I wanted to name the subject matter I was involved with. Other women told me they too were trying to deal with subject matter about their own identities, behind a kind of neutralized abstract structure. I never meant all women made art like me. I meant that some of us had made art dealing with our sexual experiences as women. I looked at O'Keeffe and Bontecou and Hepworth and I don't care what anybody says, I identified with that work. I knew from my own work what those women were doing. A lot of us used a central format and forms we identified with as if they were our own bodies. I'd say the difference between *Pasadena Lifesavers* and a Noland target is the fact that there is a body identification between me and those forms, and not between Noland and the target. I really think that differentiates women's art from men's.

*At least that particular kind of identification with a central*

*image is closed off to men, simply because their body forms
don't contain.*

Reading and studying for the past five years in women's
history and literature and art, I discovered a coherent body
of information, a whole subcultural perception of the world
that differs from men's. Once I established this context, I
could plug into it, into a dialogue with those other women.
What has happened to all of us over and over is that our
work has been taken out of our historical context and put
into some mainstream context it doesn't belong in; then it is
ridiculed, or incorrectly evaluated. It's also important to re-
member what the climate was when I said women made art
different from men. That was a real tabu. Everybody flipped
out.

*In New York it's still ninety-nine percent tabu, even though
everybody has to admit a woman's biological and social ex-
perience is entirely different from men's in this society, and
since art comes from inside, it must be different too. But
people are still ashamed to say they're women people.*

I've done a lot of thinking about why there's resistance to
the idea. I think it's unconsciously based on the notion that if
women make art differently from men, it means that women
are in actual fact independent from men. And if you are in-
vested in the structure and values that male dominance has
provided, even if you're involved in being dominated, or if
you want validation from those institutions that have grown
out of that structure, then you don't want to recognize that
women exist separately from men. I didn't have to go outside
the structure of art to understand the whole value structure
of the society, because what subject matter and what forms
are important, and what the nature of art is and who defines
it and who makes it, and how much it costs are simply pro-
jections of the male value structure. If we as women chal-
lenge those values in our art, then we are challenging the
whole structure of male dominance. That means you have to
move outside of the structure of the art world, because you
don't get brownie points for telling men to fuck off.

The way women have been oppressed has revolved around
our sexuality, either by turning us into sexual objects alto-
gether or by denying our independent sexuality. Men's work
in this area is not informed by that incredible urge to say "I
am, I am, I am, and this is who I am," which is basic to a lot
of women's work whether they work abstractly or figuratively.
Our sexual identities are very basic to our whole perception

of the nature of reality. To change that basic ordering of things, to reevaluate what it is to be a man and what it is to be a woman, actually leads you into a reevaluation of everything. The problem for women's art, and certainly the problem for "high art," lie at this point of confrontation with society. If it is not perceived that my work is about the nature of women, then all the other things that are in my art are invisible. That's where the value confrontation has been so frustrating for me.

You have to remember, I observe as an artist; I look at work in terms of content and subject matter. I feel very alienated from most art that's made; it exists in narrow strata and does not come out of the depths of human emotion and experience. I can't relate to work that is cerebral and has to do with process or the nature of art. That's dehumanized. And I want to continue my struggle to eliminate that dehumanization from my work, because I know it's still there.

*A lot of work you find dehumanized and still neutralized, I find very moving, because I see so much neutralized work. There is plenty of women's art that formally resembles men's art, but often there's a very different aspect under there somewhere. That's what gets to me. I want to find out what that is, that sensibility which exists even in the "middle ground" women's work you find it hard to deal with. I want to try to be more specific about that, find ways of looking at women's work that provide insights and make more people aware and able to deal with it, even if no conclusions are drawn. I don't really care about conclusions, or theories; they contradict each other too convincingly, too easily.*

There's a difference between female point of view and feminine sensibility. You're talking about feminine sensibility, something about the female personality structure that informs the works.

*I'm also curious about how much of that is conditioning, and how much is highly conscious female, i.e. feminist, point of view. I think it's going to be years before we can really put our finger on female sensibility. I like the idea of isolating it, but once I do, I may just be isolating what's happened or happening to women, rather than what we are.*

Absolutely, but of course you could say the same thing about men.

*On the other hand, we may be seeing female sensibility in a purer and more innocent form right now, because of the isolation of women until now.*

What we're really talking about is not the subject matter, but where the approach to the work is conditioned. Those women involved in weaving and sewing and all—that's informed by feminine *sensibility*, by role conditioning, and a certain sensitivity to surface, detail. You see it in writing, too. My investigation of women's art has led me to conclude that what has prevented women from being really great artists is the fact that we have been unable so far to transform our circumstances into our subject matter. That is the process of transformation men have been able to make while we have been embedded in our circumstances, unable to step out of them and use them to reveal the whole nature of the human condition. I feel that I'm just about to make that step, but it wouldn't be possible without the alternate structure of the Woman's Building.

# Pandora *

GUSH. OOZE. Matter. Things coming out that should be kept in. What on earth? No. Not here. Yeccchhh. You must be kidding. Try to restrain it. It keeps on coming. I mean, this is a public place. After all. Why did you have to open it? Where is it all coming from? I didn't, I don't want to know what's inside. It's really not nice to show me if I don't want to know. Part of my education? Of life? Oh!

Marjorie Strider's art has not really changed since she began her mature work, although change is one of its components. The subject matter has been movement, manipulation, time, whether it has been imposed upon pictures of bathing beauties, vegetables, clouds, windows, water, brooms, Greek vases, brand-name boxes, or words. It has never been pretty; is, in fact, usually awkward, funny, grotesque, or heavy-handed. Earnest. Although technically ingenious, her built-out, and later burst-out, forms are never slick enough to seem easy. Another component is uneasiness. I often think when I see her sculpture that surely it could have been "done better." But what, and how, and why? Since it makes such a point of not being done better, or rather of ignoring the virtues of ease, of remaining stubbornly antiromantic and at the same time antipragmatic.

---

* Reprinted from *Strider: Sculpture and Drawings*, Weatherspoon Art Gallery, The University of North Carolina, Greensboro, North Carolina, October 16–November 10, 1974.

231

Marjorie Strider: *Brooms.* 1972. Styrofoam, urethane foam, oil paint.
60″ × 132″ × 120″. Courtesy Nancy Hoffman Gallery, New York.

Her pieces are more real than Surreal, but real what? A
broken cement bag, a powdered-soap packet, a soda box,
an anonymous carton—these might conceivably be expected
to spurt a viscous mass of colored somethingorother. But a
book? (purple prose). A broken Greek vase? (explosive con-
tent). The year 1973? (lurid past). Serial is more like it, but
despite her involvement in performances and progressive

visual readings, there is no resemblance to the cult of per-
mutations except the intelligence way behind the scenes.

The most interesting nonformal aspect of Strider's work is
its eroticism, its need to "let it all hang out," its inelegant
assertion of the flesh. A passionate exposure, activated in-
teriors, blobs that threaten to envelop the preconceptions
you're standing in. The most interesting formal aspect about
Strider's work, aside from its awesome bulk, is its mixture
of two and three dimensions; as Michael Kirby remarked:
"Painting has been forced upon, and controls, sculpture." I
remember a group of works from several years ago: bulbous
free-hanging clouds and moons had the windows through
which they were seen depicted on their contoured surfaces,
depriving the window of its flatness, but not the view of its
distance. Around the same time Strider made a beautiful
paradox in which a solid chunk of sculptured wave surface
was activated by water pouring over it. Two kinds of move-
ment—pictorial and real. That confrontation is, if anything
is, her style.

Strider has equated her work and her life. About her work:
"Everything a movement from the wall to the middle of the
room and back again . . . a breaking out, a flowing . . .
to make round and flatten out again . . . motion existing in
going from fullness to fractional and back again . . . eventu-
ally, for the perfection and fullness of life, a synthesis of
things . . . everything coalesced into one moving entity."
And about her role as a woman and an artist: "Out from un-
derneath to the outside . . . from being thought odd to
being realized . . . from being an object to being a being
. . . out from sex as a barter system to sex as pure enjoyment
. . . from being small to being large and always moving
only out and up . . . the motion being one huge expansion."

It's spreading.

# May Stevens' Big Daddies<sup>*</sup>

Big Daddy is watching you, but with total incomprehension, with his phallic, bullet-shaped, bomb-shaped head, with his baby fat of useless age, himself a prick with the bulldog— *his* prick—secure in his lap. His eyes are blank or blindered. His costume varies, but his complacency, his passivity, his "male authoritarian figure" remain the same. He is watching the world go by, the world for which he is responsible, and his expression does not change. Wars against defenseless villagers, the oppression of women, racist murders, economic discrimination against more than half the world, children not allowed in schools—"yes, yes," he nods sleepily (or shrewdly), "that's the way it is." He is sometimes draped by the stars and stripes, by army helmets, or police uniforms; his round bare ass and back may be turned to George Jackson's visionary glance; he may be mirrored in indecent twinship with himself or multiplied into the mob he symbolizes. He may masquerade in a cowboy hat or a gray flannel suit, but his original incarnation is the truest one. Big Daddy is May Stevens' father. In 1967 she painted his portrait in an undershirt, his back to a blank TV set in a dark room. There was still a glint of kindliness in his face then, a glint of bewilderment, a hint of the ambivalence his daughter must feel in making one of her progenitors a symbol of the world's destructive forces. But since then, his own fantasies have

* Reprinted from *May Stevens: Big Daddy 1967–75*, Lerner-Heller Gallery, New York City, March 1975.

obscured him, and his monumental frontality carries no human aspect. His face, and still more so his body, are entirely soft and mean. He represented to her "a closed attitude toward the world. It was a middle-American attitude toward culture, toward politics, toward Black people, and toward Jews. He was a person who had stopped thinking when he was twenty and hadn't opened his mind to anything since."[1] Soon after she made the first portrait, Stevens was a visiting artist at a Midwestern college. Her stay there "exacerbated my antiwar feelings and my anger at the ignorance and callousness around me. I felt deeply implicated. These people were my people, my relatives. I understood them; I loved them and hated them." While she was working on the subsequent series, she demonstrated against the war, and her son was called to register for the draft.

Passion seems to have mounted accordingly. The form and content so effectively established, repetition brought Big Daddy an icon status. For the artist, one suspects that he eventually became an abstraction. The "cool" style is also a metaphor for the detachment she feels from her own people. The almost voluptuous contour of the round but hard head, the blatant flatness and emptiness of his background, contrasts with the modeling in his features (and those of his canine avatar) and make him a commercial trademark—not quite decorative enough to fall into the hard-core Pop Art category, not quite trivial enough to be real merchandising. Brutality made nearly palatable. There is a nice irony (and perhaps a certain decadence) in the treatment of this obscene figure as a desirable product. But product he is. Stevens is using the means by which patriotism is sold to middle America to reveal the rottenness of that same patriotism. Big Daddy and his dog are not so much the double sides of humankind—mind and bestiality—as they are a single side; in fact, the image is the epitome of one-sidedness, of the flat, the cruelly bland. It raises the question: How has such an obviously pathetic creature attained such heights of power over others whose human attributes are much more developed and admirable? How indeed!

"Political art" is an unresolved subject at the moment, especially within an art world and larger society which ab-

<hr>

[1] The quotations are taken from "Conversations with May Stevens" by Cindy Nemser, *The Feminist Art Journal* (Winter 1974–1975), and from a recent statement by the artist.

May Stevens: *Big Three*. 1975. Acrylic on canvas. 72" × 90". Courtesy Lerner-Heller Gallery, New York. Photo: Bevan Davies.

sorbs all dissent with such ease. The only real political art is an art with political effect, and that is far rarer than art with political subject matter. It does not exist in museums and galleries. Most political art, as Stevens realizes, preaches to the converted: "I don't think that art should be manipulative or should try to achieve effects on people in terms of spurring them on to action or even educating them or propagandizing them," she says. "If my art can confirm or affirm

a certain world view, fine, but it's not out to change anybody's mind." Stevens' work is instead a subtle reminder of our real-life political situation. When she showed her first political painting, in Paris in 1951, a critic "liked" it but did not approve of political emphasis in art. This is a curiously common attitude. In a post-Duchampian and -Warholian day when *all* materials and activities and subjects are automatically accepted as art-worthy, overt politics remains virtually the only tabu.

Stevens has avoided a shrill overpainted style as she would avoid rhetoric. Big Daddy is grotesque but not too grotesque. He is, in fact, frighteningly ordinary; not really caricature because not really exaggerated. There *are* people like this all over the place. His quietude is more chilling than Hitlerian histrionics at this point in time. His solidity, "his mass, his authority, and his unimpeachable rightness" (I'd say righteousness instead)—which is how the artist described Ingres's portrait of Louis Bertin—is a foil for his ignorance and bigotry. The control is not only part of an esthetic contemporaneity—of Pop Art and color abstraction—but has an inner source as well. It is a graphic representation of the authority figure with which all subordinates must contend, an authority figure which has a special meaning for a woman in a male-dominated society. Stevens brings to the *Big Daddy* paintings a controlled but powerful rage against imperialism on the foreign and the domestic fronts.

# Louise Bourgeois:
# From the Inside Out*

It is difficult to find a framework vivid enough to incorporate Louise Bourgeois' sculpture. Attempts to bring a coolly evolutionary or art-historical order to her work, or to see it in the context of one art group or another, have proved more or less irrelevant. Any approach—nonobjective, figurative, sexually explicit, awkward, or chaotic; and any material—perishable latex and plaster, traditional marble and bronze, wood, cement, paint, wax, resin—can serve to define her own needs and emotions. Rarely has an abstract art been so directly and honestly informed by its maker's psyche.

Each period of Bourgeois' work tends to correspond to the hidden rhythms of her life at the time. It ebbs and flows between anxiety, tenderness, fear, rage, and, sometimes, a stoic calm. Obsessed with her content, she moves back and forth between techniques and styles, doing what she has to do to exorcise the images that haunt her. The resulting unevenness reflects primarily an internal erraticism and only secondarily an external eclecticism. While her work has formal affinities with that of artists as diverse as Miró, Kiesler, Hesse, Arp, Hepworth, Giacometti, or the Salemmes, it so clearly has other origins that such comparisons are far less interesting than the violent clues to the artist's intentions which provide the aura for these forms. I am also reminded by this almost animistic oeuvre of various "primitive" artifacts, of their emotive qualities more than their formal influence (shared

---

° Reprinted from *Artforum*, 13, No. 7 (March 1975).

by the Cubists whom Bourgeois knew in Paris, by her friends among the Surrealists and the burgeoning New York School in the 1940s and 1950s). Much tribal art is made to ensure continued contact with natural forces, to ward off evil, encourage good, and to deal with fear. Bourgeois' animism serves similar functions.

Her references are frequently nostalgic. She traces her obsession with houses and rivers, and all they imply as symbols, to her childhood along the Bièvre River. (Bourgeois was the daughter of two self-employed tapestry workers with roots in Aubusson.) It would, however, be a mistake to see Bourgeois as the classically "feminine" artist, adrift in memory and intuition, for her first formal "revelation," and the origin of her love for sculpture, was solid geometry. Although from the age of fifteen she worked with her parents as a draftswoman restoring ancient tapestries, she majored in mathematics at school, took her baccalaureate in philosophy, and studied calculus and solid geometry at the Sorbonne. Only in 1936, at the age of twenty-five, did she begin to study art history and art—with Léger, among others. She arrived in New York in 1938—French, newly married, appalled by the impersonality of the skyscraper city, already a loner and something of an eccentric.

A lasting preoccupation with "the relation of one person to his/her surroundings"[1] was augmented by her spatial fascination with and alienation from New York. The small surrealizing paintings and stark engravings—graphic representations of sculptural forms—made in the 1940s dealt with "uneasy spaces,"[2] a world where the embrace is smothering. Recurring themes were containment, the woman's body-house; the frustrated desire for escape (ladders going the wrong way, a balloon hovering desolately in a room, foiled by too small a door); houses with wings or containing fires "against depression"; looming columns with circular eyes; a "coffin, for time that is gone." Anxiety is pervasive in these highly autobiographical works which reflect the artist's view of herself as a little girl—"trying to be good and absolutely disgusted with the world."

Another constant theme is the hermetic portrait. Bour-

---

[1] All quotations not otherwise cited are from the artist in conversation with the author, fall 1974.

[2] Daniel Robbins, "Sculpture by Louise Bourgeois," *Art International* (October 20, 1965).

geois' first two sculpture shows, in 1949 and 1950 at the Peridot Gallery, consisted of a series of painted black, white, and red wooden pole pieces brought together in an empty room as an environment of abstract *personnages*. The lovely stemlike figures stood in couples or alone, and observers remarked a painful sense of isolation. Each piece was pointed, "reluctant to touch anything, fearful of life itself." Their hooded, ghostlike quality, reminiscent of primitive ancestor totems, was indeed part of a private ritual by which Bourgeois could "summon all of the people I missed. I was not interested in details; I was interested in their physical presence. It was some kind of an encounter." She also had "a portable brother—a pole you could carry around"; the abstract portrait of one of her sons as a child is in the form of a freelying wooden knife—the bottom forked, the sharp top painted in a "window" pattern; upside down it resembles a horned Bambara mask.

In the 1960s, pieces with repeated leaf and tentacular shapes on one base, usually surrounding a single form colored or shaped differently, evolved into the "crowds" of breastphallus protrusions, fingerlike growths, rounded cylinders with various vertical or horizontal emphases. Sometimes these are flexible bunches, pushing up through the rough terrain, sometimes bullet shapes on flat platforms, sometimes sensuously shining domes covered by a Baroque drapery from which some emerge, beneath which others hide. These last are titled *Cumulous*, recalling earlier drawings of clustered hills and hill-breast-clouds. "If we are very, very compulsive, all we have at our disposal is to repeat, and that expresses the validity of what we have to say. This is so important to me that all I can find is to repeat and repeat and repeat."

The "crowds," or multiplied standing forms, make up a good deal of the past few years' work. They are frequently groups of crisp geometric columns of marble with the tops sliced off at an angle to form a clean facet—found objects in Italy, where Bourgeois, undaunted by its traditional references, began to work in marble during the summer of 1968. Appropriately enough, these forms are the cores of containers, of marble vases and pitchers made for the tourist trade. The most impressive use of these forms is *The Marchers* (1972), shown at the 1972/73 Whitney Annual, in which a large number of faceted columns of varying sizes and colors were placed on the floor in neither chaotic nor ordered rows. The image of a solemn mob was augmented, not entirely

successfully, by a sweeping light which gave the effect of movement; also implied was the FBI's "searching" at demonstrations. Bourgeois has always been politically active and *The Marchers,* the black bullet pieces, and an evocative *Molotov Cocktail* (1968) noted the existence of the Vietnam war. One of the sculptures which prefigured the dramatic quality of *The Marchers* was *The Blind Leading the Blind* (1949)—a black lintel and spiked post piece made around the time that Bourgeois, with Duchamp and Ozenfant, was investigated by the House Un-American Activities Committee.

Her show at the Stable Gallery in 1964 introduced the "lair"—a wholly different image, although still preoccupied with dependence and independence, enclosure and exclusion, the aggressive and the vulnerable, order and disorder. The lairs, made from plaster and latex, had their sources in some obsessively linear landscape drawings that also refer to skeins of wool, associated with the artist's mother; in one of these the cave-tunnel made its first appearance. The hanging, nestlike bag forms merge inside and outside to return to the body-house images. Like the skeins of wool, they are "friendly; you can hide inside of them." Peering into the lairs is like walking through a rough-walled labyrinth. They "grow from the center, the more important organs being hidden; the *life* is inside. . . . which causes it to grow to a certain size."[3] One lair continues, ropelike, to turn upon itself and is hollow; some are weighted in such a way that they rock on their bases and "eventually come to rest through their own stability."

The latex pieces, hanging, folding, rising with a curious and sensual combination of limpness and stiffness, are the plaster pieces inside out. One has a slit into a viscous labial interior; another is a miniature landscape or viscerascape of shining flesh-colored undulations. Others are almost scatological; others hang like the memories of performances.[4] Throughout Bourgeois' oeuvre, shapes and ideas appear and disappear in a maze of versions, materials, incarnations.

---

[3] From notes written by the artist in response to questions posed by William Rubin in preparation for an article on Bourgeois.

[4] Some of these latex pieces from the mid-1960s were shown at the Fischbach Gallery in New York in the "Eccentric Abstraction" show, September 1966; with Bruce Nauman's early latex work, also in the show, they suggested possibilities later expanded as "anti-form."

She has used latex as the soft avatar of her hard forms. A shape may be made first from soft plaster (which turns hard), then cast in latex so that a permanently soft mold, or skin, exists independently, then made in marble, which is the final epitome of hardness. She thought at one point of having a performer dressed in a latex mold act out the piece's symbolic origins.

The most recent and ambitious lair was a full-scale environment in Bourgeois' December 1974 show at 112 Greene Street. Called *Le Repas du soir* (*The Evening Meal*), it was intended as a nightmarish comment on the family—the weights and pressures and anxious zones of close interaction. The space was claustrophobically squeezed between a field of hard domes, a lumpy evocative "landscape," and the domes' soft counterparts hanging bulbously from above with a Damoclean tension. Molds of chicken legs lay strewn around it and a male portrait head rolled in a dark corner. Both hard and soft forms were a pale color and, enclosed in a dark curtained box, they glowed eerily. The whole exhibition—Bourgeois's first in ten years—had a curious aura of loneliness *and* intimacy. In that vast shabby space, she placed her relatively small marble pieces without bases, almost at random (a tiny, white marble female waist-to-knees figure was cast off on the floor by itself). Some were dimly lit, others not at all, simply holding their own in the gloom. One had to go very close to come into real contact with each piece. In a well-lit room they would have become conventional objects too small for the space. As it was, they fully inhabited it.

Nature is an indirect, perhaps subconscious, source for many of these images. A large oval plaster relief with an amoeboid form pushing up as though into another medium has a strongly fetal imagery; its source is the tadpoles the artist played with in the river as a child. Another group of forms are almost literally alive, formed as they were by placing wet wood inside plaster; the plaster dried the wood, which then split its shell, using physical pressure as a simultaneous metaphor for anxiety and birth. As William Rubin has observed, "We are in the world of germination and eclosion—the robust sexuality of things under and upon the earth."[5] Bourgeois is aware of the eroticism in her work,

5 William S. Rubin, "Some Reflections Prompted by the Recent Work of Louise Bourgeois," *Art International* (April 1969), pp. 17–20.

although she insists "I'm so inhibited at the reality level that
the eroticism is completely unconscious. I find great pleasure
and great *ease* in doing things that turn out to be erotic, but
I do not *plan* them." For many years she did not openly
acknowledge the sexual content of her art:

> People talked about erotic aspects, about my obsessions,
> but they didn't discuss the phallic aspects. If they had, I
> would have ceased to do it. . . . Now I admit the
> imagery. I am not embarrassed about it. . . . When I
> was young, sex was talked of as a dangerous thing;
> sexuality was forbidden. . . . At the École des Beaux-
> Arts, we had a nude male model. One day he looked
> around and saw a woman student and suddenly he had
> an erection. I was shocked. Then I thought what a fan-
> tastic thing, to reveal your vulnerability, to be so pub-
> licly exposed! We are all vulnerable in some way, and
> we are all male-female.[6]

Bourgeois' phallic images are at times benign—fat, nes-
tling, almost "motherly." *Le Trani Episode* (1971) is two
long round soft forms piled comfortably on top of each other;
one has a nipple on the end, and both look like penises. She
sees such mergings of "opposites" as a presexual perception
of the dangerous father and the protective mother, "the
problem of survival, having to do with identification with
one or the other; with merging and adopting the differences
of the father." *Fillette* (*Little Girl*, 1968)—an ironically titled
latex and plaster penis and testicles hanging from a hook—is so
large "you can carry it around like a baby, have it as a doll."
Nevertheless, the element of cruelty is unmistakable, as it is
in several other phallic pieces, such as a plaster spiral that
represents "strangling—twisting the neck of an animal. How
do you define pain, suffering? Nobody has words to make
other people understand what you've gone through. This is
an inner image of this element."
  Bourgeois' images of women and woman's experience are
also ambivalent, juxtaposing a nurturing power of growth
and emergence with the sharp threat of oppression. Her
plaster *Self-Portrait* (1965/1966) is armless, legless, cen-
trally armored in heavy rib forms, but soft at top and bottom.

---

[6] Quoted in Dorothy Seiberling, "The Female View of Erotica,"
*New York Magazine* (February 11, 1974).

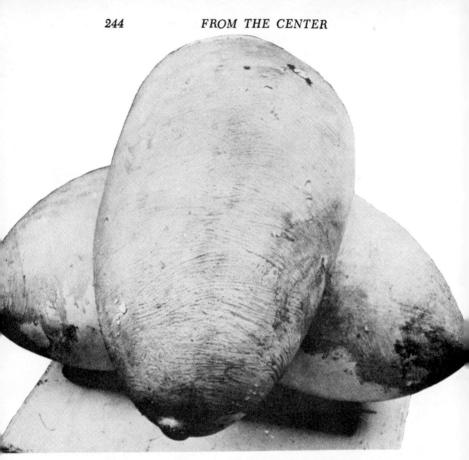

Louise Bourgeois: *Le Trani Episode.* 1971. Latex over plaster. 24" × 24"
× 17". Courtesy Fourcade, Droll, Inc., New York. Photo: Peter Moore.

Louise Bourgeois: *Self-Portrait.* 1965/66. Wood and cement. 25" × 15"
× 7½". Courtesy Fourcade, Droll, Inc., New York. Photo: Rudy Burckhardt.

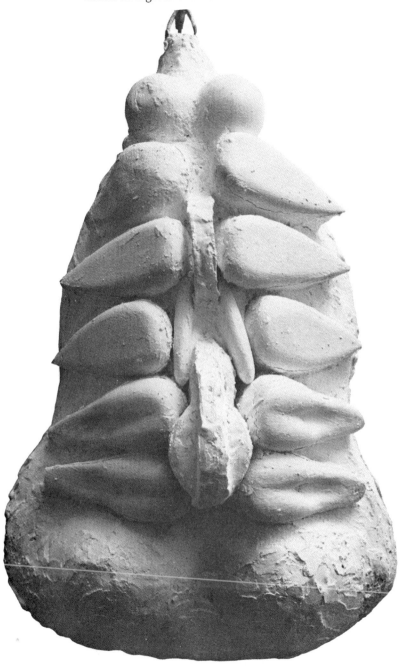

The little stylized torsos in black and white marble are "rigid, becoming masculine forms." From the early pole sculptures ("posts—you dig a hole and pound them in; they are defensive images") came the *Femme pieu* (stake-woman). In one of several versions she is a grotesque parody of the Venus of Willendorf (thought by some to have been made by a woman as a fertility charm), lumbering forward, armless, her head replaced by a stakelike point, defending her exaggerated voluptuousness. Similarly, the knife-woman (*Femme couteau*, 1969/1970)—a wrapped and folded marble blade with delicate pudenda exposed—

> embodies the polarity of woman, the destructive and the seductive. . . . The woman turns into a blade. . . . A girl can be terrified of the world. She feels vulnerable because she can be wounded by the penis. So she tries to take on the weapon of the aggressor.[7] But when woman becomes aggressive, she becomes terribly afraid. If you are inhibited by needles, stakes, and knives, you are very handicapped to be a self-perceptive creature. These women are eternally reaching for a way of becoming women. Their anxiety comes from their doubt of being ever able to become receptive. The battle is fought at the terror level which precedes anything sexual.

One of the most pathetic manifestations of such a double image is a small *Femme pieu* (c. 1970) of green brown wax which lies, again legless and armless, like a stranded turtle on its back, breasts and vulva and an abdominal wound exposed to all comers. Bourgeois used this piece as a pincushion, and the soft form is violated by large and small needles, suggesting some terrible fetish. She, too, connects the image with sorcery. As a child, she was attached to a fur piece held together by needles. "The needle was so effective and so small that it had a magic quality. You could hurt people and you could make things people liked. Its magic power has never quite vanished. It is partly a way to be appreciated, a desire to please."

Bourgeois makes certain types of work under specific emotional conditions. After her husband's death she turned to "aggressive" work—cutting and drilling bits of wood to be

---

[7] *Ibid.*

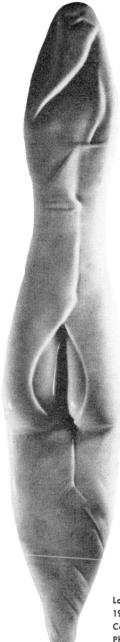

Louise Bourgeois: *Femme couteau.*
1969/70. Polished marble. 26" long.
Courtesy Fourcade, Droll, Inc., New York.
Photo: Peter Moore.

strung on metal rods—something she has done off and on for years and considers "a kind of knitting." The thick wood is cut and bored, "dismembered"—processes she finds "unbearable" and does "only under very strong anxiety. The aggressive ones make me doubt my femininity and I can't stand that. When reality is manageable then I can become a woman again and pour, make the feminine works." Plaster, wax, and latex, she sees as friendly materials, and I prefer the work she does in these media to that in bronze (which she admits is "dead" compared to the "richness and live quality of plaster") or marble, though she likes its permanence. Equally at home with additive or subtractive processes, the flexible and the resistant, she has "never believed in the romanticism of 'truth to material.' Some materials are fine for the pinning down of ideas, but they are not permanent and they do not take on a satisfactory surface."[8] The major function of her work is to follow the "inner necessity, to release anxiety into a formal perfection."

Bourgeois actually has a very literal imagination. Patrice Marandel points out that her sculpture, "though it is not figurative, develops nevertheless in an *atmosphere of figuration* which engages the viewer in interpreting it on his/her own terms."[9] Many of these viewers are put off by the prospect, preferring to deal with art at a more oblique angle. Bourgeois exists in the dangerous near-chaotic climate of Surrealism's "reconciliation of two distant realities." While some of her sculpture seems to be the result of random exploration with no immediate point in view, this is not wholly a disadvantage unless one thinks in terms of logical progression, which she certainly does not. Lovingly and fearfully woven and unwound from her own body and from her own needs, her art's sensuality can be so strong that it overwhelms all other considerations. Like many women, she identifies surfaces with her skin—it can be the cloth in *Cumulous,* or a thin layer of peeling latex over bulbous plaster, or the heavier folds in *Fillette,* or a glowing flow of dark resin totally immersing underlying forms. Within the art (as, one suspects, within the artist) form and the formless are locked in constant combat. The outcome is an unusually exposed demonstration of the intimate bond between art and its maker.

---

[8] Notes for Rubin (see note 3).

[9] Patrice Marandel, "Louise Bourgeois," *Art International* (December 1971), pp. 45–48.

Despite her apparent fragility, Bourgeois is an artist, and a woman artist, who has survived almost forty years of discrimination, struggle, intermittent success and neglect in New York's gladiatorial art arenas. The tensions which make her work unique are forged between just those poles of tenacity and vulnerability.

# Rosemarie Castoro:
# Working Out*

All of Rosemarie Castoro's art is about a fine bond between mind and body—gestural, but above all disciplined. Its major impetus is kinesthetic. (Not incidentally, she has on occasion danced with Yvonne Rainer and while a student at Pratt was seriously involved in choreography.) She invests movement, and by implication, her work, with a highly personal content: "When I danced," she wrote in a 1973 journal,

> I leapt through the air and continued to remain up there. . . . I felt a self-propelled air-stretch. It was a way to leave this earth to think in another path, to bring coherence to reality, to find the path again, to deepen the grooves and push through the forest of the half-blind.[1]

Castoro's continuous activity focuses on line as a formal solution. Although sexual in its drive, her work is too fast to be sensuous, too controlled to release all of its energy; it exists in a state of extremely structured tension, its momentum expressed with great physical intelligence by implied projection of the body (and the body ego) into space. ("What does an artist want? Exposure. Something snaps out vision. The body responds with production. . . . I think of myself as a container, and what I do as an eruption of what

---

* Reprinted from *Artforum*, 13, No. 10 (Summer 1975).

[1] Unless otherwise cited, quotations are from the artist's journals as published in Syracuse University's Lubin House Gallery catalogue of her work (December 1973) or from conversation with the author.

I am. Where do you get nourished? That's where you have something to do.") Until she began to make sculpture in the round, some of this momentum seemed frustrated by the rectangle, the formalist limitations of abstract painting. In 1964/65 Castoro was making allover abstractions of gestural but tightly packed tilelike shapes that evolved into a basic **Y** unit, and then into strands or bands, like beams of light intersecting and interweaving in space. Several of the latter were shown in Eugene Goossen's "Distillations" show in 1966. In the next two years, the structure became somewhat freer but the tension was maintained by an obsessive diagonal line, anticipating the later graphite panels. In the meantime, from around 1968, though still painting, she also ventured out of the studio, "moving ceilings," "cracking rooms," doing street works, and making Conceptual pieces in the form of diaristic texts ("I sometimes watch myself in time by recording my activities with a stop watch"). These constitute the best "fiction" I have read about the life of an artist.

In March 1969 Castoro rode her bicycle at midnight from Spring Street to 52nd Street, leaking white enamel paint from a pierced can and leaving behind a linear trail. In April she "cracked" a block of the sidewalk on 13th Street with a meandering line of thin silver tape; in May she used the same medium to splinter the rooms of the Paula Cooper Gallery, and in September, she made a gigantic cracking at the Seattle World's Fair Center. It visually evoked a seismic disturbance quite out of proportion to the material expended. These curious kinetic remains were accompanied by a similar activity—the "moving" of ceilings, or parts of them, by marking out a rectangle overhead with four wheeled "casters" (the pun was intended).

The element of humorous hostility in these inconspicuous but startling objects was later resurrected in the suspended sculpture, *Burial* (1973), which, more organic than geometric, reflected the change in her focus. Its "roots growing down from the ceiling" were seen as metaphoric extensions of "buried people on the roof." In 1970 she constructed a room in Vancouver within which a rheostat-controlled light grew gradually brighter over a three-and-a-half-minute cycle maintained until the door opened—part of an evolving conception of manipulating spaces that led to the freestanding panels and combinations of panels shown at Tibor de Nagy in 1971 and 1972. These were paintings taken off the wall and transformed into their own enclosures—"screens," "corners," a "revolving door," and a curving "tunnel entranceway."

Graphite rubbed over a dense impasto surface of gesso and modeling paste provided a muscular abstraction of their creation. The vigorous swashes resisted and eventually rebelled against rectangular confinement, and during 1972 the "brushstrokes" broke away and became separate entities. Actually broom-and-mop strokes on Masonite, cut out with a saber saw, they were hung on the wall as individual or groups of units. One series of flowing single strokes suspended vertically from the ceiling or horizontally from an edge were named after body parts (*Bangs, Armpit Hair*), a result of the artist's starting "to relate to myself as a building. . . . parts of me coming off different parts of the wall."

The brushstrokes soon acquired an animistic life of their own and developed from abstractions into a calligraphic shorthand that stood for initials and people, then into smaller hairpinlike stick figures—"groups of people in the streets relating to each other." Hung almost randomly with space between them, these tighter units retained some of the liveliness of their broader predecessors, but when shrunk, and crowded or regimented together to form an illusionistic X or "parade ranks" dwindling into the distance, they got fussy and lost the vitality that was their major advantage. The relative failure of these "exoskeletal auras as wall sculpture" may have resulted from an uneasiness about moving toward an overtly anthropomorphic from a long-standing nonobjective approach to physical phenomena. In any case, it also led to the next step: bringing the work into three-dimensional space and eschewing dependence on a wall support.

While Castoro was teaching for two months in Fresno in 1973, she symbolically "buried" these figures, and in *Small Burial*—a group of silvery twiglike stalactites suspended from the ceiling—they also found their regenerative function. When she returned to New York, she began the large organic sculptures, some of which were exhibited in her "Suspensions" show at Syracuse University's Lubin House Gallery in December 1973, in New York City. Objects whose presence was finally supported by their own properties rather than by an implied activity in the past, the three large pieces consisted of long, awkwardly gangling tentacles of pigmented epoxy and fiberglass daubed over styrofoam and steel rods. *Growing* leaped in midair; *Tunnel* hovered like a huge spider; and *Burial* dangled from the ceiling. Like *Symphony* and *Two-Play Tunnel*, the two pieces in Castoro's most recent show at Tibor de Nagy (February 1975)—both of which are firmly rooted to the earth and can survive outdoors as well—evoke

Rosemarie Castoro: *Small Burial.* 1973. Masonite, steel rods, epoxy, gesso, marble dust, graphite, lacquer. 72″ × 36″ × 19″. Courtesy Tibor de Nagy Gallery, New York. Photo: Eeva-Inkeri.

Rosemarie Castoro: *Symphony.* 1974. Pigmented epoxy and fiberglass over styrofoam and steel rods. 6′ 4″ × 9′ × 24′. Courtesy Tibor de Nagy Gallery, New York.

exotic vegetation, weird creatures, trees, roots, legs. Their shiny surfaces, with slabs of brown, black, blue, olive, ocher, are painterly when seen up close and look like generalized skin, or bark, from a distance. *Symphony,* which filled the larger room, is several units of four tall "legs" joined at the top. *Two-Play Tunnel,* its legs multiplied and closer together,

crouched malevolently in the small room, an earthbound version of *Sky Tunnel* (1973), whose more bulbous units threatened to drop over the viewer; "My tunnel thinking has to do with the left and right hands coming together and not touching, as if to hold an imaginary body."

In all of these works there is an underlying current of pathos (they sprawl like a young animal learning to walk) that relates to Eva Hesse's early sculpture or to some of Tony Smith's solemn incursions into space. Their uniqueness lies in the projection of Castoro's restless, self-oriented energy. "Paintings are the places where you watch yourself. Paintings are reflections. They are the manifestations of sexuality," she wrote in 1970; two years later she noted that her work is "about people and how I feel they relate to one another and myself." The subtle element of auto-eroticism, or auto-voyeurism, is a natural outcome of her subject matter—her own "activities," paramount among them the motions of her own limber and athletic body. Although she declines to be politically classified as a feminist, preferring the image of an androgynous amazon ("the politics of my mind is one big orgy"), in the so-called woman's issue of *Art News* (January 1971), she quoted, without comment: "Castoro, Castoro, I saw your paintings at Johnny's. I liked them very much. I thought you were a boy." The heightened sense of self that pervades her work can be attributed at least in part to her position as an independent and ambitious woman in the art world, long denied the degree of respect she might justifiably have expected as a serious working artist.

For several years the sexual origins of Castoro's art were more or less hermetic, appearing mainly as an expansive gesturalism, an insistence on either filled or vacant stage/space. A readable image of "the jungle" of "chaotic experience" emerged when the forms became three-dimensional, though there were clues in her journals, such as a poem about eating apple pie: "Peel Off/Poke Into/Pass Through/Emerge from under/Scrape your eyes/Clamber about/Trip over mound of hard darkness/Land backside/Stop breathing. . . ." In 1970, the theme of organic immersion was applied to the drawings:

> I am in dirt continually. The closer I am to myself the dirtier I become. My studio is covered with graphite. I am Diogenes sitting in a pile of dust. My ocean is made of graphite in front of which I tumble, chase, flop over.

Later she talked about survival in terms of

> depth of roots, elbow room. . . . An elbow was in my
> heart. I swung out and away. It touched my shoulder. I
> went to sleep at the foot of the forest. A new piece
> started yesterday afternoon: crouching crotches in a
> circle. . . . I am making a forest. It will crowd out
> anguish and misery. Structure comes from chaos, from
> quiet contemplation after engaging experiences. . . .

Castoro uses the image of the forest—its "male" components
and "female" entity—in her writing and sculpture (as has
Max Ernst). In another journal entry she expands this
metaphor to include the city:

> New York is Dante's Inferno, extruded up from the hori-
> zon of rooftops meeting sky, down through the layers of
> dirt polluted, facaded levels. New York is buried down
> from its roofs. It is female from chimney to basement.
> You might think upon approaching New York from
> Brooklyn or New Jersey that it is a rectilinear moun-
> tain . . . male, you say. Not when you are in it, occupy-
> ing any level of coffin space chimney down from the
> roof.

The sculpture is clearly about this sort of experience,
evoking as it does the groping forms of physical adaptation
to an environment.

> When you bury something, it grows in a different form.
> . . . I am thinking I have a balanced anima/animus.
> I wanted to be rooted (anima needs penetrating). . . .
> I extended my animus (to penetrate) into reality and re-
> leased suspended crotches/double penises/legs, into three
> interdependent groups. . . .

The sexual dualism found here is essential to the best art of
erotic content. Castoro's work has metamorphosed and ex-
panded to include e-motion as well as motion. *Branch Dance*
(1975), made of simple tree branches in two days in Mount
Berry, Georgia, suggests the choreographic freedom sculp-
ture has offered the artist. In the process, the "lines" have
been reintegrated, disembodied limbs combining now to
form another whole, the activities of which have yet to be
fully determined.

# Faith Ringgold's Black, Political, Feminist Art[*]

The rooms of Faith Ringgold's Harlem apartment are crowded with people—her art: dolls (models for larger sculpture and a Senegalese original), grotesque but somehow lovable masks, paintings framed in brilliant fabrics, gangling foam-rubber figures, and the new work—larger-than-life-size "portrait masks" with skirtlike "clothes," but no bodies, intended for both exhibition and performance. Their heads are large, made of foam rubber, visibly stitched into highly realistic faces. They can be worn above the performer's head so the figures tower but are still manipulable, like a gigantic hand puppet. The cast is immediately recognizable to the Black community: LeRoy, hip and ex-militant in his dashiki; Martin Luther King, solemn in his preacher's robe; the archetypal respectable Mama, with hat and fur collar; Adam Clayton Powell ("I practically grew up at Abyssinia; Adam taught me to be political"); Molly, the Harlem socialite, gowned for action, and the "victim"—a young girl named Joanna who is to be the star of a performance at the Sojourner Truth Festival of the Arts in May, and is described thus: "Suppose a girl of 12, who had been born blind, deaf and dumb, found on her 13th birthday that she could see and hear for the first time . . . that she now wanted to know everything that she had not had an opportunity to learn before about her past, her present, and her future, about her Blackness and her femaleness."

Faith Ringgold herself, wrapped in a colorful African

---

° Reprinted from *Ms.*, July 1976, in somewhat revised form.

print, relaxed and warm, making with whoops of rich laughter, emanates substance and energy. Underneath it all, there is a complex personality. As a Black woman artist who exists outside of the white, male art establishment, but is nevertheless well-known nationally, has shown abroad, and is much in demand as a speaker and performer, she is in a unique position—unique, and not entirely enviable. Both as a feminist and as a Black activist, Ringgold has been isolated from her peers, from other Black women artists; she has been ostracized for speaking out against Black male domination at a time when Black solidarity seemed more important than women's rights.

"There is racism in the women's movement and Black women should be attacking it," she says.

> If you're not there taking care of business, you're just not going to get it. . . . It didn't take very much courage for me to do what I did. It was the only way to go. If I was going to be an artist, I was going to have to do something and if nobody was going to come into it with me—I'd just do it by myself. If there had been more activism on the part of Black women, I don't think the women's movement would be as all white as it is now. Young Black women are busy trying to erase the stereotypes about Black women as castrating, dominating, matriarchal, but eventually they'll have something to see. Because I'm definitely going to make waves. I'm going to make my art, and I'm going to show it; I'm going to show it to *somebody*. That's the struggle.

And she seems to be winning that struggle. Ringgold was born in Harlem. The new apartment building where she now lives on the fourteenth floor looms above the tenement five blocks away where she was raised, daughter of a truck driver for the Sanitation Department and Willi Posey—who began as a housewife and some time after separating from her husband went into business as a dress designer. Ringgold decided to be an artist in high school. She had always done drawings. "I was the kid who did Santa Claus on the blackboard every Christmas." As a child, she watched boys streaming up the hill to City College and decided that when she grew up she'd go there too. She did, although she had to minor in education since women weren't allowed in the Liberal Arts Program. Her family was unenthusiastic. "I was supposed to go to college to *be* somebody; being an artist

wasn't *being* anybody, wasn't a serious vocation." But she studied with Yasuo Kuniyoshi and Robert Gwathmey (a white southerner who painted Blacks in cotton fields), received a B.S. and an M.A., and went on to teach art in the public school system. Now she says if she'd known what was going on (the prejudice, restrictions, and machinations of the white "art world"), she wouldn't have gotten into art herself. But by the time she found out, it was too late and she was hooked.

Ringgold's mature work began to develop in 1963, with the early civil rights movement as subject, and a harsh, semi-Cubist figuration as style. She painted a pyramid of faces, white over Black, and a Black artist with a white model, and later, a Black "commemorative stamp" with one hundred faces, ten of them Black (for ten percent of the population). In 1967 she made a large canvas called *Die,* depicting a blood-spattered riot, and her series on the American flag is notable for a combination of decorative strength and bitter social comment. (A painting called *Die Nigger Flag* was almost bought by the Chase Manhattan Bank until they deciphered the hidden message written into the image.) Her *United States of Attica* poster has been widely reproduced, and in 1970 she was arrested with Jean Toche and Jon Hendricks for helping to organize "The People's Flag Show" at the Judson Church—a protest against repressive laws governing the use of the stars and stripes in art.

In the late 1960s Ringgold developed a technique she calls "Black Light" and began a series of masklike frontal portrait heads influenced by the matte, close-valued "colored blacks" of abstract painter Ad Reinhardt. She also adopted the eight triangles of the Bakuba motif, which served to "get rid of that up and down business and create a poly-rhythmical space." Since Cubism itself was derived from African art, Ringgold noted the Black artist's right to reclaim it. Her most ambitious use of the Bakuba motif was in the mural for the Women's House of Detention on Riker's Island in 1971/72. It was painted to the inmates' specifications ("they wanted something stimulating to prove women could be rehabilitated"), and depicts white and Black women (no men) in different professions—a cop, a bus driver, a basketball player. There is a traditional mother, "but she's reading feminist literature to her daughter," and a woman being married by a female priest and given away by her mother.

The "Black Light" technique also appealed to the artist

because it reflected "the blacks and browns and grays that cover my skin and hair." Its use marked the beginning of her literal identification of herself and her art. In regard to her rubber sculpture, she says: "Roll and fold and sew; I'm a woman, and I'm soft." She finds her work "looking more and more like my image as I come closer to self-realization. . . . I don't feel restricted by being female, any more than I feel restricted by being Black or being American—these are the facts of my life. It is powerful to know who you are. The restriction comes in not knowing." Armed with this knowledge, in the early 1970s Ringgold began to pull it all together—the history of her people, her interest in non-Western cultures, her feminism, her family. At first she combined them in a series of *Political Landscapes* (outwardly just landscapes, but political "because all the political people are buried in the ground which makes the landscape," she says with delighted giggles). Then came a series of *Slave Rapes*, the horrific subject matter belied by gorgeous brocade frames designed and made by Ringgold's mother. She calls these *tankas*, inspired by Tibetan and oriental wall hangings seen at the Rijksmuseum in Amsterdam.

Then Ringgold began to see painting as simply "a backdrop for something else," which was masks, or "Witches"—heads of weeping women, beaded and fringed and embroidered on fabric, showing the magical power attributed to women, their mouths open to denote the need for women to speak out. Then she began to make portraits of people she had known as a child, most of whom were women. ("I always wondered what they would have been like if they had had the op-portunity to develop themselves. They were pretty sharp and skillful people. They knew how to *do* so many things. Real survivors.") These were portraits in the African sense—"the quality rather than the likeness of a person." Her mother, who of course had known them too, dressed the figures and gave them their "body look." The traditional aspect of women collaborating on art has not escaped Ringgold, whose two daughters (one a writer, one a linguist) are responsible for the skits written for her masks and "Soft People." She firmly believes that "art has gender, that women have their own culture and it needs to be modified, freed, to produce a new, unrepressed female art."

The "Soft People" were the first figures to have whole bodies, made of rolled-up foam rubber, coconut heads, yarn wigs, full of humor, exaggeration, and a strong sympathy for

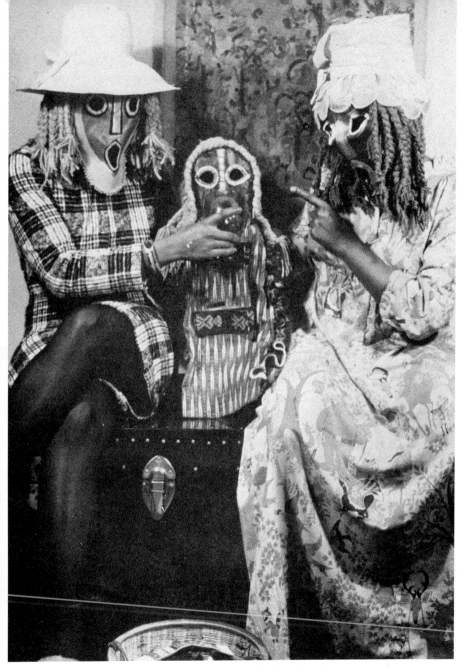

Faith Ringgold: *Portrait Masks* and *Witch Mask*. Worn by the artist's daughters for performance. 1973. *Tanka* in background.

how Black people live, fail, and triumph. Many of these deal with family and the relationships between men and women. Ringgold feels that the destruction first of the extended family and then of the family itself is a negative result of the Black and the women's movements. She herself has been through two marriages. Finding that she couldn't make it as wife *and* artist, she chose her work, and motherhood (which has also meant companionship; her oldest daughter, writer Michele Wallace, is a co-activist and vital ally). The first stuffed people—Zora and Fish—illustrate the artist's concerns: "She's a shopping bag lady. He carries her chair so she can beg and then he can fall out drunk. They have a relationship too."

In the process of this development, Ringgold has had to make several decisions. First, she had to show outside of New York, since her art, with its urge to communicate, rather than to impress, is decidedly unfashionable in the white art world. (She has had only two one-woman shows in New York, none since 1969, although a ten-year retrospective was held at Rutgers University in 1973.) Second, the work had to be easy to ship, install—and understand. "There's no reason why art has to be so complicated and difficult to deal with. That's one of the things I've gotten from the feminist movement." The new work—the *tankas*, the "Soft People," the masks—are all so light that the problems involved in hoisting and crating heavy stretched canvases have disappeared. "Now I can send 32 pieces out for a show; it weighs 11 pounds and costs about $150 to ship, round trip, with $8,000 insurance." When she travels, Ringgold can take four figures and some *tankas* in her suitcase. Her lectures include informal performances with artist and audience collaborating, trying on masks and improvising. Because she's "not just into esthetics," she is extremely popular with non-art student audiences, Black and white. "At Howard University, they yelled out things each slide I showed; I never saw a crowd get so carried away." In the past Ringgold was asked to talk by women, as a feminist, and only very recently has she begun to be invited by Black Studies programs—the result of what she sees as a definite

Faith Ringgold: *Weeping Woman* #2, from *Witch Mask* series. 1973. Beaded and sewn mixed media. 46" × 4" × 6".

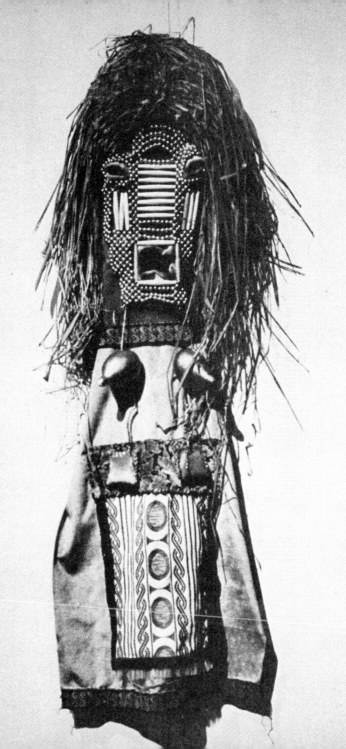

change in the attitudes and raised consciousnesses of Black men. As for the art world, her unique working situation is one that more artists would do well to adopt. Ironically, this way of reaching out to a broader audience is more "radical" than the strategies of most so-called Conceptual artists who are confined to the regular commodity-oriented art circuit.

The most recent piece has been evolving slowly out of these audience-participation situations. In the lace-curtained studio of Ringgold's apartment, covered, so they aren't too frightening for her housekeeper, two "dead bodies" lie on a red, black, and green flag. Part of a funereal tableau entitled *The Wake and Resurrection of the Bicentennial Negro,* they are accompanied by a line of black masks made of varied black fabrics, each with different lights and textures. The mourners, all women, cry tears of jet, rhinestone, or sequin. They represent a return to the Weeping Woman motif—"women crying over some man—mommies. Mommies are always crying." Bubba, the son, has died of an overdose. When he is resurrected in performance, he raps about the evils of drugs. The daughter, Bena, "died of *Grief.*"

# Yvonne Rainer on Feminism
# and Her Film*

The appearance in fall 1974 of Yvonne Rainer's compre-
hensive documentary book—*Work 1961–73*[1]—and of her sec-
ond movie—*Film About a Woman Who . . .*[2] has put in
perspective what had been for me an ongoing, provocative,
but never properly framed experience. I saw Rainer dance
first at the Judson Church in the winter of 1963/64. A
dance illiterate, my own education began with the Judson
performances, so I was spared any roots, and thereby any
shock at what I later discovered were radically new ap-
proaches to dance. I was particularly turned on by those
elements bounding on so-called Minimal Art, with which I
was coming of age as an art critic. Since then, I have gradu-
ally become aware of how crucial these ideas have been to
the "advanced" art, dance, film, and performance that have
followed.

Despite the impressive company she kept, Rainer was
always the most impressive figure in that group. Like many
of my women friends in the art world at the time (probably

* Reprinted from *The Feminist Art Journal*, 4, No. 2 (Summer
1975).
[1] Yvonne Rainer, *Work 1961–73* (Halifax: The Press of the
Nova Scotia College of Art and Design, 1974; New York: New
York University Press, 1974).
[2] *Film About a Woman Who . . .* , 1974, 16mm, black and
white (some color), 105 minutes. Written and directed by Yvonne
Rainer; cinematography by Babette Mangolte; edited by Rainer
and Mangolte.

men, too), I was somewhat awed and intimidated by her intellect, strength, and not least, her physical presence. By the time I met her, I had also heard tales of her various physical and personal misfortunes, which made her all the more of a legend. All of this apropos of the fact that Rainer's recent work, especially the two feature films, incorporates autobiographical material to an extent that has tantalized, confused, and oddly, surprised her audiences; I say oddly because she has used autobiographical fragments as "props" since 1962. In 1971 Rainer announced that her next work would deal with human relationships. She had been working up to this since around 1969. Until then, her choreography had been, at first glance, rigorously formalized, while on second thought it could be seen breaking out into the unpredictable hilarities, ironies, and idiosyncrasies which in fact have provided the foreground of the newer work. The rigorous structure remains, as a more or less hermetic armature, most conspicuous in the deadpan presentation of psychological subjects and the ways in which those parts have been twisted, turned, and rearranged to make a whole—a work of art.

1969/70 were troubled years in which real-life dissent penetrated even the art world. Rainer supported the Art Workers' Coalition and participated in several protest events. At the Judson Flag Show her by-then famous *Trio A* was performed nude under large American flags; at the Metropolitan Museum, while Artworkers co-opted themselves over caviar and pink champagne, she started a sarcastic clapping toast to the occasion; when we invaded Cambodia she made a parade piece through the Soho streets with black armbands; and at the anticensorship demonstration against the cancellation of Hans Haacke's show, she organized a chanting conga line up, down, and around the Guggenheim ramps. Characteristically, the response in each of these cases was a spontaneous but ritualized version of her emotions.

It was also during these years that the women's movement hit the art world and, not coincidentally, a behavioral emphasis on content began seeping into the reigning Minimalist styles. Rainer came to some meetings, but was not involved in consciousness raising. The dance world was already matriarchal, and though accustomed to working with others as a dancer, she despaired of functioning politically in groups, remaining the admirable but distant role model. Nevertheless, all of these factors, along with the improvisational work she

had been doing with The Grand Union, undoubtedly affected her decision to deal with "human" as well as physical relationships. The fact that these relationships turned out to be based on (but not faithful to) her own life was a daring step, given the mythological proportions of her image in the eyes of some audiences. Yet by committing herself to film on as large a scale as was financially possible (feature-length as opposed to the short films she had made as "accompaniment" to earlier performances), Rainer has also committed herself to a much larger audience, one that in the end will depersonalize her life again, truly fictionalizing it for viewers who know no gossip. While she continues to perform (performance sequences in the films are there because "I am a dancer and I was going to have dance in this movie willy-nilly"), Rainer uses performances as rehearsals or sketchbooks for the films. She is now working on her third dual work (film evolving from performance) entitled *Kristina* (*For a . . . Novella*). This time there is also a *photo romanzo*, to be published in *Interfunctionen*—a "story" told partly in photographic comic-book style.

*Film About a Woman Who . . .* is a fragmented narrative about two couples in their thirties or forties. It foils the would-be plotter by switching rhythms, time/spaces, even characters. Rainer uses words and images as though they were the same medium, as though you could start a sentence verbally and finish it visually. Thus for all the extremely familiar situations, phrases, and activities, the viewer must finally give up the idea of knowing exactly what is going on. One *senses* the connections, but they are difficult to articulate, and the film's impact is broadened by the associations and possibilities that exist in the interstices. Because of its elaborate formal strategies and internecine humor, *A Woman Who* must be seen more than once. I found that by relaxing the second time around, I enjoyed it more than the first, when I had been trying too hard to "understand" it. The book on Rainer's work, which leads up to this film, provides a highly recommended preparation, its synthesis of casualness and intelligence, its collage of notes, scripts, letters, photographs, and reviews both intimate and informative.

The following compilation is not intended as an overview of Rainer's accomplishment, but focuses on the role her experience as a woman and hesitant feminist has played in that oeuvre. I have augmented my interview with her (taped in March 1975) with passages from her book, which appear

in quotations; italicized passages within the interview are my commentary. A second, critical, text on *A Woman Who*, which can be considered to supplement this one, has not yet been published.

<center>◦</center>

"This is the poetically licensed story of a woman who finds it difficult to reconcile certain external facts with her image of her own perfection. It is also the same woman's story if we say she can't reconcile these facts with her image of her own deformity" (text from the film).

<center>◦</center>

*Do you consider yourself a feminist?*
Well, to feminists I always say I'm not and then I wait for them to tell me that I am and then I end up agreeing with them. I addressed Mimi Schapiro's class in the Feminist Art Program at Cal Arts and I was told that my work deals with myself as a woman therefore I am a feminist—a very broad definition of feminism. What's your definition of a feminist?
*It goes further than just being a woman and dealing with it to any old extent in your work, and further than political activity that doesn't affect your work. To begin with, I'm absolutely convinced that you'll have to deal with it differently because you're a woman and your experience is entirely different no matter how much the same as a man's you may want it to be. No, I think it's more a recognition of the fact that you're a woman and then seeing this as a positive factor, being conscious of its ramifications. That being a woman isn't bad, isn't something to be ashamed of, in fact is good, and that there is material for both art and life in that difference, and pride in it.*
Then inasmuch as making art is a positive thing, making art about one's experience as a woman is positive?
*Yes, but one can do that and still deny the positive aspects of that experience. Feminism also has to do with that denial factor—the degree of denial of oneself as a woman, and denying the positive aspects of other women too—women who may be going about things differently. It's certainly not just rhetorizing and grabbing a piece of the pie, but a real consciousness of what it is to be a woman for you and for other women. What there is in common. How you use that awareness. . . . .*
An awareness of difference and trying to clarify it?

*And that becomes political, even if the art itself isn't directly political in subject matter. Making other people aware is a political act.*

Well then, you've convinced me that I'm a feminist. . . . I should stop playing this game and just stand up on my hind legs and admit it. It's just that I guess I make a distinction for myself. I didn't come to be an artist or an independent person directly dealing with this female experience through the women's movement, so somehow I'm reluctant for that reason to proclaim myself. I don't want to get on the bandwagon.

*The women's movement shouldn't get all the credit either, huh?*

Right. It works both ways.

*Several years ago you wrote that you were "unconcerned with feeling," that your focus was on bodies as objects, not people. Then more recently you said, "For me the body alone is no longer the main focus. I'm interested in private experience and the problems of projecting it." Did that change have to do with the women's movement? It coincided with it, in any case, around 1971.*

It wasn't directly related to the women's movement but I don't know exactly how to account for it other than by a process of osmosis or coincidence that I began to think of my examinations of problems of intimacy and sex as material for art collaboration.

*It's gotten to be a cliché, but true to an extent I think, that women deal more openly with feelings than men do, that the movement has developed a humanist rather than a formalist approach in art.*

Is it necessarily a dichotomy—formalism-humanism? I'm not convinced it is. I'm constantly trying to have the best of both worlds. In fact, that is an underlying theory which I probably will continue to pursue, that the most scabrous confessional soap-opera kind of verbiage or experience can be transmitted through highly rigorous formal means and have a fresh impact. That's what I'm gambling on. Depending on how people are affected by these two elements. Some people are put off by the soap opera, some people simply see the strategies. That's what's confusing about some of my recent work, and I feel that I'm constantly weighing these things at every step of the way. But I accept this dichotomy as a necessity of modern art. I'm not trying to work my way *back* to a more direct relationship to subject matter.

❋

Rainer's style has not, incidentally, changed so much as it has expanded. Nor is there any basic conflict between the device of repetition used so frequently in her earlier dances and the device of fragmentation or disjunction used in the films. In fact, the latter is simply a complicated version of the former, allowing for a composite viewpoint. What may seem to be unrelated fragments often turns out to be, under scrutiny, repetition of a phrase or a situation or a movement which, seen from different angles in different contexts, different tones, seem different in themselves. Because words have assumed a more dominant role in the films, she prefers to think of them in terms of fiction rather than performance, or theatre, but the concreteness of the images and the detachment with which words are "spoken" (mostly in titles or narration, with little lip synch) give her movies a three-dimensionality that harks back to the dance.

❋

*Eva Hesse said she used repetition because of its absurdity, the way it exaggerated everything, and life was absurd. There seems to be some connection in the ironic way you use emotion. Do you feel that way about it?*

If something is complex, repetition gives people more time to take it in. I always remember Twyla Tharp saying she repeated movement so people wouldn't think she was improvising. I haven't been involved in repetition for a while. I try to avoid it. Because I'm not involved in formal *patterns*. The camera and editing allow me to use repetition in a way I hadn't been able to before—going from closeup to long shot with the same material. . . .

*A lot of women's work in film and video has been accused of being narcissistic, which might also be a part of the process of finding one's own identity.*

Well, I've *had* all that experience, as a performer. I'm not very interested in being directly in the work, though I am going to be in the next film. Now I feel I can do that, having gotten *out* of the work, out of the content.

*You've talked about how in your early work you were trying to get away from the "narcissism of traditional dancing."*

Whatever narcissism there is now is in the content and not in the presentation, not in the performance. A *Woman Who* is a personal film because you're always very conscious

Yvonne Rainer: Shirley Soffer and Yvonne Rainer in *Film About a Woman Who . . .* 1974. Photo: Babette Mangolte.

of the author-director's hand. But you can't say it's about narcissistic people. You can't pin that on the characters in their performance because they're so tightly controlled, although you might say this kind of self-investigation is narcissistic in a general sense. The characters are puppets, they're stand-ins for this experience that is conveyed by a text, a voiceover, framing, and so forth.

Does the emphasis on psychological experience alone convey a narcissism? My work is much more novelistic in the way it weaves autobiography into fiction, so I feel it avoids the cult of narcissism altogether. It's accepted in the

traditional novel to integrate highly personal experience. Somehow that isn't as established in filmmaking. So the work I've been doing for the last couple of years is still confusing. There was a perfectly obsessed young man in Los Angeles who asked me in six different ways at six different times in the course of the evening what exactly in *Woman Who* was true and what wasn't. I said I don't remember anymore. Who knows! Who cares!

◦

*In 1972 Rainer told Liza Béar and Willoughby Sharp (in an interview in* Avalanche, Summer 1972) *that her art would reflect her "womanness or personness" whatever she did, and she was therefore not really concerned about it. In regard to her solo in* Inner Appearances *(a performance), in which she used a vacuum cleaner, she remarked on how unintentional any political overtones had been:* "I don't think I could have made that dance if I'd set out to make a live feminist tract, as it's been called. It came out like that because of the way this kind of material is being looked at today. And conversely, I couldn't have made it before now." *She agreed that the women's movement had functioned for her as a cultural influence rather than as a political issue.*

*The notorious vacuum-cleaner sequence, originally written for a female, was later performed by a man:* "After I began to receive feedback about the political overtones of the piece—that the vacuum cleaner stood for women's oppression, that it was a statement about 'women's lib'—I had to rethink the whole thing. I felt very ingenuous in not foreseeing this response. I usually live alone and I occasionally use a vacuum cleaner to clean my house. I have never felt oppressed by having to accommodate certain hygienic needs in this manner. Well, I thought, if it's going to be received as a political statement then it must be made more radical. My solution was to rewrite it for a male performer. The problems were fascinating and staggering" (book, p. 278). "I found that I couldn't automatically transpose the pronouns from one gender to another, that there are all kinds of cultural variables. It's amazing to try to do that, to find out in what cases it worked and what cases it didn't work, in what cases very small modifications had to be made."

*For example, one of the texts that appeared when the woman was vacuuming read:* "Why do women value their insights more than their work, she thinks. Now she is laugh-

ing inwardly at her cliché—the old intuition bit. But it seemed true in the cases where *men* valued women's insights more than women's work. The generalization as usual could be discredited." *When the man was vacuuming, the text was changed to read:* "Now this character is thinking about a friend with great contempt. 'Why do men value their work more than their insight?,' he thinks. Now he is laughing inwardly at his cliché—the inverse of the old female intuition bit. But it seemed true in the cases where the *women* valued men's work more than men's insights. The generalization as usual could be discredited."

*When the sexual revisions were first made, she showed the whole thing to a male friend.* "His response in effect was that the same readings when applied to both male and female made for a 'strong woman' and a 'weak man.' I naturally objected. If a woman is 'strong' for revealing her humiliations and vulnerabilities and a man 'weak' for doing the same thing, then that just points up our need for new values. . . . For a while I stuck to my guns: A woman's complaint about 'not being taken seriously' by a man is so ordinary as to be commonplace, and women's anger over this has become similarly familiar, thanks to the women's movement. However, 'She doesn't take me seriously. Goddamn her!' as spoken by a man is by no means culturally commonplace at this time. The line jumps from the page with an urgency that the female version just doesn't have . . . Thus the male version is highly political in the question it raises while the female version is not. . . .

"In the spring of 1973 John Erdman and I did five West Coast performances of an abridged version of *Woman Who.* . . . The vacuum cleaner, which was a different kind in each place, elicited many gender-oriented remarks. The industrial vacuum cleaner was called 'mansize,' the little electric broom was thought appropriate because it was so 'phallic,' etc. The image of a man vacuuming was obviously too extraordinary to pass notice. I had never encountered such remarks when I had performed the work myself" (book, p. 279).

○

*When you were choreographing, were you aware of using men's and women's bodies differently?*

No. I never did. At the time I was interested in a certain kind of sexually undifferentiated athleticism, in using the body as an object, just in terms of its weight and mass, which

was a reason why no sexual differentiation was made. I made solos for people, or trios, or duets, and chose people for various athletic abilities, but the movement always came out of my body. That solo for Valda in the long dark dress, in *Lives of Performers* [Rainer's first film, 1972], was very specifically based on a female model—Nazimova in *Salome*— a very Art Nouveau silent movie. I thought of Valda as soon as I saw it. That was sort of an anomaly right there. I rarely work that way.

*When you picked women to play the parts of you in the films, were you aware of picking your own persona? I mean, were they types you identified with on any level?*

I wanted people in *Lives of Performers* to be totally different types. Individually they could be seen as examples of typecasting or stereotypes, like Valda the Femme Fatale, or Shirley the Older Woman, Fernando the Latin Lover. . . . And I was aware a little bit of a duality in my own personality, of ordinariness and glamor, that I'd played off of in my dancing.

*You know, you've represented for a lot of women, for a long time, the epitome of the Strong Woman.*

I hope I've disillusioned them.

*At the same time, with all the problems you've had, you've also been the epitome of the victimized woman, not victimized by a single person or circumstance, but . . .*

But by my own . . .

*Maybe by your own strength. Women look for different things in your films, from what they know about you.*

Women certainly relate to the film more than men do. Or that's the feedback I get.

*I was interested in that letter to you from Nan Piene that's in the book, where she mentioned "the way women at times communicate intensely through the medium of men."*

She got that out of *Lives of Performers* and I hadn't realized I'd been doing that in making the relationship between Shirley and Valda very tight, and also they were involved with the same man. It's funny. That was very unconscious . . . I simply distributed parts. Later I got a little better at obfuscating particular plot situations. . . . You know, I used quotes from a conversation you and I had in the *photo romanzo* that's coming out. You asked this beautiful question —not directly of me, but in relation to Eva Hesse: "Do you think there's a network of identification between women who have been ripped off by men?" I wasn't ready to acknowl-

edge that about myself to you at that point. Another uncon-
scious thing—the women at *Camera Oscura* [a new women's
film magazine published in California] pointed out to me that
in both films the references to other movies—Pabst's *Lulu*,
and *Psycho*, the stabbing in the shower—had to do with
women being stabbed to death. I hadn't been aware of that
at all.

*That's a classic—Maya Deren's knife between the sheets
. . . Would you have used that same theme a second time
if you had been aware of its implications?*

Yes, I think so.

*On the other hand,* A Woman Who *is not at all a sensuous
film. I guess I was sort of disappointed by that aspect.*

That may be my sensibility. You've never seen that in
my work, have you?

*I guess I've confused erotic with parodied erotic, or
stylized sensuousness. Like in the early dance where people
jump over something and as they land the catcher puts his
or her hand on breast or crotch. It was very funny.*

I always called that the fly in the ointment. I can't make
something funny just through words. All I get is a kind of
irony or self-mocking tone. I can only do it through juxta-
position.

*The audience laughed when I saw* A Woman Who. *I
think it was mostly the laughter of delighted identification
rather than about jokes, though.*

Anyway, the erotic sequence in *A Woman Who* is not at
all sensuous. It's eerie, and sinister.

*Why do the women undress and not the men, in that film?*

In that sequence it's because it's a woman's sexual fan-
tasy and that was the nature of it, that she has these two
clothed parental figures catering to her.

❂

*Before I was a conscious feminist I found I was always
saying—and I still hear this all the time from other women—
"I made it as a person, not as a woman." It was a real reve-
lation when I realized I was ashamed of being a woman
person.*

Well, whatever shame there was in my experience I think
it had more to do with existing than with being a woman.
I had a very difficult early experience, but I don't know.
Maybe I haven't really examined it. Certainly I had no
choice but to admire the father and brother. My mother—it

was not only that she was a woman, but she was someone whose total identity was extremely shaky, at times to the point of collapse.

*You've talked about the importance of Martha Graham for you as a woman and as an innovator. You said in Avalanche: "At that time, even though I had no idea of what my potential was, there was the beginning of this extreme ambition. And I wanted to define what she had done and why she had done it."*

Yes. Strangely enough when it came to becoming an artist—I don't know whether that was coincidence either, but I fell into dance, where there were certainly strong female role models. . . .

*A friend and I have a theory that there is a special kind of fragmentation that often surfaces in women's work in all media. Your films, and the book as well, have that quality of pulling a lot of things together, bouncing from one idea to another, presenting, say, five unlike things that turn out to have an undercurrent of likeness via association. We thought of it perhaps as a desire to please that leads to a special kind of adjustability forced on women by our lives, which might have something to do with the ability to make those changes, those jumps, while still maintaining continuity.*

It's the opposite of the gestalt. Disjunction.

*No matter how you look at it, you don't see it all.*

But if I think of influences, things I saw at impressionable periods, there's Rauschenberg, and Johns, and certainly Cage. Doesn't that destroy the feminist interpretation of fragmentation?

*Except that Cage's fragmentation is like explosion. The connections are defied, where the kind of fragmentation I'm talking about retains connections, is a network of apparently unrelated events or images which actually open up new ways of looking at things, like how Ree Morton's sculpture differs from, say, Barry Le Va's scatter pieces. And I think of Robbe-Grillet's fragmentation, for instance, as entirely structured.*

Yes. I have the feeling that Robbe-Grillet simply is using a very traditional form and cutting it up like a puzzle and reassembling it. I don't start out with a whole. My process is one of accretion and then finding the underlying connections, either thematic or visual or psychological or temporal or whatever, after I have accumulated things that interest me. There always comes a point where I've made all the connections I can, and there's still stuff hanging around that

doesn't fit in. Then I will invent new connections to bring that in, but it isn't a process of knowing where you're going and putting it all together . . . which might be looked at as a risk, or a frailty of my work, that it has this meandering quality, constantly turning corners. You know where you are at any one moment and then you're supposed to be in a different place. It sometimes has a gamelike quality.

*The audience guessing at the narrative, how to put it together, adding pieces of themselves to fill it in. I love that sort of thing.*

That business of storytelling. I have this basic belief that I couldn't tell a convincing story if I tried, so again it's a matter of having little fragments of stories in a kind of wishful frame for a story into which I can put all kinds of authentic moments in a totally inauthentic frame. In the next film there'll be more people, and the scenes will shift. There will be a story told right at the beginning with the names of the two protagonists, but the people who play these two protagonists will change.

o

Most of the formal devices in Rainer's work are motivated by the fine line she walks between esthetic distance and the "unalleviated intensity" of soap opera, between seriousness and absurdity, detachment and engagement. When she wrote an introduction to Nancy Graves' show in Philadelphia in 1973, she saw their common need for "structural supports for the elaboration of a personal iconography and mythology . . . perhaps based on a deep distrust of any creative act that has its origin solely in the imagination, or draws its inspiration from an 'overwrought' tradition such as painting or dance." By the use of "an intermediary between our imaginations and consummated acts" they become "free to deal with problems of 'context' rather than 'significance.'" *A Woman Who* begins and nearly ends with the actors and actresses sitting before a screen watching themselves and others on slides (still photographs being one further remove from life than motion pictures). The audience is immediately and firmly reminded that here, and throughout the film, we are seeing neither life nor live performances, that we are looking at looking, rather than looking at things happen. (This effect is sharpened by the use of voiceover and titles instead of synchronized speech, and by Babette Mangolte's extraordinarily sculptural camerawork.)

Yvonne Rainer: Denster Leech and Renfrew Neff in *Film About a Woman Who* . . . 1974. Photo: Babette Mangolte.

The degree of detachment and engagement in a work of art is crucial insofar as it affects the degree of communication. On one hand I worry about the downgrading of emotional intelligence which threatens the art audiences with the same disembodied, disengaged stance as that affected before a television set; for over a decade now an imposed—perhaps masculine—detachment masquerading as "modernism" has insidiously denigrated feeling. On the other hand, as Rainer suspects, "there is no way to go back" to an emotional involvement without some removal element to set it

in relief. "It's like wishing for a lost innocence." Thus it has come to seem that only a formal approach, which constantly joggles the viewer's sights away from the "slice of life" in which he or she is determined to wallow, can enlarge an anti-formalism that penetrates to other levels and brings to light any new sensibility. Rainer is not alone in her preference for melodrama over drama. Drama in our culture has been cheapened by commerce and propaganda and has become as a result a gold mine of humor and irony for artists. Style has become far preferable to "sincerity" because in some curious way it is more difficult (or less painful) to exploit. Rainer's problem, and it is a central one to all of the arts, is how to connect private experience to a larger context; how to "link it all up with the kinds of conditioning and power structures that govern our lives." At its best her work combines a consummate sense of style with psychological insight—both of which can come only from self-honesty. When the combination works, it overcomes the need to remove herself, and by proxy her audience, too far away from her content. It is from artists like Rainer, who have consistently pushed at formal barriers, that we can expect this ultimate experience.

# Distancing:
# The Films of Nancy Graves*

## I. The Background

Nancy Graves was first known as a sculptor fashioning strange, life-size near-replicas of various breeds of camel that startled a predominantly Minimal art world in 1968. From there her three-dimensional work, while still concerned with animal structures and reconstructions, became more abstract and shamanistic, offering with feathers, webs, and especially bones, what Martin Cassidy from the Museum of Natural History has called "haunting structural evocations."[1] In 1971 Graves turned to painting, still taking her subjects primarily from the natural world and her approach from paleontology and archaeology. Since then she has worked from maps, charts, and photographs of such *terrae incognitae* as the ocean floor, the moon, Antarctica, Mars.

A group of drawings from 1970/71, when Graves was also making her first films, indicates the increased involvement with fragmentation, polarity, repetition, unity, and disunity that existed embryonically in her sculpture, became somewhat more obvious in the paintings and found its natural extension in film. Grid-structured, these drawings serially portray moving figures; their titles also suggest cinematic

---

* Reprinted from *Art in America*, 63, No. 6 (November 1975).
[1] Martin Cassidy in *Nancy Graves: Sculpture/Drawings/Films 1969–71*, Neue Galerie, Aachen, October 1971.

sources: *Diagonal Sequence of Limb Movements in a Newt, Camel Walking (.057 sec.) after Muybridge, Undulating Snake Motion Transformed by Time Fragmentations.* In the paintings, too, Graves was altering highly technical mapping information by means of visual overlays, subtle color movement, a dot or pointillist technique which gives the impression of transparency and motion by its slightly blurred and very dense surface. These paintings can be seen as an abstract utilization of the sort of composite viewpoint found in Sung landscape painting, where landforms are seen from several points of view simultaneously, providing in a single picture a nonperspectival overview of a whole body of visual information.

Given these concerns, it seemed only natural that Graves, who is always delving deeper and deeper into the available data on her chosen subjects, should want to explore movement as well as structure and should turn to film as an extension of her researches. (She sees the 1970s as defined by "an immediate access to information allowing for the contemplation of infinite time and space, whether it be evolutionary, ethnographic, or geophysical."[2]) The five films she has made since 1970, though their subjects are as various as her interests, are consistently characterized, in the words of Jonas Mekas, by "classic simplicity, no unnecessary effects, total dependence on subject, and respect for the subject."[3] Film, providing an intersection of time and space neither painting nor sculpture can equal, has offered her rich possibilities in the plays of light and reflection and in the relationship of part to whole—both of which have always been major factors in Graves' art.

Her three major films deal with the camel, two species of exotic birds, and the surface of the moon. (Two earlier films about the camel she now considers study projects rather than finished work.) Each film was preceded by a long travel and research period during which Graves immersed herself in the subject at hand. She has been able to avail herself of primary scientific sources because her knowledge and conscientiousness, as well as the resultant projects, are respected

---

[2] Nancy Graves in conversation with Brenda Richardson, *Arts Magazine* (April 1972), p. 61. Unattributed quotations are from the artist's unpublished notes.

[3] Jonas Mekas, "Movie Journal," *The Village Voice* (October 4, 1973), p. 75.

by professionals. Unlike most artists, she does not skim the surface of another field to take the visual cream but demands of herself a fundamental understanding before she begins to interpret esthetically. Thus her choice of the camel in the mid-1960s, for instance, was not, as it seemed to some when the sculptures were first exhibited, merely the choice of an eccentric image, but of an interrelated system of intricate form, structure, history, and evolution. Once one has seen several of Graves' realistic camel sculptures and/or her three films on the camel, one begins to understand her obsession with this extraordinary creature—its bizarre shape, haughty dignity, serpentine neck movement, languorous gestures, hilarious facial expressions, complex origins, and the sensual sounds and rhythms of its interactions. (There is an Arab proverb explaining the camel's supercilious mien: Mohammed told mankind twenty-one of the twenty-two secrets of life but told the camel all of them.)

In the three major films—*Izy Boukir* (camels), *Aves* (birds), and *Reflections on the Moon*—Graves has arrived at her own style, one of deceptive simplicity underlaid by acute attention to detail and variety. Each of these films is potentially monotonous. Camels move back and forth, birds wheel against a pale sky, the barren lunar landscape passes back and forth before us. At first the vast amount of information in each film seems distilled to almost a single image, until finally, almost in spite of ourselves, we begin to see what the artist has seen. Graves' films are neither narrative nor documentary, neither openly didactic nor overtly ingratiating. Like her paintings, they are fundamentally abstract even though the images are "representational." Their real impact comes not from the initial image—camel, bird, or moonscape —but from the unfolding in time of explorations of color, light, form, surface. And while each of the three is in its own way highly specific, showing us the subject isolated from everything but its own kind and its own immediate, natural, featureless space, there are also more general implications to be drawn from such extremely concentrated glimpses of another creature. The prologue of *Izy Boukir* is a quotation from naturalist Henry Beston:

> We need another and wiser and perhaps a more mystical concept of animals. Remote from universal nature, and living by complicated artifice, man in civilization surveys the creatures through the glass of his knowledge

and sees thereby a feather magnified and the whole image in distortion. We patronize them for their incompleteness, for their tragic fate of having taken form so far below ourselves. And therein we err, and greatly err. For the animal shall not be measured by man. In a world older and more complete than ours they move finished and complete, living by voices we shall never hear.[4]

## II. The Films

*200 Stills at 60 Frames* (1970, 8 minutes, silent): This first film, now seen as a study project, was Graves' self-imposed introductory course in filmmaking, undertaken with the help and encouragement of her editor, Linda Leeds. It consists of two hundred different color and black-and-white pictures of camels, taken from the most diverse sources—postcards, Xeroxes, magazine reproductions, photographs taken by the artist; there are camels in Australia, in Turkey, in Mongolia, in India, in zoos. Each image remains on the screen for two and half seconds—long enough for a real look but short enough to keep things moving, to make this procession of stills into a "motion picture."

*Goulimine* (1970, 8 minutes, color, sound; camera by Bob Fiore, edited by Linda Leeds): Graves now considers this too a study project—perhaps her "graduate thesis," for she took it seriously enough to make it on location in a small camel market in the Sahara and to edit it in New York down to one-tenth of its original footage. *Goulimine* is the only one of Graves' films to include anything but the most neutral background; its local color includes an occasional tent or building or camel handler. The hobbled and herded animals' terrifying shrieks, violent and unnatural movements are also in marked contrast to the undistracted calm of the later films. This makes *Goulimine*'s general aspect somewhat chaotic, but it contains the seeds of Graves' filmic style—the relationship of detail to entity (hump, head, lips, eyes, legs, feet to camel; camel to herd; herd to space) and the coincidental tableaux and rhythms in unison or counterpoint that seem, once caught on film, to have been posed and choreographed

---

[4] Henry Beston, *The Outermost House* (New York: Ballantine Books, 1971), p. 19.

284

Nancy Graves: stills from *Izy Boukir*.
1971.

by sheer willpower on the part of director. This is especially true of those sequences, here and in *Izy Boukir*, of overlapping legs, intended to "establish a structural rhythm of body motions." These sequences inspired her "variability" sculptures of the same year, one of which in particular—*Variability of Similar Forms*—seems to be the key to the camel films; its cinematic title alludes to thirty-six pairs of camel leg bones, a forest of apparent repetition that provokes the same process of observation and distinction.

*Izy Boukir* (1971, 20 minutes, color; camera by David Anderson, edited by Linda Leeds, sound by Jack Baran): The film begins with a small herd of camels looking in from the left, with sky and sand filling most of the frame; then the camels move forward, fill the frame and stop, as though populating that space; then they run in one direction, then back across the screen in the other. Sometimes the movements seem artificially slowed, but that is an illusion fostered by the animals' unfamiliar locomotion. A good part of the film is devoted to a beautiful sequence in which the camels are drinking, their necks rising and falling in accidental arabesques, gangling legs crossing other legs, occasionally an incredible still sculpture of two legs reflected in water, of a hairy rump rich against the blue or of two heads chewing in parallel motion, shape moving hypnotically against shape. There are also a nearly erotic nursing section and a majestic communal pissing. The variety of framing seems endless, and the sound track of eerie camel sounds gives the same restless-restful effect as the images.

*Aves* (1973, 23 minutes, color; camera by Herman Kitchen, edited by Linda Leeds, sound by Jack Baran): The original idea for this film was tripartite—black, white, and pink birds —the magnificent frigate bird, the snowy egret, and the great flamingo. However, the egret had to be omitted because the footage did not meet the artist's standards. The completed film is bipartite, so that the contrast between the graceful, soaring, magnificent frigate and the oddly proportioned, flapping great flamingo is quite marked, though both are filmed the same way—against a blue sky, except for three brief glimpses of treetops in the flamingo sequence.

The species were chosen, after a good deal of research, for their dissimilar profiles and flight patterns; these are the subject of the film—the way both elements produce a "multi-layered motile space," defined by "the disparate motion of

overlapping forms in flight."[5] Where the frigate birds hover in space and slide across the screen, the flamingos seem to swim in a heavier medium, like pigs on wings. This effect depends on the angle from which they are filmed, though, for they can look awkward or elegant, and their frantic reversals can give way to perfectly coordinated squadron flying. At times they make almost reptilian movements, recalling the neck forms in the camel films and the fact that "birds as a class have a close affinity to reptiles from which they are believed to have developed."

Purity of spatial experience is the salient quality of *Aves*. One senses through the birds' movements the contours of the unseen land below and the swells of the air itself. The black frigate birds drift as though blown across the frame, the light catching their white breasts and beaks. As one bird cuts abruptly down and across the others, as many birds are seen like points on a line or a map (the whole film is very linear), or as they are blown back and forth, up and down, they describe a visible space lattice on their "spaceless" blue ground. The space is gradually revealed in strata, a shallow closeup giving way to a plane of birds further away, which in turn cracks open into emptiness. The sound track in both sections is of wind whistling eerily in space (with some birdcalls, crickets, and waves). It augments the effect of vastness and, paradoxically, of silence.

The double-sectioned form provides a double time sense. The viewer flies first with the frigates and then with the flamingos. After the initial beauty of the images, one expects more change, realizes there will be little obvious variation, is temporarily disappointed, then sinks to a second, contemplative level—a kind of physical identification with flight. At that point the experience becomes more about space than about time; one floats from tempo to empathetic movement. Just as one is enveloped in this experiential layer, a change does come as frigate birds give way to flamingos; and no matter how much one might earlier have desired change, this comes as an almost irritating diversion. The whole process is then more or less repeated in the second section.

Some factual notes: This ambitious film took two years to complete, due to difficulties in finding and then in filming migratory birds under proper conditions. (The lab destroyed one whole section that could not be reshot until the birds

---

[5] Nancy Graves, prologue to *Aves*.

returned the following year.) The frigate birds were filmed at Marquesas Keys, Florida, the flamingos at Lake Nakuru, Kenya. Originally the film was to include nesting sequences and environmental data along with more detailed closeup information on flight mechanism and the structures of feathers, eyes, wings. These ideas were discarded so that the film would not resemble a documentary "nature movie," as well as for financial reasons. As a "shooting script," Graves gave the cameraman notebook pages with pictures of birds in flight, cut from magazines, annotated, and with frames drawn over the areas she wanted to translate. She also made drawings (frames) of thirteen specific configurations of birds in flight and requested six variations on each for each species. Leeds' superb editing was particularly crucial in *Aves;* if the flow of flight had not been smoothly maintained through innumerable cuts, the film would not have worked.

*Reflections on the Moon* (1974, 33 minutes, black and white; camera by David Anderson and John Barone, edited and coauthored by Linda Leeds): The punning title might also imply a third level of "reflection"—the fact that this "motion" picture was filmed, like Graves' first attempt, from some two hundred stills, in this case chosen from thousands made available to her from the Lunar Orbiter collection by the Goddard Institute of Space Studies (NASA), New York City. The simulation of movement also "reflects" the "simulation" of the moon landings as we saw them on television. And despite recent scientific discoveries, we still "see" the moon through a haze of semi-knowledge—an atmospheric haze of mythology. The moon is "outer space," but it has always been romantically associated with "inner space" and is a female symbol for this and other reasons. Graves is convinced that great art must "respond to the philosophical implications of its time," of which there could be no better emblem than the embattled moon with all its levels of content and cliché.

All the movement in *Reflections on the Moon* is the camera's and, by kinesthetic identification, the viewer's. "What the airborne camera brings down from the sky is a load of field notes in the form of spatial relationships between images that as such are intrinsically accurate but that as abstract information are only more or less complete."[6] In this

---

[6] Nancy Graves, "Lexicon of Mapping," in *Nancy Graves,* La Jolla Museum of Contemporary Art, La Jolla, California, 1973, p. 4.

film the active camera is used very graphically; it literally *draws* in the viewer's memory, as it draws on the screen. When the image of one area of the moon's surface is turned and perused, one sees it as a kind of gestalt collage of all its aspects. "I intend to overwhelm the viewer with the presence of the moon," Graves wrote as she began to work, and "afford an experience of prolonged intellectual and physiopsychological identification with the enormous variety of geophysical properties."

She and Leeds have done just that, from the first shot—in which the semicircle of the moon descends heavily from the top of the frame to fill the black void below—to the last ones, which move repeatedly over the moon's surface up to those black depths where a tiny earth hovers. During the body of the film, the camera pans back and forth, zooms in and out over often spectacularly detailed lunar features: the dark *maria* (seas) and bright *terrae* (highlands), faults, rills, domes, and craters. At times it follows the path of a sinuous rill or crater chain so that the landscape itself determines the structure. Height differentiation is established by light ratios, and when the image focuses on pale, bubblelike domes and dark empty sockets glaring balefully like eyes, it is tempting to see there the many faces of the man in the moon.

Orientation and scale shift frequently—a fact one perceives not only unconsciously but via the thin bands into which all the photos are divided. (Each is actually a composite created by scanning cameras filming next to each other on the orbiter.) These repetitive strips become larger and smaller according to the distance of the camera, and in the film may be vertical, horizontal, or oblique. They also flatten the image's surface (except at one point when they look like furrows). Eventually trompe l'oeil gives way to the rhythms of filming—dissolves and blackouts providing the boundaries— and illusionism is vanquished. Added to the implied vertigo of content, there is also an experiential contradiction: some images appear to be seen frontally, others lying horizontally because whereas most of the stills were photographed on the wall (with an Arriflex camera on a tripod with a Moy head),

some were made on a flatbed Oxberry animation stand—a process whose greater expense provides a commensurately greater degree of control.

Throughout the film, the visual images are accompanied by a soothing, sighing sound track approximating seismic sound. It consists of four or five different sound patterns produced by an oscillator. Certain sounds were chosen for certain images, sliding up or down a linear scale, or evenly repeated like the camera movements coinciding with them. Sound and image often seem mutually to affect each other. As the film progresses, the different regions of the moon become both sites and sights, newly familiar to the viewer and then unfamiliar again when seen from another viewpoint. *Reflections on the Moon* is a scanned accretive mosaic as well as a journey which at its end makes sense as a visual whole.

Graves has interpreted the earth (or *terra* in general) from greater and greater distances, though it has kept its tactile hold on her imagination. Camels walk the earth, their rich textures and colors reflecting its substance and giving a sensuous identity to the structural information offered. Birds soar over the earth, defining it by the patterns they form above it. The mysterious moon is still more sensorially rich because it is unknown. Graves' next film was to have been on Antarctica, until a grant fell through at the last minute. Whatever it does turn out to be, her selection of subjects of so grand a scope and her commitment to so thorough a coverage of available data will guarantee an experience fuller than most artists' films can offer.

# Camouflage:
# Films by Holt and Horn[*]

Two films could hardly be more different, but Nancy Holt's
*Pine Barrens* and Rebecca Horn's *Dreaming Under Water*
are both camouflaged, for protection, perhaps, of a vulner-
able core. Both films are intentionally elusive. I find myself
thinking more about what escapes me than about what is
there.

In *Pine Barrens*, elusion is the prime cinematic device. The
32-minute color film made in 1975 is about a place Holt has
been visiting since she was eight years old. It is a mysterious,
isolated place, a kind of high desert of sand, scrub pine
forest, and swamp that · exists anageographically, in New
Jersey, a couple of hours from Manhattan. It is an in-
habited place but we see no people, only hear voices; at
the end the director's shadow and her footprints appear like
a signature. The camera is driven and walked through a
relatively monotonous landscape with a minimum of pictur-
esque or pretty detail, so the movement itself takes over. It
travels the road, pushes through the brush, squelches through
bogs. The sound track consists of country music by Bill
Patton's Pine Barrens Trio, of natural sounds, factual in-
formation narrated deadpan by the artist, and equally low-
keyed if whimsical excerpts from interviews with the in-
visible natives, or "Pineys," as they call themselves. Their
stories of survival and superstition are the most "entertaining"
part of the film.

---

* Reprinted from *Art-Rite*, No. 10 (Fall 1975).

Nancy Holt: still from *Pine Barrens* (footprints). 1975. Courtesy Castelli-Sonnabend Tapes and Films, New York.

*Pine Barrens* opens like a parody on all those 1960s road movies, with country music and a bumpily unfolding stretch of red dirt ahead. When one realizes one is not going to see people, houses, towns, the ambiguity heightens. It's like talking to someone you've never seen over the telephone. There are spaces to be filled and the viewer has to do the filling. The structure, too, is unpredictable. The music that begins the film strikes up again about two-thirds of the way

through and, accustomed as we are to Hollywood symmetry, we figure that's the end, but it isn't. The last section is the most interesting, especially the parts in which isolated trees —tall, skinny, sparsely branched—are filmed still for two seconds, then moved ever so slightly off register for another two seconds, so there's a curious jump, sort of a kinetic "Oh, I see!" that jolts perception—a neurotic movement that also confirms something about the place itself.

Since the film is about the topography, the feel, and the mythology of an almost featureless area, spoken words take on more importance than they would if accompanied by a "livelier" image, and the place is eventually defined more by absence than by presence (reversing Holt's earlier "locator" pieces). At the same time it is implied that this absence is a cover for some undefined presence. If it had been defined, the film would have been a travelogue. For art's sake it's a teaser instead. I wonder if, in fact, "the audience for the film will extend much further than the art world," as Holt hopes, or whether only its subjects and the art world will enjoy being so skillfully teased.

○

Horn's film is also about a place, an elegantly claustrophobic interior (also inner) space defined by the activities that "take place" in it. These activities are erotic, sometimes potentially sadistic, rituals, and the film's slow pace and elaborate vacancy are not so far away from those of *Pine Barrens,* though the sensibility is an almost opposing one. *Dreaming Under Water* (also made in 1975, in color and about a half hour long) is awkwardly subtitled *Exercises in Nine Pieces.* Each of the nine fragments is a tiny film in itself. They are linked by style and imagery while narratively unrelated, building up a chain of silent sensual events. The absence here is not spatial, informational, even physical, but is a psychological product of the activities.

In the first exercise, Horn, in gigantically elongated "gloves" extending her fingertips to several feet (she has used them in previous works), moves slowly down an empty, narrow room scratching the walls on both sides; the sound is eerie, harsh, repellent both associatively (fingernails on blackboards) and actually in its identification of confinement. Two other exercises also depend on machinelike body projections—a bizarre harness that makes feathers controlled by a woman's toes dance over her shoulders in the inverse of a marionette; and a couple bandaged together so their de-

Rebecca Horn: stills from *Dreaming Under Wate*

liberate but groping gestures are unnatural and obscene. The bondage imagery is rather martial, but gentle too. Frustration is another frequent theme. In one piece a cockatoo is mimicked by Horn until he is driven frantic, pecking at himself in a mirror. In another a mirror-shuttered window apparatus finally, reluctantly, gives up its reflection; in another two tiny goldfish appear to swim down the hairline of a man's stomach while cocktail music plays and a fan blows the hairs as if they too were under water.

My favorite sequence is one in which a green-tinted nude body glides through profuse foliage simulating a jungle closeup, though still clearly "indoors." The body parts are

75. Courtesy Rene Block Gallery, New York.

never put together or even fully recognizable as they become
in turn a variety of strange creatures. A wet navel through
the leaves looks like the eye or mouth of some weird sucking
organism; arms undulate like serpents; flesh and vegetation
merge to suggest abstraction without giving up their over-
powering sexuality. The lushness, and at the same time a
certain harshness, are ominously Surrealist in the Northern
tradition, recalling Ernst or Grünewald in the combination
of quaintness and menace. The impression comes danger-
ously close to one of a morbid High German decadence, but
this is mitigated by the quality of the imagination at work,
and by that incongruous gentleness which is a saving grace.

# PART III: FICTION

# Waterlay*

If women find that the clitoris has become the only site as long as there has been an earth, the moving masses of pleasure instead of acting as a kind of sexual overdrive in more air than we call winds have swept back and forth across its general response, they will find themselves dominated by the surface. And as long as there has been an ocean, its waters have ethics which might not itself be a regression if stirred to the passage of the winds. Most waves are the result of performance principle in our society, included enterprise and creativity of the action of wind on water. There are exceptions, such as enterprise and creativity are connected with libido, which the tidal waves sometimes produced by earthquakes under does not survive the civilizing process. Women must struggle to the sea. But the waves most of us know best are wind waves to attain the kind of strength that can avail itself of them. Sex is harnessed to roll across half an ocean in the service of revolution. It is a confused pattern: everything happens in a swoon or a swamp of undifferentiated sensation, a mixture of countless different wave trains, intermingling, prudish, overtaking, passive, passing, calculating, or sometimes engulfing one an-

* Reprinted from *Center*, No. 4 (November 1972), where it was untitled; excerpt from a book-length fiction entitled *I See/ You Mean* (unpublished). Parts of this and the following text are "found" material taken from a random collection of printed matter.

other, selfish and dull, despite her miraculously expanding tits, some doomed never to reach any shore, others destined to loll on her deflated airbed, wondering what went wrong.

Young waves, only recently shaped by the wind, have a steep, peaked shape when well out at sea. Not all the women in history have been humble and subservient to such an extent. From far out on the horizon you can see them forming whitecaps as they come in. It is nonsense to say that a woman feels nothing when a man is moving his penis in her vagina; bits of foam are spilling down their fronts and boiling and bubbling over the advancing face, and the final breaking of the wave is a prolonged and deliberate process. The orgasm is qualitatively different when the vagina can undulate around the penis instead of vacancy. But if a wave, oncoming into the surf zone, rears high as though gathering all its strength for the final act of its life, if the crest forms all along its advancing front and then begins to curl forward, if the whole mass of water plunges suddenly with a booming roar into its trough—then you may take it that these waves are visitors from some very distant part of the ocean, that they have traveled long and far before their final dissolution at your feet. The differentiation between the simple inevitable pleasure of men and the tricky responses of women is not altogether valid. What is true of the Atlantic wave we have followed is true, in general, of wind waves the world over. If ejaculation meant release for all men, given the constant manufacture of sperm and the resultant pressure to have intercourse, men could copulate without transport or disappointment with anyone. The incidents in the life of a wave are many. The process described by the experts, in which man dutifully does the rounds of the erogenous zones, spends an equal amount of time on each nipple, turns his attention to the clitoris (usually too directly), leads through the stages of digital or lingual stimulation, and then politely lets himself into the vagina, perhaps waiting until the retraction of the clitoris tells him that he is welcome, is laborious and inhumanly computerized. How long it will live, how far it will travel, to what manner of end it will come are all determined, in large measure, by the conditions it meets in its progression across the face of the sea. The implication that there is a statistically ideal fuck that will always result in satisfaction if the right procedures are followed is depressing and misleading. For the one essential quality of a wave is that it moves; anything

that retards or stops its motion dooms it to dissolution or death. There is no substitute for excitement; not all the massage in the world will ensure satisfaction, for it is a matter of psychosexual release.

An island has no parallel in young female groups. The growing girl, standing beneath the base of the cliff, limited usually to the school situation, conscious of "that powerful marine gnawing" by which her coasts are eaten away, only after repeated trials has confidence to pursue our investigations. More than once doubting the protection of our rocky shield, her strong desires become dissipated in passive fantasies. In this critical period, in that part of the mine where but nine feet of rock stand between us and the ocean, the heavy roll of the larger boulders, the ceaseless grinding of the pebbles, the fierce thundering of the billows, with the crackling and boiling as they rebound, a girl is expected to begin her dealings with men. When a girl fails to manipulate her sexual situation, one of the present engineers writes, she is required to adopt the proper feminine passivity and continue her own repression by herself. In these palmy days of the permissive society the situation has placed a tempest in its most appalling form too vividly before me ever to be forgotten. And yet we owe some of the most beautiful shoreline scenery to the phenomenon of girls agreeing to massage boys to orgasm. Any Saturday afternoon in a provincial English town one may see the sculpturing effect of moving water. Caves are almost literally blasted out of the sex object. The ominous withdrawal of the sea from its normal stand is ironically the conditioning for the intense polymorphous genital activity which characterizes male puberty. Eventually a hole is torn through the roof of the cave.

# Caveheart[*]
# (for Charles)

### I.

For sixty million years this principle has been forming the
law of the heart. In some places the topography is a dead
giveaway. The first clue is the stimulation of the parasympa-
thetic nerves. Instead of the usual pattern of little brooks
flowing into creeks and creeks flowing into rivers, the pres-
sure rises and the result is violent erosion and related venous
inflow. In the hollowed vastnesses created by water when the
heart chambers dilate greatly and the force of contraction
becomes very great, a flash flood is an everpresent possibility.
Other clues are depressions. The nervous system is con-
nected. The arterial pressure pulsates. Increased vigor. Rocks
showing bruises and wear as if they had been used as ham-
mers. The kind of deluge that can dam up in the veins.
There has to be a hole. Vibrations set up in the pink gypsum.
Abnormal leakage from the electrical current of the heart.
. . . Water ran off into the venous reservoir.

### II.

Another hole! The blood flows around and around a con-
tinuous circuit when the land is moist and the water table is
high. Standing at the bottom, impulse travels slowly. A

---

[*] Reprinted from *Center*, No. 5 (September 1973).

302

mud bank slopes off into darkness. An entrance. I continue
my descent in silence. I pass a small opening in the denuded
endometrial wall, causing a rise in venous pressure. At the
bottom of the drop, tissues slough into the uterine cavity. A
sparkling waterfall tumbles from a dome where the deeper
layers of the endometrium proliferate three-fold. A clay bank
rises from the floor to ceiling initiating a new cycle. The in-
cline is too slippery to scale, so growth then stops. Crossing
the room lengthwise I encounter a passage into large pla-
cental chambers. The fetal portion is decorated with many
small cauliflower-like projections extending into the clay
bank. I climb the valves and folds along the ductus. Changes
in hormonal secretion probably account for the rare ad-
ventures in a virgin cave.

**III.**

Pressure deep underground—pressure of water upon water—
can be great. The male and female dispositions seeping or
flowing in any direction, even upward, could move freely
along joints, fractures, and bedding planes. A contraction
which, more than any other factor, decisively influences the
later development of the human being. In the little girl,
cavities develop. They often appear as springs or water holes,
even as lakes. The little boy takes the place of the lime-
stone it has dissolved and carried off to some surface outlet.
Enlarged by solution, the erogenous zones—the cracks, the
joints, the spaces between bedding planes—become caves.
The place in the rocks where the venous fluids and phallic
formations meet is not a fixed and stable one. Indeed, in
rainy seasons, the libido rises, and following droughts, it falls.

**IV.**

When an uplift occurred. When the earth created a dome
in the course of time. Minute mountains rising from mortar
flesh. Creating a city in the course of space. Touch, touching,
move, moving mountains. Frequent spontaneous discharges.
Dusty hills and contours waiting to be pressed. Deep under-
ground, water upon water. A twitching. A slowly building
wall. Watching it grow from brick to brick. A cave formed in
limestone that once was saturated. Eroding the body. A tun-
nel, a path down the side, a field of poles. The spaces wid-
ened. The hill is a breast is a well. After the cave was filled

with air instead of water. Seeing the sky through the hole. Rooms, some standing, some worn away to skeletons. Entering intimacies long since. Seepage water has weakened the ceilings. Earth absorbed back into the cavities. Water reflecting skies. The body's faults and freedoms. Breakdown did not always result in domes. Fingers walking through my landscape, sinking. Crevasses and crannies, one remaining wall. Sometimes the cracks were close together. Entering tiny rooms. Learning to be a cave. Seeping along any of these fissures. Leaving depressions in the landscape. A path to the penis, a wall around the nipple, a tower in the brush. The topography itself can be a dead giveaway. Waves have washed over those parts that hold you. The sex life of horizons. The little people form a chain and move their lives across the hills, into the caves.

# Index

*Italicized page references are illustrations*